THE NEW
MUSEOLOGY

THE NEW MUSEOLOGY

Edited by Peter Vergo

REAKTION BOOKS

Published by Reaktion Books Ltd
1-5 Midford Place, Tottenham Court Road
London W1P 9HH, UK

First published 1989

Designed by Humphrey Stone

Photoset by Character Graphics,
Taunton, Somerset
Printed and bound in Great Britain by
Redwood Burn Ltd, Trowbridge, Wiltshire

British Library Cataloguing in Publication Data
Vergo, Peter
The New museology.
1. Museology
I. Title
069

ISBN 0-948462-04-3 Hbk
ISBN 0-948462-03-5 Pbk

Contents

Photographic Acknowledgements

The editor and publishers wish to express their thanks to the following for permission to reproduce illustrations: BBC Hulton Picture Library, p. 180; The Bethnal Green Museum of Childhood, pp. 27, 28, 30; History Trust of South Australia, pp. 106, 108, 110; Ironbridge Gorge Museums Trust, p. 63; Manchester City Art Galleries, p. 128; National Film Archive, p. 69; The Trustees, The National Gallery, London, p. 127 top; The National Museum of Ireland, p. 187; The National Portrait Gallery, London, p. 127 bottom; Sotheby's, p. 184; The Board of Trustees, Victoria & Albert Museum, pp. 11, 13, 16.

Notes on the Editor and Contributors

PETER VERGO is Reader in the History and Theory of Art at the University of Essex. His books include *Art in Vienna 1889–1918: Klimt, Kokoschka, Schiele and their Contemporaries, The Blue Rider*, and an edition of Kandinsky's *Complete Writings on Art*. He organised the 1983 Edinburgh International Festival exhibition, 'Vienna 1900' and, more recently, 'Crossroads Vienna: Music and the Visual Arts', shown at the Royal Festival Hall, London, in 1988. He is currently preparing the *catalogue raisonné* of the twentieth-century German paintings in the Thyssen-Bornemisza collection, Lugano, and organising an exhibition of the German Expressionist paintings in the collection, entitled *Expressionism and its Heritage*, to be shown in Lugano in 1989, and subsequently at the National Gallery of Art, Washington, DC, and the Kimbell Art Gallery, Fort Worth, Texas. Peter Vergo is a member of the editorial committee of the journal *New Research in Museum Studies*.

CHARLES SAUMAREZ SMITH is Assistant Keeper at the Victoria and Albert Museum, London, with special responsibility for the V & A/RCA MA course in the History of Design. His two forthcoming books are *The Building of Castle Howard* (to be published in 1990) and *The Room 1700–1800* (to be published in 1991).

LUDMILLA JORDANOVA is Senior Lecturer in the Department of History at the University of Essex. Her *Lamarck* was published in 1985 and *The Languages of Nature*, which she edited, in 1986. Her most recent book is *Sexual Visions: Images of Gender in Science and Medicine between the Eighteenth and Twentieth Centuries* (1989).

COLIN SORENSEN is Keeper of the Modern Department at the Museum of London. He has made TV and radio broadcasts and written reviews for the *Burlington Magazine, TLS*, and other publications. He has organised 'London's Flying Start', 'A Tale of Two Stations: King's Cross and St Pancras' and other exhibitions and events for the Museum of London.

PAUL GREENHALGH is a course tutor for the V & A/RCA design course and a part-time tutor in the History and Theory of Decorative Art at the Royal College of Art, London. His *Ephemeral Vistas: The Expositions Universelles, Great*

Exhibitions and World's Fairs, 1851–1939 appeared in 1988. He is currently editing a book on 'Modernism in Design' in the series 'Critical Views' for Reaktion Books.

STEPHEN BANN is Professor of Modern Cultural Studies at the University of Kent at Canterbury. His many books and publications include *The Clothing of Clio: A Study of the Representation of History in Nineteenth-Century Britain and France* (1984) and *The True Vine: On Visual Representation and the Western Tradition* (1989).

PHILIP WRIGHT is a visual arts consultant. He currently works as a freelance writer, researcher and exhibition organiser. During 1975–6 he was Assistant to the Keeper at the Scottish National Gallery of Modern Art, Edinburgh. Since then he has been Director of the Visual Arts Department at the Scottish Arts Council (1978–82) and Associate of the Directors at the Waddington Galleries, London (1982–4).

NICK MERRIMAN is Assistant Keeper of Antiquities, Prehistoric and Roman Department, at the Museum of London. His *Early People* was published in 1989. He is currently writing a book on 'Prehistoric London', and translating (with Caroline Beattie) *L'amour de l'art: les musées européens et leur public* by Pierre Bourdieu and Alain Darbel.

NORMAN PALMER is Professor of Law at the University of Essex. He has published books on *Personal Property* and *Building Contracts and Practice*, and he is currently working on *The Law of Cultural Property*, to be published by Oxford University Press.

Introduction

PETER VERGO

What is museology? A simple definition might be that it is the study of museums, their history and underlying philosophy, the various ways in which they have, in the course of time, been established and developed, their avowed or unspoken aims and policies, their educative or political or social rôle. More broadly conceived, such a study might also embrace the bewildering variety of audiences – visitors, scholars, art lovers, children – at whom the efforts of museum staff are supposedly directed, as well as related topics such as the legal duties and responsibilities placed upon (or incurred by) museums, perhaps even some thought as to their future. Seen in this light, museology might appear at first sight a subject so specialised as to concern only museum professionals, who by virtue of their occupation are more or less obliged to take an interest in it. In reality, since museums are almost, if not quite as old as civilisation itself, and since the plethora of present-day museums embraces virtually every field of human endeavour – not just art, or craft, or science, but entertainment, agriculture, rural life, childhood, fisheries, antiquities, automobiles: the list is endless – it is a field of enquiry so broad as to be a matter of concern to almost everybody.

Museums, in the sense in which the word is today commonly understood, are of course a relatively recent phenomenon. The foundation of the great publicly funded (and publicly accessible) institutions such as the British Museum or the Louvre goes back no more than a couple of hundred years, to the latter part of the eighteenth century. But in origin, museums date back at least to classical times, if not beyond. The origin of the museum is often traced back to the Ptolemaic *mouseion* at Alexandria, which was (whatever else it may have been) first and foremost a study collection with library attached, a repository of knowledge, a place of scholars and philosophers and historians.[1] In Renaissance Europe, those whose power and wealth permitted them to engage in such pursuits looked beyond the boundaries of the city-state, beyond Europe itself, in

their quest for dominion over nature and their fellow man. An essential part of that quest, as the princes and statesmen of the time realised perfectly well, was to attain a more complete understanding of both man and the world. The collections they amassed – not merely of art, but of artefacts, antiquities, scientific instruments, minerals, fossils, human and animal remains, objects of every conceivable kind – the *studiolos* and cabinets of curiosities which have recently become objects of considerable interest to historians, and which were museums *avant la lettre*, served not merely the baser function of the display of wealth or power or privilege, but also as places of study. This notion of the dual function of collections as places of study and places of display was inherited, both as a justification and as a dilemma, by the earliest public museums. Overlaid with the more recent sense of an obligation that museums should not merely display their treasures to the curious and make their collections accessible to those desirous of knowledge, but also actively engage in mass education, the dilemma is complicated still further today by the entrepreneurial notion of museums as places of public diversion. Paul Greenhalgh's essay in the present volume makes clear what uneasy bedfellows instruction and entertainment are, and have always been, both within and outside the context of museums.

But museums are of course far more than just places of study, or education, or entertainment. The very act of collecting has a political or ideological or aesthetic dimension which cannot be overlooked. According to what criteria are works of art judged to be beautiful, or even historically significant? What makes certain objects, rather than others, 'worth' preserving for posterity? When our museums acquire (or refuse to give back) objects or artefacts specific to cultures other than our own, how does the 'value' we place upon such objects differ from that assigned to them by the culture, the people or the tribe from whom they have been taken, and for whom they may have a quite specific religious or ritual or even therapeutic connotation? In the acquisition of material, of whatever kind, let alone in putting that material on public display or making it publicly accessible, museums make certain choices determined by judgements as to value, significance or monetary worth, judgements which may derive in part from the system of values peculiar to the institution itself, but which in a more profound sense are also rooted in our education, our upbringing, our prejudices. Whether we like it or not, every acquisition (and indeed disposal), every juxtaposition or arrangement of an object or work of art, together with other objects or works of art, within the context of a temporary exhibition or museum

display means placing a certain construction upon history, be it the history of the distant or more recent past, of our own culture or someone else's, of mankind in general or a particular aspect of human endeavour. Beyond the captions, the information panels, the accompanying catalogue, the press handout, there is a subtext comprising innumerable diverse, often contradictory strands, woven from the wishes and ambitions, the intellectual or political or social or educational aspirations and preconceptions of the museum director, the curator, the scholar, the designer, the sponsor – to say nothing of the society, the political or social or educational system which nurtured all these people and in so doing left its stamp upon them. Such considerations, rather than, say, the administration of museums, their methods and techniques of conservation, their financial well-being, their success or neglect in the eyes of the public, are the subject matter of the new museology.

Museology is, in any case, a relatively new discipline. Not until long after the foundation of the first museums did anyone think of them as a phenomenon worthy of study; and it is more recently still that museology in the extended sense outlined above has come to be recognised as a field of enquiry in its own right. If the reader is prepared to concede that there exists, as the title of this volume implies, not merely such a subject as museology, but a number of possible museologies, including a 'new' (and therefore presumably also an 'old') museology, what then is a definition of the 'new' museology? At the simplest level, I would define it as a state of widespread dissatisfaction with the 'old' museology, both within and outside the museum profession; and though the reader may object that such a definition is not merely negative, but circular, I would retort that what is wrong with the 'old' museology is that it is too much about museum *methods*, and too little about the purposes of museums; that museology has in the past only infrequently been seen, if it has been seen at all, as a theoretical or humanistic discipline, and that the kinds of questions raised above have been all too rarely articulated, let alone discussed. Contemplating the history and development of the museum profession – and, in this country at least, its present sorry plight[2] – the comparison that springs irresistibly to mind is with the coelacanth, that remarkable creature whose brain, in the course of its development from embryo to adult, shrinks in relation to its size, so that in the end it occupies only a fraction of the space available to it. Unless a radical re-examination of the rôle of museums within society – by which I do not mean measuring their 'success' merely in terms of criteria such as more money and more visitors – takes place, museums in this

country, and possibly elsewhere, may likewise find themselves dubbed 'living fossils'.[3]

However pressing the need for such a re-examination may be, the present volume does not attempt to offer any comprehensive account of the entire field of museum-related activities. It was not our aim to achieve a balanced spread of topics; rather, we addressed those topics that we felt urgently needed addressing. The reader will look in vain for coverage of subjects such as museum administration, conservation techniques, registration methods, or corporate sponsorship; essays on such matters are to be found in adequate, if not yet plentiful, supply elsewhere in the growing literature on museology. We also took cognisance of some of the most recent 'alternative' literature, which likewise adopts a critical stance vis-à-vis the 'old' museology, such as Robert Lumley's excellent anthology *The Museum Time Machine*, which in part examines the various constructions which museum display inevitably places not merely upon history, but upon such things as gender, race, and class[4] and Brian Durrans's forthcoming book, *Making Exhibitions of Ourselves*, which considers among other subjects the fascinating question of the public display of (usually subject) peoples.[5] Once again, such topics are here, in the main, conspicuous by their absence. Nor is the present volume intended to do justice to museum theory and practice outside the United Kingdom. Though almost every essay refers in one way or another to developments abroad, and two in particular – by Philip Wright and Stephen Bann – give more extended consideration to museums in the United States and in Australia respectively, the various essays are written essentially from a British perspective. *Ex Africa semper aliquid novi*; and while innovations elsewhere may hold important lessons for museum practice in this country, in our view it is here, in Britain, as the twentieth century draws to its uneasy close, that the problems, the issues and the controversies are to be found in their most acute form.

The essays included in this volume are not written from a single viewpoint, nor even from a single point of departure: they are as different in approach, in emphasis, in style of writing as the personalities and interests of their authors. It was never my intention as editor to invite a 'representative' selection of museum professionals to write about a 'comprehensive' list of museum-related topics. Instead, I asked a small number of colleagues – friends, rather, by now – to write on subjects about which I knew they felt passionately. If the volume as a whole appears to the reader or critic 'unrepresentative', not comprehensive enough, lacking in cohesion, then the fault is entirely mine, though I have

to say that if these things are faults, then they are deliberate ones. If, despite the fact that the contributors consulted neither with myself nor with each other before putting pen to paper, their various essays seem, on the other hand, to betray a certain, if not coherence, then at least unanimity of spirit, it is perhaps because of the strength of shared convictions, a common concern with the health, indeed the survival of the profession in which so many of us are engaged. I salute them for their courage in raising issues that are often passed over in silence, for uttering thoughts often considered to be better left unspoken, and I am grateful to them for their selflessness in putting aside other equally urgent tasks in order to contribute to this volume.

PETER VERGO
December 1988

I

Museums, Artefacts, and Meanings

CHARLES SAUMAREZ SMITH

The original intention behind the establishment of museums was that they should remove artefacts from their current context of ownership and use, from their circulation in the world of private property, and insert them into a new environment which would provide them with a different meaning. The essential feature of museums – and what differentiates them from the many extensive private collections which preceded them – was, first, that the meanings which were attributed to the artefacts were held to be not arbitrary; and, second, that the collections should be open and accessible to at least a portion of the public, who were expected to obtain some form of educational benefit from the experience. This is evident in the historical trajectory which led to the formation of museums in England.

In the seventeenth century there was a complex spectrum of collections which might be open to the public, as, for example, the collections of John Tradescant the elder at Lambeth, which could be visited on payment of a fee; but the essential characteristic of Tradescant's collection, and why it is better described in its original terminology as 'The Ark' than as a museum, was its personal nature and that its accumulation was owing to a single individual who retained the power and freedom to alter the nature of the display.[1] It was not until the collection had been inherited by Elias Ashmole and donated to the University of Oxford that it took on the name of 'museum' in recognition of its nature as a public foundation rather than a personal collection. This is made clear in the wording of the original regulations of the museum dated 21 June 1686:

Because the knowledge of Nature is very necessarie to humaine life, health, & the conveniences thereof, & because that knowledge cannot be soe well & usefully attain'd, except the history of Nature be knowne & considered; and to this [end], is requisite the inspection of Particulars, especially those as are extraordinary in their Fabrick, or usefull in Medicine, or applyed to Manufacture or Trade.[2]

Knowledge was to be promoted through the study of three-dimensional artefacts for the benefit of the public in a collection which was expected to be established in perpetuity. The first usage of the word 'museum' in its sense not just of an antique institution dedicated to the study of the Muses, but as a modern institution which might contribute to the advancement of learning, is recorded by the *Oxford English Dictionary* as being in 1683, when Elias Ashmole's collection was referred to in the *Philosophical Transactions* of the Royal Society as a 'Musaeum'.[3]

This process of transformation from a private collection into a public institution is equally evident in the foundation of the British Museum, the most important institution in dominating the public consciousness of what a museum is. The collections of the British Museum originated in the massive and diverse private collections of Sir Hans Sloane, which were housed first in Great Russell Street and subsequently in Cheyne Walk. There they were accessible to interested members of the public and were arranged with an attempt at systematic classification and taxonomic order. On 29 July 1749, Sloane made his will bequeathing the collections to the public on payment of £20,000 to his family. As Horace Walpole wrote to Sir Horace Mann on 14 February 1753:

You will scarce guess how I employ my time; chiefly at present in the guardianship of embryos and cockleshells. Sir Hans Sloane is dead, and has made me one of the trustees to his museum, which is to be offered for twenty thousand pounds to the King, the Parliament, the royal academies of Petersburg, Berlin, Paris and Madrid. He valued it at fourscore thousand, and so would anybody who loves hippopotamuses, sharks with one ear, and spiders as big as geese![4]

Yet, in spite of this attitude of mind, the collections were in due course purchased by Parliament and were installed for the benefit of the public in Montagu House in Bloomsbury. Once again, the proper designation of the collection as a museum came at the point when it was acquired on behalf of the public and when it was assumed that the collection would not subsequently be in any way dispersed. The collection remained essentially the same in the way that it was ordered, but its status and meaning were adjusted in terms of a degree of public ownership and a sense of perpetuity. It had become a museum. As the act of incorporation stated, it was intended 'not only for the inspection and entertainment of the learned and the curious, but for the general use and benefit of the public', even though the Trustees immediately instituted a system of fees which effectively restricted the nature of the public which could obtain admittance.

By the second half of the nineteenth century, the tendencies which had

been evident in the first foundation of museums were generally accepted and effectively promoted by the Government. These tendencies may be reduced to four principal characteristics which cluster round the definition of a museum: the first is that the collections on display should in some way contribute to the advancement of knowledge through study of them; the second, which is closely related, is that the collections should not be arbitrarily arranged, but should be organised according to some systematic and recognisable scheme of classification; the third is that they should be owned and administered not by a private individual, but by more than one person on behalf of the public; the fourth is that they should be reasonably accessible to the public, if necessary by special arrangement and on payment of a fee.

This mixture of meanings provided a powerful degree of idealism in the boom time in the establishment of museums in the second half of the nineteenth century. This idealism is clearly evident, for example, in the origins of the South Kensington Museum. The museum was not established for the purposes of a limited or restricted scholarship, let alone for the development of specialist connoisseurship in the field of the applied arts, but with a broad instrumental and utilitarian purpose that it might be conducive towards the education of public taste in order to promote a better understanding of the rôle of design in British manufactures.[5] As Henry Cole wrote in his first report to the Department of Practical Art:

The Museum is intended to be used, and to the utmost extent consistent with the preservation of the articles; and not only used physically, but to be taken about and lectured upon. For my own part, I venture to think that unless museums and galleries are made subservient to purposes of education, they dwindle into very sleepy and useless institutions.[6]

The extent to which this original intention was fulfilled is made clear in Moncure Conway's *Travels in South Kensington*, published in 1882. Conway came from Virginia. He had been brought up on the banks of the Rappahannock river, trained as a lawyer, became for a short time a Methodist minister, abandoned this for Cambridge, Massachusetts, where he made friends with Emerson, Thoreau and Longfellow, then came to England where he met Leslie Stephen, Carlyle, Dickens, John Stuart Mill and Rossetti, before becoming a minister at South Place, Finsbury, and building a house in Bedford Park. *Travels in South Kensington* illustrates very clearly the sense of intellectual interest which surrounded the formation of the South Kensington Museum, because of the capacity of artefacts systematically organised to demonstrate aspects

of cultural difference and change. Some of this interest is faintly repellent, clearly demonstrating a form of intellectual imperialism, annexing colonial territory into a uniform system of laws of social development; but what is impressive is that, at this stage in the museum's development, objects were not viewed purely for their own sake as fragments from a shattered historical universe, but rather as possible indicators, as metonyms, for comparative study. As Conway wrote, the visitor will 'find at every step that he is really exploring in this gallery of pots and dishes strata marked all over with the vestiges of human and ethnical development'.[7] He reminded his readers, 'This institution, it is important to remember, did not grow out of any desire to heap curiosities together or to make any popular display; it grew out of a desire for industrial art culture.'[8] It had over a million visitors a year.

In the second half of the twentieth century, the high idealism and the academic intentions which lay behind the foundation of museums are in danger of being forgotten. One of the most insistent problems that museums face is precisely the idea that artefacts can be, and should be, divorced from their original context of ownership and use, and redisplayed in a different context of meaning, which is regarded as having a superior authority. Central to this belief in the superior authority of museums is the idea that they will provide a safe and neutral environment in which artefacts will be removed from the day-to-day transactions which lead to the transformation and decay of their physical appearance. Museums are assumed to operate outside the zone in which artefacts change in ownership and epistemological meaning. Yet anyone who has attended closely to the movement of artefacts in a museum will know that the assumption that, in a museum, artefacts are somehow static, safe, and out of the territory in which their meaning and use can be transformed, is demonstrably false. The process whereby the meaning of artefacts can be transformed through their history within a museum can be illustrated by three case studies of the way artefacts have been treated in the Victoria and Albert Museum.

These three case studies are not intended to be representative; rather the opposite. They concern artefacts which are, in some way, particularly problematic, which do not fit easily into an otherwise ostensibly neutral environment, and which hit a boundary of consciousness in our understanding of the nature and purpose of museums. By exploring the problems posed by these case studies, it is possible to throw light on the broader issues of methods of display and interpretation.

The first of the artefacts to be considered is the Saxon god, Thuner, which recently arrived in the British sculpture gallery. It is worth prefixing the discussion by stating unequivocally that this is a good example of the public benefits of museums. The statue was one of a group of Saxon deities commissioned by Lord Cobham from the Flemish sculptor J. M. Rysbrack for the eighteenth century gardens at Stowe. It was sold from Stowe in 1921 and then lost to scholarly and public view. It turned up in the gardens of an obscure prep school in Hampshire, where it was reputedly used as a cricket stump, and was sent to Phillips to be auctioned in 1985. It was then acquired by the V & A with help from the National Arts Collections Fund and placed in its present prominent position, looking angry and uncomfortable amongst the serried ranks of portrait busts. Had it not been acquired by the museum, there is every likelihood that it would have been sold to a private collector, probably abroad, and so, once again, would have disappeared, known only to specialists and to the circle of friends and acquaintances of whoever was forturate enough to acquire it.[9]

There is a question here about how one weighs up the relative merits of private possession and public ownership, which in this case seems reasonably straightforward, but would become less so if, as happens, the work was confined to a store. But a more significant problem is the way that the sculpture sits so uncomfortably in its surroundings. This was emphasised when the statue was first displayed by the fact that it was placed on the makeshift wooden stretcher which had been used to transport it, thereby signalling its recent arrival, as if it was only making a temporary public appearance. It has now been given a more permanent wooden plinth, while a higher one is constructed comparable to the one on which it was displayed at Stowe; but it still looks out of place.

There are several ways of trying to explain the apparent awkwardness of the statue in its surroundings. The first is to say that it belongs to a different genre from the other works nearby: it was made to be seen from a distance in a garden and so is carved more crudely and vigorously. The second might be to introduce an argument of quality and suggest that it is a great work by a sculptor who was attempting to establish a public reputation in a piece which was bound to be seen by large numbers of the eighteenth century aristocracy, whereas many of the other works on display are more private busts by sculptors who did not necessarily have the same abilities at Rysbrack. Neither of these arguments is satisfactory. Part of the reason why the Rysbrack statue stands out so conspicuously is that it has not yet been sent to be conserved and still retains the covering

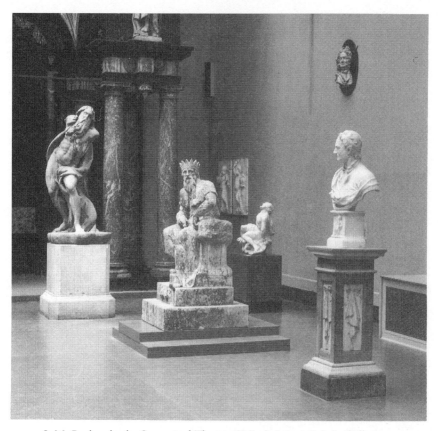

J. M. Rysbrack, the Saxon god Thuner (V & A A10-1985), in Gallery 50
of the Victoria and Albert Museum.

of lichen which it acquired during its long sojourn in the gardens of
Stowe and the Hampshire prep school. In amongst the clean and polished
portrait busts and the rather academic display, it still retains vestiges of
its life in, and passage through, the outside world. It has not yet been
accommodated and absorbed by its museum environment.

This case study provides an indication of the changing status of the
artefact as it travelled through its history from the time when it was first
commissioned, most probably as a monument to its owner's antiquarian
learning, with possible political innuendoes, by reference to the freedom
of the Saxon state in contrast to Walpole's England; through the later
eighteenth century, when it was seen and admired by visitors to Stowe
in relation to its original landscape setting; through the nineteenth and

early twentieth century when it was gradually forgotten and lost signifi-
cance; a brief moment of commodity value when it appeared in the
Stowe sale and then a long era of neglect when it served as a prep school
cricket stump; sudden press interest in the statue as a lost work of art,
in danger of being exported; an attempt by the Georgian Group to block
its sale on the grounds that it was a garden fixture; the attention of a
national museum when the prestige of individual curators and the pur-
chasing power of a particular department come into play. At each point
the statue is subjected to multiple readings: as a commodity, as an early
work by Rysbrack, as a representation of an obscure Saxon deity, as
private or as public property, as a fine old bearded man who is growing
lichen.

The literature of the transformation of goods as they travel through
a life-cycle suggests that once artefacts appear in museums they enter a
safe and neutral ground, outside the arena where they are subjected to
multiple pressures of meaning.[10] This is not true; on the contrary,
museums present all sorts of different territories for display, with the
result that the complexities of epistemological reading continue. Arguments
about artefacts tend to be conducted in strictly binary terms: are they
in public or private possession? are they what they pretend to be? are
they good or bad? In fact, the museum itself frequently changes and
adjusts the status of artefacts in its collections, by the way they are
presented and displayed, and it is important to be aware that museums
are not neutral territory.

The second artefact to be considered as a case study is a doorway.
The problem with this doorway is, more or less, exactly the opposite
from that of the Rysbrack statue; it is an artefact which, although equally
prominently on display, has essentially been lost to view from both
public and scholarly attention. It is the doorway which has been adopted
as the logo for V & A Enterprises, the company which Sir Roy Strong
has promised will turn the V & A into the Laura Ashley of the 1990s.[11]

The current label states boldly that it is a

DOORWAY
ENGLISH: About 1680

As is the way with museum labels, this conceals a complex history. As
might be suspected from its size, it was not in fact a doorway, but an
entrance archway into a long forecourt, which led off Mark Lane in the
City of London to No. 33 Mark Lane, a grand, three-storey, brick house

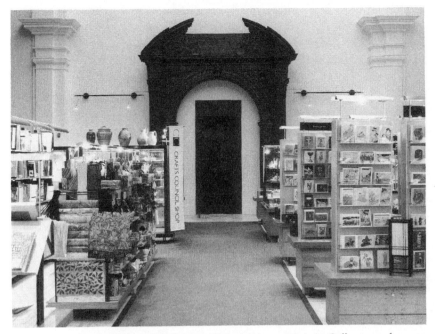

An archway from 33 Mark Lane (V & A 1122–1884), in Gallery 49 of
the Victoria and Albert Museum.

of the late seventeenth century, with good quality wood-carving on the
staircase inside as well as in the archway. In 1884, the house had become
offices for an assortment of shippers, merchants and solicitors and, in
that year, was presented to the museum by a Major Pery Standish.

The art referee who reported on the acquisition of the Mark Lane
archway by what was then known as the South Kensington Museum
was John Hungerford Pollen, a significant figure in the early history of
the museum.[12] He had been educated at Eton and Christ Church, Oxford,
where, like so many of his generation, he had come under the influence
of the high church Oxford Movement. Following ordination, he con-
verted to Rome and then practised as a decorative artist in a flat, pseudo-
medieval idiom. In 1863 he was appointed an Assistant Keeper of the
South Kensington Museum, for which he wrote several descriptive
catalogues – on enamels, on furniture and woodwork, on architecture
and monumental sculpture – as well as contributing to the art periodicals
of the day, resigning his appointment in 1877 to become private secretary
to the Marquis of Ripon. The fact that he was in favour of the acquisition
of the Mark Lane doorway suggests something of its late nineteenth-

century appeal. While based in South Kensington, Pollen had been in-
volved with the so-called School of Art Wood-carving in Exhibition
Road; he was interested in the revival of decorative wood-carving and,
like many of his generation, he greatly admired the rich ornament by
anonymous wood-carvers of the generation of Grinling Gibbons. So, the
Mark Lane archway entered the collections alongside many other
exhibits, in order to demonstrate the qualities and characteristics of a
particular school of woodwork, and it seems to have been exhibited,
although there is little evidence of how and where it was displayed, in
the North Court of the museum.[13]

The history of woodwork in the V & A is an example of the way a
museum can assemble a collection for good and legitimate reasons and
then forget what those reasons were, or, alternatively, change its ideology
and move in a different direction, leaving a portion of its holdings
stranded and forgotten. An attempt was made some time in the 1970s
to reinject vitality into the woodwork holdings in a display at the far
end of the gallery which is now the V & A shop. This display, the
so-called Furniture and Woodwork Study Collection, was a curiously
miscellaneous, but attractive and fascinating, assembly of bits of
exploded upholstery, different types of wood, and a random group of
doorways. It was swept away by V & A Enterprises and now the door-
ways only survive as bricolage in the shop refurbishment, employed as
suitable architectural backdrops to the current preoccupation of the
museum with commerce and merchandise.

The Mark Lane doorway is a further example of the process whereby
a museum can shift and adjust the meaning of an artefact from being a
surviving fragment of late seventeenth century London, a fine example
of carved woodwork, to becoming a shop fitting and a company logo
– in other words, the exact reverse of the trajectory artefacts are supposed
to follow on entering a museum, where their history is intended to be
conserved, not lost.

The third exhibit to be considered as a case study is not so much an
artefact, except in the loosest sense of the term, as a room. It is the
Clifford's Inn Room, a panelled late seventeenth century interior which
was acquired by the museum at auction in 1903. It is exceptionally well
documented, in that it is known that the first occupant of the room was
a lawyer called John Penhallow, who, in 1674, was admitted to chambers
which were pulled down in 1686 and reconstructed. Two years later, it
was recorded that he had spent a considerable sum of money 'in rebuild-
ing the same chamber'. According to the slim blue guidebook which was

issued in 1914 on the Clifford's Inn Room:

The panelled room from Clifford's Inn offers an excellent illustration of the principles of architectural design, which by the time of Charles II had been universally adopted. Symmetry and balance were demanded as important factors in the plan, and comparative proportions were arrived at by a logical system of calculation, which contrasts with the more haphazard methods of earlier periods. In this room ornamental details are arranged with due regard to balance, and the floral carvings on the chimneypieces and doors, although elaborate in design and execution, avoid the over-realistic treatment which is usually associated with the school of Grinling Gibbons.[14]

So, like the Mark Lane archway, the Clifford's Inn Room was felt to be a particularly fine example of late seventeenth century artisan joinery; it was believed that it would give the museum visitor a sense of the architectural scale and proportions of the period, in order to set contemporary domestic artefacts in an appropriate visual context.

There used to be a great vogue for period rooms, not only in the V & A but elsewhere, as anyone who has visited the great museums of the east coast of America will know: in New York, Boston and Philadelphia there are whole sequences of them, torn out of their original settings.[15] At the V & A, the period rooms were an essential feature of the new set of galleries which was set up by Leigh Ashton after the Second World War to demonstrate in a clear, didactic way the main aspects of chronological change in the applied arts and how different types of artefact of a particular period interrelate both visually and stylistically.

More recently, as with the Mark Lane archway, hard times have hit the period rooms in the V & A and, indeed, the whole sequence of British galleries. In the mid-1970s, plans were drawn up for the redisplay of these galleries in a way which was deliberately intended to be extremely minimal, partly because of the lack of availability of funds to attempt anything more ambitious, partly because of the inability of the government Property Services Agency at the time to produce and, more especially, to maintain anything which was technically sophisticated, and partly because it was believed that a severely minimal form of architectural display would allow the artefacts to be seen without extraneous visual interference. After the first set of galleries was opened it was felt that this form of display was not just neutral but aggressively bleak, and plans for continuing the sequence were shelved. The Clifford's Inn Room lies wrapped up in an empty gallery, posing the problem as to how it should be redisplayed.

There are at least four main arguments against the display of period rooms.[16] The first is the argument of priority in the allocation of available

The Clifford's Inn Room (V & A 1029-1884), in Gallery 56 of the Victoria and Albert Museum.

space. It is thought that, when there are so many artefacts which are not on display, it is not sensible to use up a large amount of space with a single gigantic artefact, especially if it is judged to be, on its own, of no particular historical significance (which, so far as the V & A is concerned, means that it is not associated with a known designer). The second argument against the display of period rooms concerns the structure of the building as an historic artefect in its own right. Now that Sir Aston Webb is regarded as a great and important Edwardian architect, it is believed that the architectural interiors of a building by him should be treated with due respect and that an attempt should be made to allow the overall proportions of the rooms to be seen independently of the displays they contain; this means, in effect, that they cannot be made to contain smaller rooms of a completely different historical period. The third argument against the display of period rooms concerns authenticity. Since the Clifford's Inn Room was acquired by the museum without any of its original furnishings, to put in appropriate furniture, even if it were of the right historical period, is held to be inauthentic, a form of make-believe which might be legitimate for a museum of social history but not

for a museum of art and design, which regards the authenticity of artefacts as paramount. The fourth argument against period rooms is concerned with audience. It is assumed that, as there are over a million members of the National Trust and less than a million annual visitors to the V & A, visitors will have a reasonably good knowledge of the historical and architectural context for which artefacts on display were originally made; and that the museum itself owns three houses of different historical periods which show artefacts in an appropriate setting, so that visual context should not be a priority of the South Kensington galleries.

None of these questions concerning the use and display of period rooms are simple and straightforward. In considering them, one gets close to some of the central theoretical problems and dilemmas which currently confront not just the V & A, but other museums as well.

The first issue is: how does one establish relative priorities in the display of artefacts? In the case of the display of period rooms, since a careful historical reconstruction of the original appearance of the interior from contemporary inventories would permit the creation of a complete *mise en scène* which would enable the visitor to visualise the way artefacts worked and were used in their original environment, then this is worth the sacrifice of several display cases. But there is a larger issue at stake, which is the question of authority and of who makes such decisions and on what criteria. One of the things that is uncomfortable about the way a state-run museum operates is that it maintains a belief in anonymous authority. Instead of viewing the display of a gallery for what it is, a set of complex decisions about a number of alternative methods of representation, there is an idea that the procedure must be suppressed: labels, for example, tend to state straightforward information which pertains only to the artefact on its own, not to its place in the gallery; visitors are not encouraged to view the gallery as an arbitrary construction; the type of design which is currently in favour, at least at the V & A, is of a highly aestheticised late modernism, the architectural style which is most inclined to reduce the element of ephemerality and theatricality in display; and the design of galleries is thought to be a problem independent of the way that artefacts are viewed and understood by visitors, whereas, of course, the environment conditions and codifies the visitor's expectations.

The second issue about period rooms is closely related and concerns precisely the inter-relationship and relative importance of the environment and of what is on display. This is not a problem which is in any sense confined to museums which have inherited buildings that are of

independent historical importance. It applies just as much to new museums, particularly if – as is increasingly the pattern – they are designed by internationally important architects and, as in the National Gallery extension, are the result of huge public competitions. Since all the surveys of the patterns of museum visiting demonstrate that visitors spend extremely little time inspecting any of the contents, except in the museum shop, it is arguable that the overall environment is of greater importance than what is actually displayed. This is not as straightforward an issue as museum curators are likely to think. I certainly do not visit botanical gardens, which I like and enjoy, for the plants which are on display, in which I have very little interest. Where the Aston Webb interiors are concerned, it is a question of design; but there is and ought to be a symbiotic relationship between a building and its contents, which needs to be recognised and articulated.

The third issue concerns authenticity. This whole matter is highly problematic since the notion of authenticity, the idea of the True Cross, lies at the heart of all museum activity. Museum visitors are probably much more sophisticated than is generally recognised in comprehending the boundary between what is being represented as real and what is being shown as convenient fiction; but this is a difficult borderline and the most effectively displayed period rooms are those at the Smithsonian Institution in Washington, where there is no pretence that the display is anything other than a carefully contrived illusion. It becomes a question of the demarcation of effective boundaries and of permitting variety in the nature and style of display.

The fourth issue concerns the question of the audience and what expectations and knowledge they bring. In the case of period rooms, this is a relatively straightforward matter. The experiences of visiting historic houses and visiting museums are, and should be, completely different. It is never possible, in visiting historic houses, to see and compare the features of rooms of different historical periods in strict sequence. Period rooms in museums can be laboratories for experimental display in a way that historic houses cannot. But the larger question of who the audience is, and what their expectations are, is not easy to answer. The traditional perception of the audience in museums was, on the one hand, of a small élite of people who were considered to have a supposedly 'real' interest in what was on display – that is, in the V & A, a band of scholars, connoisseurs and collectors – and, on the other hand, everyone else – an undifferentiated, so-called general public. This is clearly a difficult and sensitive area which needs much deeper analysis

in terms of post-war class formation; but it is evident in other media, especially television, that there is a mass audience for what used to be regarded as minority interests, which might possibly adjust museums' perception of their rôle. The implications of this are that a populist display need not be, in fact, should not be, patronising in its conception of audience response.

These three case studies of the way artefacts have travelled through their life in the Victoria and Albert Museum pose a series of problems as to the way in which artefacts should be treated in museums generally. Wherever one turns in discussing the display of artefacts in a museum there is a problem of epistemology, of how artefacts are perceived and represented by the museum curator, and of how they are perceived and understood by the museum visitor. It becomes clear that this is a highly fluid and complex activity, which is not susceptible to straightforward definition: that visitors bring a multiplicity of different attitudes and expectations and experiences to the reading of an artefact, so that their comprehension of it is individualised; that curators equally have a particular and personal representation of historical and aesthetic significance; that artefacts do not exist in a space of their own, transmitting meaning to the spectator, but, on the contrary, are susceptible to a multiform construction of meaning which is dependent on the design, the context of other objects, the visual and historical representation, the whole environment; that artefacts can change their meaning not just over the years as different historiographical and institutional currents pick them out and transform their significance, but from day to day as different people view them and subject them to their own interpretation.

The idea that artefacts have a complex presence which is subject to multiple interpretation has important implications for the way museums think about and present themselves. Most museums are still structured according to late nineteenth century ideals of rigid taxonomies and classification, whereby it was believed that artefacts could be laid out in a consistent, unitary and linear way. Meanwhile, intellectual ideas have moved away from a belief in a single overriding theoretical system towards a much more conscious sense of the rôle of the reader or the spectator in interpretation. How, it should be asked, should museums restructure their activities to relate more closely to a changed epistemological environment? The idea that objects are not neutral, but complex and subject to changing meaning, should compel museums to adjust their activities in three important areas.

The first area in which museums should reconsider their position is conservation. Much conservation, although certainly not all, is based upon the premise that the artist's original vision of an artefact represents the most true and authentic appearance of that artefact, as if artists and makers were not themselves aware that they were launching an object into a long and complex journey in which it might be changed in both physical appearance and in meaning. The life-cycle of an artefact is its most important property. It is a species of contemporary arrogance which regards it as possible to reverse the process of history and return the artefact's appearance to exactly how it was when it popped out of its maker's hands.

The second area in which museums need to consider more carefully the epistemological status of artefacts is that of display. What is required is a greater reflexive consciousness about the variety of methods of display which are available and of the fact that each of these display methods has a degree, but only a limited degree, of legitimacy. There is a spectrum of strategies for the presentation of artefacts ranging from the most abstract, whereby the artefact is displayed without any reference to its original context in time and space, to the most supposedly realistic, whereby there is an attempt to reconstruct a semblance of its original setting. It is important that museums acknowledge that all these strategies of display are necessarily artificial and that the museum visitor be made to realise that display is only a trick which can itself be independently enjoyed as a system of theatrical artifice. The best museum displays are often those which are most evidently self-conscious, heightening the spectator's awareness of the means of representation, involving the spectator in the process of display.[17] These ideas can be formulated into a set of requirements: that there should be a mixed style of presentation; that there should be a degree of audience involvement in the methods of display; that there should be an awareness of the amount of artificiality in methods of display; and that there should be an awareness of different, but equally legitimate, methods of interpretation.

The third area in which museums need to reconsider their position is in the nature and purpose of museum scholarship. Museum scholarship has traditionally been reticent in its methods of interpretation. It has been assumed to be adequate to assemble as much information as possible which appears to pertain directly to the original circumstances of an object's production without much investigation of the nature of the relationship between the artefact and its life-cycle. As a result, museum scholarship has steadily drifted out of the mainstream of research in the

humanities into a methodological backwater governed by empiricism. Yet there is a current tendency within the social sciences to look anew at the type of evidence which artefacts might provide about social relations.[18] It is important that museums acknowledge and embrace these developments and permit themselves to be active centres of investigation into the nature of the relationship between the individual and the physical environment. As Lévi-Strauss has written:

The museographer enters into close contact with the objects: a spirit of humility is inculcated in him by all the small tasks (unpacking, cleaning, maintenance, etc.) he has to perform. He develops a keen sense of the concrete through the classification, identification, and analysis of the objects in the various collections. He establishes indirect contact with the native environment by means of tools and comes to know this environment and the ways in which to handle it correctly: Texture, form, and, in many cases, smell, repeatedly experienced, make him instinctively familiar with distant forms of life and activities. Finally, he acquires for the various externalizations of human genius that respect which cannot fail to be inspired in him by the constant appeals to his taste, intellect, and knowledge made by apparently insignificant objects.[19]

If this text were retranslated so as to avoid the implication that all museum workers are male, then it provides an adequate agenda for the establishment of a new museology, one which is always conscious of, and always exploring, the nature of the relationship between social systems and the physical, three-dimensional environment, and always aware of the ethnography of representation.

2

Objects of Knowledge:
A Historical Perspective on Museums

LUDMILLA JORDANOVA

The world is so full of a number of things,
I'm sure we should all be as happy as kings.
ROBERT LOUIS STEVENSON 'Happy Thought'

In *A Child's Garden of Verses* (1885) Robert Louis Stevenson sought
to put into words the innocent wonderment that epitomised childhood.[1]
Of course, 'childhood' and 'the child' are historically specific, adult
inventions, ones that we still subscribe to. Museums are designed to
elicit just such childish awe at the stupendous variety of natural objects
and artefacts, and to offer pleasure as a result. Those who organise
museums may not be fully aware of their desire to generate wonder and
delight, but a glance at *Museums and Galleries in Great Britain and
Ireland*, 'a comprehensive guide to over 1200 museums and galleries',
shows how ubiquitous such as assumption is in the world of public
exhibitions.[2] There are so many museums, and in them you can examine
just about everything imaginable. The advertisements in the guide
repeatedly insist that new and amazing experiences await eager patrons.
We have become accustomed to think of museums in terms of discovery,
and there is no category of people as closely associated with the novelty
and satisfaction of discovery as children. In museums, everyone becomes
a child because new, precious, and important objects are the source of
revelation to visitors. That at least is the idealised image. The reality is
rather more complex.[3]

In order to explore this complexity, it is necessary to tease out some
of the assumptions under which museums operate. The most important
of these is the taken-for-granted link between viewing items in a museum
and the acquisition of knowledge – the assumed function of museums.
This is discernible in museum architecture, the selection and organisation
of objects, display techniques, catalogues and advertisements. We believe,
as people have for at least two hundred years, that we learn things from
museums. Naturally, it is accepted that there are different kinds of

museums, but the overall experience associated with museums is edifica-
tion. 'Edification' itself takes many different forms, and I use the word
intentionally here to draw attention both to the common hope that
visiting a museum offers enlightenment, and to the complexity of the
experience once there.

My purpose in this essay is to explore the links between museums and
knowledge, which can be treated in three main ways. First, it is possible
to examine the assumption that looking at an object is a major source
of knowledge, not just about the thing itself, but about larger processes.
This is to locate museums within the broader sweep of the history of
knowledge, of theories of looking and of scientific method. Second, we
can focus on technologies of display, the mechanisms through which
objects are exhibited and the ways in which these contribute to the
construction of meaning. Third, in order to discriminate between distinct
kinds of knowledge purportedly offered by museums, we can compare
the treatment of different sorts of objects, paying particular attention to
special cases where it is particularly difficult to assign the museum con-
tents to a single category.

All museums are exercises in classification. It is easy to appreciate
how necessary is the imposition of order and meaning upon objects from
the sense of bewilderment we experience when invited to look at some-
thing – a piece of pottery, a fragment of rock, a metal implement –
without already knowing what, precisely, we are looking for or why it
is significant. Therefore, it is clearly not just the visual experience such
items give rise to that is important. Objects are triggers of chains of
ideas and images that go far beyond their initial starting-point. Feelings
about the antiquity, the authenticity, the beauty, the craftsmanship, the
poignancy of objects are the stepping-stones towards fantasies, which
can have aesthetic, historical, macabre or a thousand other attributes.
These strings of responses should not be accorded the status of 'know-
ledge', however, but should be understood in terms of their own distinc-
tive logic.[4] The 'knowledge' that museums facilitate has the quality of
fantasy because it is only possible via an imaginative process. The ways
in which the contents of museums are presented lead to, but do not fully
determine, what visitors experience and learn. It is therefore important
to understand the multiple taxonomies present in museums.

There are three principal levels of classification operating in museums.
First, we place the entire institution into a category frequently derived
from the nature of its contents: geology, natural history, fine arts, social
history, photography, technology; from the kind of person around whom

it is organised: great writers, reformers, collectors; or from the locality it serves. It is essential to note that none of these designations is stable or clear-cut. Are textiles and pottery fine art? What are the expected contents of a natural history or a social history museum? In a museum of photography, do you include the equipment as well as the prints, and if so, does this threaten the status of photography as 'art'? The International Museum of Photography at George Eastman House has found a neat solution to this taxonomic quandary. The prints are displayed in the old house in the manner of paintings and hence can be seen as 'fine art'. The equipment is displayed in a more recently built part and in large glass cases. This style suggests a museum of science or technology. Whole classes of objects, for example, artefacts from non-Western cultures, may be difficult to place, especially in aesthetic terms. Hence the overall category a museum fits into plays a major rôle in determining whether contents such as these are seen as 'art' or not.[5]

The second level of classification concerns the interiors of museums which are organised into major areas – schools, periods, countries, functions of artefacts, donors – that seem 'natural' because they have been deeply conventionalised. To return to Eastman House, there is no *logical* reason why prints should not be displayed alongside the cameras used to take them, which would have the effect of undermining rather than reinforcing the art/technology divide. Yet this would offend a collective sense of order, propriety and value that has been unconsciously internalised. Finally, systems of classification work at the level of individual objects. Museum labels offer a plurality of taxonomies pertaining to authorship, authenticity, antiquity, value, originality, significance. It is important to recognise that although labels offer a context within which the item in question can be 'read', this context is limited, selective and manipulative, since it generally invites visitors to perceive in a particular way. Accordingly, works by unnamed hands are seen and evaluated differently from those by known 'masters' – the label that names a maker confers value and status, and thereby constructs a setting for the item.

Two additional issues emerge from a consideration of the links between museums and knowledge. First, museums of science and medicine, with their exceptionally direct associations with classifying the world in an authoritative manner and hence also with validated knowledge, are an especially significant type of museum. There is no reason why the museum of fine art should be deemed the paradigm of the museum enterprise. Natural history and science are central vehicles for the promotion of 'society's most revered beliefs and values', especially because they appeal

to wide audiences and are less 'tainted' with cultural élitism than are art galleries. Since their pedagogical aims are openly proclaimed, they can promote 'facts' and 'values' simultaneously, despite the insistence of scientific and medical practitioners that they hold these two categories cleanly separate. Furthermore, since looking has long held a privileged place in scientific and medical practice, there is a special compatibility between the acquisition of natural knowledge and such museums.[6] Second, in order to gain knowledge from museums, viewers, whether they are aware of it or not, *both* reify the objects they examine, treating them as decontextualised commodities, *and* identify with them, allowing them to generate memories, associations, fantasies. It is necessary to examine both these processes – they are bound together and it is in combination that they produce the insight and understanding that, ideally, typify a museum visit.

The most common kind of knowledge claimed to derive from museums is a sense of the past. Take, for example, the Jorvik Viking Centre in York, where the very name suggests a research group rather than a commercial spectacle. An advertisement for it enjoins: 'Visit the Jorvik Viking Centre, step aboard a time car and be whisked back through the centuries to real-life Viking Britain. . . . Now a bustling market, dark, smoky houses and a busy wharf have all been recreated in accurate detail so that you can experience in sight, sound and smell exactly what it was like to live and work in Viking-age Jorvik . . . '[7] This is, of course, an extreme example, since the claim is not simply that the museum generates knowledge, but rather that a simulacrum of the past is available that renders the conventional notion of a museum obsolete. The search for the authentic is taken to its limits, by stimulating *three* senses, and by stressing the ability not to convey information but to mimic experience.

There is a theory of history implicit in such claims, and it hinges upon our ability to use objects as means of entering into and living vicariously in a past time. Visitors are required to assent to the historical authenticity and reality of what they see, while they simultaneously recognise its artificial, fabricated nature. The advertisement's claim to exactitude is an open lie, because an exact facsimile is technically impossible, and many aspects of life cannot be conveyed through looking, smelling and listening – work, hunger, disease, war, death are obvious examples. We understand the past, not by spuriously re-experiencing it, but by turning over many different kinds of evidence relating to it and by generating from this an understanding which inevitably has a strong intellectual, that is, abstract component. To pretend we 'know' the past by looking

at reconstructions devalues historical scholarship and allows audiences to cultivate a quite unrealistic belief in their own knowledgeability. What they see is highly selective because only those aspects that are easy to visualise are present. It is hard to convey a legal system in visual terms, but law is no less central to our historical understanding because of that. What is present, like that which is omitted, is not accidental, even if the selection processes are largely unconscious. It is precisely in this way that historical myths are constructed – myths that express powerful, if silent needs.

The drive to make the past come alive is unusually vigorous in museums of childhood, which have been presented as historically illuminating in the conventional sense, and as offering each visitor a chance to relive their own particular childhood. The Bethnal Green Museum of Childhood in London may be taken as a convenient example. It contains toys, games, dolls and puppets on the ground floor, while a new gallery dedicated to the social history of childhood is being constructed on the top floor. This includes clothing and the everyday accoutrements of children, such as babywalkers. It is immediately obvious that the classification of objects here poses some problems. They are arranged less by their age than by their function, so that all the dolls are grouped together. The labels vary; some are simple, being clearly addressed to children, while others are more complex and have been written with collectors in mind. Accordingly, some dolls have labels that provide information such as date and place of production, distinctive marks and provenance. As collector's items they have market value and, increasingly, aesthetic value. What they reveal about childhood is negligible. By contrast, many other items on display enjoy a status closer to that of ephemera. Multiple classifications are operating here and different audiences are being addressed.

In order to see the implicit historiography of the museum, it is necessary to turn to its recently published booklet. Here two basic assumptions about the museum are expressed: 'The Bethnal Green Museum tries to preserve something of everybody's childhood, and it is a museum that should appeal to everybody – for there is no one who was not once a child.' And '[Pictures and objects] often speak louder than words or statistics, and can help museum visitors to sense what it was like to be a child, or a parent, in the past.'[8] The museum thus claims that its contents can elicit memories in everyone, which, by implication, are universal, and that it provides a privileged access to childhood in the past. Although it is not explained *how* this is done, looking at objects

A display case in the Bethnal Green Museum of Childhood.

associated with childhood supposedly unleashes memory and produces historical knowledge. More than this – '[toys] show us the world in miniature' – a statement which implies that toys have such powerful mimetic properties that a simple glance is sufficient for information about the *world* to be conveyed by them. The confident related assumption of the booklet that making the world in miniature is an inherently human trait is, to say the least, dubious.[9] It removes a sense of the historical and cultural specificity of the trappings of childhood; it assumes too much about how toys are actually used.

This is not an empirical lacuna. It is simply not possible to know what toys mean to children, especially in the past. To assert that 'they help children to realize their own powers, and to adjust to the grown-up world' is to do no more than spin an adult yarn.[10] Therefore, the nature of a museum of childhood cannot be clarified by more information. This can only be achieved by thinking more deeply about museums in our society, about how we invest objects with significance and about the rich and contradictory meanings which we have continually assigned to childhood.[11] Much more work is needed in these areas, which will illuminate the link between knowledge and the museum experience by helping

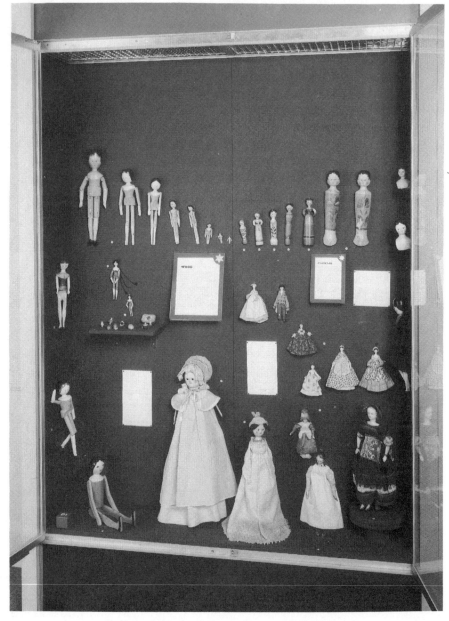

Dolls in the Bethnal Green Museum of Childhood.

us to answer questions such as: How could we see childhood in these objects? By what mechanisms could they evoke memories? While it is reasonable to assume that we *do* see something beyond the physical objects when we visit the museum, it is not valid to suppose that this process takes the same form in all cases, for the variations of childhood according to gender, class, race and religion are of paramount importance. Yet we still lack an understanding of how something more is perceived in objects and of how this varies with different audiences.

It therefore seems best to start with the nature of the evidence. All the items in the museum are artefacts; they were made, knowingly, at a particular time and place with specific clients or recipients in mind. We certainly can logically deduce something from their design, which always embodies what adults thought children wanted, ought to have, or what they anticipated would sell. For example, some of the games on display in the museum beautifully portray late eighteenth- and nineteenth century attempts to moralise children, to teach them about the marvels of nature, to learn geography or their proper stations in life. They include 'Wallis's Elegant and Instructive Game exhibiting the Wonders of Nature' (1818), 'British and Foreign Animals. A New Game, Moral, Instructive and Amusing, Designed to Allure the Minds of Youth to an Acquaintance with the Wonders of Nature' (1820), 'The New Game of Human Life' (1790), and 'Everyman to his Station' (c.1820s). Such games articulated assumptions about gender, class (invariably promoting a middle-class perspective) and social rôles as well as about the moral benefits of nature study.[12] They have the same status as other historical documents: they are texts requiring interpretation, and they need to be set in their proper historical context. It is crucial to be clear about what they do *not* reveal. They do not themselves indicate who bought them, why they did so, how the games were used, whether children enjoyed them, or what impact they had on those that used them. Strictly speaking, they do not, indeed cannot, evoke 'childhood'.

There are two reasons why an assembly of artefacts cannot convey 'what it was like to be a child, or a parent, in the past'. 'Childhood' is an abstraction, a concept of such generality that it is hard to imagine how any object could embody it except by a device like personification. When an abstraction is personified, the viewer is fully aware that a special device has been used to translate an abstract quality into a material form.[13] Not so in a museum of childhood, where visitors are invited to assent to the illusion that they are achieving real insights from the items on display. Also, 'childhood' is a name we give to a vastly complex and

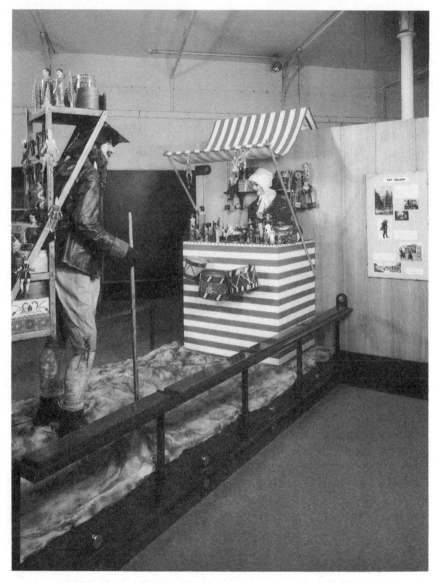

Models of toy sellers in the Bethnal Green Museum of Childhood.

variable set of *experiences*. It is simply impossible to capture them in material form. To attempt to do so is to commit a category mistake.

To say such things about museums of childhood is emphatically not to attribute failure to them. It is rather to articulate the important recognition that looking at objects cannot achieve so much, nor can objects themselves carry such information, however life-like or authentic they may be. There is currently a general trend in museums towards models, dioramas and simulation, manifest to a degree in Bethnal Green. The search for verisimilitude, like the acquisition of more 'information', only reinforces the dissonance between the illusion of exactitude and the recognition of artificiality. No one believes a reconstruction really *is* its original, although they do place confidence in its accuracy.

Such confidence is misplaced. Not only is there often only fragmentary evidence for the original scene, but reconstructions, inevitably, entail selection. For example, class differences and child labour are rarely mentioned, let alone vividly evoked in museums of childhood.[14] We know that grand houses functioned only through the arduous toil of many hands, while in practice we agree to overlook this and admire their manifest opulence. Similarly, we know that many, perhaps most children a century ago owned few toys, had little chance for 'play', received little or no education, and started work at a young age, yet in a museum of childhood we admire the fine craftsmanship of attractive Victorian toys that were for a tiny minority of children, without being conscious of dishonesty. A powerful fiction is constructed and perpetuated:

'Oh, look at this one,' shout the children. 'Ah, I had one like that,' muse the grown-ups. The Bethnal Green Museum of Childhood is one of those museums that get through to every visitor straightaway.

Yet it is every inch a museum, not a funfair. As a branch of the Victoria and Albert Museum, it holds historic collections of international range and importance. Toys, dolls, dolls' houses, games, puppets, children's dress, childhood history, children's books.

This brief guide is an introduction to a distinguished collection that offers pleasure to everyone.

This blurb on the back of the Museum of Childhood booklet is a masterpiece. It simultaneously constructs a universal childhood, and asserts both the knowledge value *and* the pleasure value of the museum, while denying that it is either frivolous or trivial. And what of the children who did not own toys like those on display, for whom childhood was painful, or simply different? So far there has been no display space for them, presumably because exhibiting something accords it public

recognition, confers upon it a form of legitimacy. We can infer, therefore, that much is at stake in the representation of childhood, and that museums are among the principal means currently available for policing it. Again it must be stressed that these processes are largely unconscious ones, so that to examine them is not to attribute blame but to translate what is taken for granted into a form in which it can be held up for critical and humane scrutiny.

Why, we must ask, do we feel such a strong need to find social relations in objects, and how is the illusion that this is possible created and sustained? Broadly speaking, such questions can be answered in two ways: by addressing the psychic level and by analysing the history of collected and displayed objects. In fact, these two projects need not, and should not, be carried out in isolation from each other.

Let us consider, for example, the theme of mastery.[15] In the history of Western societies there have been two closely related processes through which mastery has been pursued – the development of the natural sciences and medicine and of colonial expansion respectively. The first involved self-conscious mastery over nature, including human nature, the second over other cultures and their physical environments. Each form of domination produced artefacts for display. In the case of science and medicine, natural objects that either demonstrated the fundamental characteristics of the physical world or the intellectual achievements of these disciplines were exhibited alongside instruments used in the acquisition of knowledge and simulations/reconstructions of nature or of scientific and medical activities. In the case of colonial expansion, artefacts from other cultures, exotic natural objects, even the 'natives' themselves were put on view.[16] In both instances, we can legitimately speak of prized objects, of trophies, the spoils of war. The trophy simultaneously expresses victory, ownership, control and dominion. As such it has three qualities – it presents in material form, however incompletely, sets of practices; it triggers fantasies and memories; and it elicits admiration.

To analyse anthropological, scientific and medical museums within which trophies were displayed from a historical perspective it is necessary to ask about their uses and purposes, about the interests they serve. It would be possible to argue, as several scholars have done, that class, race and state interests are manifestly promoted by a wide range of museums.[17] While this may be so, such an account is incomplete. There are two reasons for this. A museum can never be read as a single text. Even if we consider the most basic question of who or what museums

are for, there is never a unitary answer. Contemporary science museums hardly conceal the fact that they promote the value of science and an ideology of progress in which the natural sciences play the heroic rôle in mastering nature. Yet, at the same time, they do far more than this. For example, they proclaim the beauty of natural objects and of scientific and medical instruments, models and representations. Equally, they serve to associate play with scientific discovery, a theme which is particularly prominent in the new 'hands-on' science museums.[18] As a children's book on museums puts it: 'There are many . . . exciting things to discover in all the different museums – almost anything, from dinosaurs to amazing machines. Museums are a bit like treasure chests, full of wonderful things to see.'[19]

If there is even a grain of truth in this, then visitors to exhibitions cannot be treated as passive recipients of an ideological position, conveyed through all the physical aspects of the museum. Rather, they have experiences as a result of interacting with the museum environment, which give them novelty, pleasure, and possibly pain, which touch them, in the same way as those visiting museums of childhood do. By going, looking, participating, they in some measure assent to the claims made by museums about the insights that looking at objects provide. But does this make museums simply expressions of social interests?

At this point it has to be admitted that some museums are more coercive than others. I mean by this that there are a variety of ways in which these institutions can express their guiding assumptions and bring them to the attention of visitors. At any given point in time the members of a particular society will find that some of these assumptions strike home more effectively than others. In such cases we are entitled to speak of the representational practices of a museum as 'coercive'. This often applies to museums that claim to be literal, life-like, exact, telling it as it really was. And, in this connection, it is useful to invoke the term 'realism'. In her study of the primate hall in the American Museum of Natural History in New York, Donna Haraway analysed the processes by which the displays were constructed using taxidermy, painted backgrounds and simulated, naturalistic settings. For her, realist representation is to be understood as the deployment of 'technologies of enforced meaning'.[20] Realism as Haraway uses it has a number of aspects – ideological, epistemological, aesthetic, political. Hence it is a term that can express diverse forms of power. She never speaks about power in a vague or totalising way, but continually strives to show us just what kind of power, for which social groups, and in relation to whom it was

The figure of 'Time' from a late seventeenth century work by G. Zumbo;
here the wax model is a memento mori.

exercised. All this contributes to a rigorous demonstration of a specific set of representational practices, which are architectural, taxidermic, and artistic (painting, sculpture, photography, film). It is precisely because these can offer a sense of unmediated vision (of the primate world) that they are central to the creation of scientific authority. The result is a potent admixture of beauty and truth. Providing a full historical account of this phenomenon involves taking a particular instance, as Haraway does, and meticulously building up an account of how the museum displays were produced, the biographies of the main actors, the social, political and ideological conditions that animated these, the social functions the museum was designed to serve and the multiple narratives constructed along the way. Although many features of Haraway's account draw on the specific circumstances of late nineteenth- and early twentieth century America, the logic of her argument applies to a wide range of museums.

Realism, in the sense that it has just been used, and the illusion of unmediated vision have been central to several kinds of museums for at least two hundred years. The diorama, for example, is not a recent invention, but enjoyed fashionable popularity in early nineteenth-century Paris as well as in other European capitals.[21] Or take the example of wax museums. Wax-modelling was already a well-established part of both popular and élite culture by the late seventeenth-century.[22] Three common features of wax models make them especially pertinent to the themes we are considering here. Coming from the traditions of votive-offering-making, there was a powerful moral dimension to wax-modelling: memento mori, exemplary persons and deeds, despicable persons and deeds were all frequent subjects. Another common feature was the use of wax to achieve an unusually life-like resemblance to the human skin. Highly 'realistic' representations of the human figure have always been favourites among wax modellers. Finally, there was a special relationship between medicine and wax-modelling, because it is possible to achieve a high degree of verisimilitude in models of most anatomical parts, especially bones, muscles, nerves and blood vessels and flesh, and also of diseases. At a time when 'wet' anatomical preparations were both rare and costly, the wax models played an important rôle.[23] But how can we define that rôle? It was certainly not confined to the teaching of anatomy, physiology and pathology. The models were exhibited in a variety of public places, just as the better-known ones by Madame Tussaud were. The models themselves suggest that more than medical education was at stake. The large wax models displayed in La Specola,

A wax model by C. Susini.

Florence, go to enormous lengths to be 'realistic'.[24] The use of hair illustrates this especially vividly – eyelashes, eyebrows, on the head and pubic area. If you add to this the pearl necklaces on recumbent female models and the look of ecstasy on the faces of these women, the glass cases and fringed silk linings, it is immediately evident that to describe these models as a deliberate substitute for a bit of nature unavailable for technical reasons does not explain anything. Wax figures have also been seen as vehicles for popular sex education, an idea which is as plausible as claims for their strictly medical function in anatomy teaching.[25]

At one level anatomical wax models simulate nature and hence can be deemed a legitimate source of knowledge. But at another they frankly invite the viewer's fantasies, fantasies which are inevitably sexual in nature. There is a similar ambivalence surrounding wax figures of the type Madame Tussaud popularised. In her mind, a moral project was uppermost – exact likenesses of major figures involved in the French Revolution had a valuable lesson to teach their audiences.[26] On the one hand we 'learn' something from the models, while on the other a whole array of feelings – from admiration to hate – may be elicited. This includes fear, since many wax museums contain a 'chamber of horrors'. And in all these cases we can admire the craftsmanship, which is in effect

Twins by C. Susini.

to acknowledge wax models as human creations, while at the same time being struck by their verisimilitude, which is to play down their artificiality.

Nowhere is the ambivalent status of exhibited objects more clearly illustrated than in the 'fetish'. Originally used to describe an 'inanimate object worshipped by primitive peoples for its supposed inherent magical powers or as being inhabited by a spirit', by the early twentieth century it was a common term in artistic and in anthropological discourses.[27] Particularly associated with African ethnographic objects, in the 1920s, 'fetish . . . described . . . the way in which exotic artefacts were consumed by European aficionados'.[28] It is now well-known that a number of avant-garde painters of the period, notably Picasso, found 'inspiration' in non-Western and especially in African objects that they studied in anthropological museums.[29] These museums have their own elaborate histories, which touch on many aspects of the West's relationships with its others. The attention given to such objects by artists brings into sharp relief a number of themes that have been explored in this essay.

By the 1920s 'fetish' was, in addition to being a key term in anthropology and fashionable culture, a central concept in Marxism and in psychoanalysis. Both Marx and Freud had been concerned with how objects become separate from people and then endowed with special, quasi-magical properties. In *Capital*, Marx argued that 'in the world of commodities . . . the products of men's hands . . . appear as independent beings endowed with life'. He was well aware of the religious origins of the term 'fetish', but the analogy he used to explain the fetishism of commodities came from *vision*: 'the light from an object is perceived by us not as the subjective excitation of our optic nerve, but as the objective form of something outside itself'.[30] Marx used fetishism to reflect on reification, and in this essay I have been exploring the ways in which museums, when they invite us to look at objects, also draw us to reify them, to treat them as commodities.

In his work on fetishism, Freud was concerned with the processes whereby 'an object [is endowed] with sexual significance'.[31] Of course, there is a concern here with reification, but Freud's primary interest was clinically directed towards the origin and meaning of fetishes and hence the early sexual development of those dominated by a fetish. In other words, he was concerned with how his patients could invest objects, including parts of the body, with erotic properties. This type of argument would not have to be confined to the sexualising of objects, but could be extended to the whole range of psychic responses to displayed objects. The history of the fetish is bound up with European relations with the

exotic, and particularly with Africa, as we have seen, and with the appropriation of this particular form of 'otherness' by art and by fashionable culture. One aspect of the fetish is accordingly about mastery and control over objects and over people, it is about the material world and its ability to freeze social relations. The other side of the fetish is about finding a magic in things and is tightly bound up with psychic development. Here are encapsulated the issues involved in following through the link between museums and knowledge.

The work of Donna Haraway and James Clifford raises issues that have a long history in Western societies through historically specific studies of museums.[32] The complex set of relationships between viewers and objects of knowledge that they point to can be seen particularly clearly in museums we can loosely designate as 'scientific'. It is, I would argue, historically quite defensible to trace the problem of how museums generate knowledge by referring to a range of examples drawn from different times and places, because there has been, at least since the early eighteenth century, a core epistemology underpinning the vast majority of scientific and medical traditions – our most authoritative sources of knowledge.[33] In practice, however, the whole range of scientific museums has been fraught with difficulties over what to include, and how to arrange it. This reveals a deeper uncertainty as to what it is possible to learn from museum objects.

Responses to items collected from other cultures are a particularly revealing example of this uncertainty. Anthropologists still seem unsure just what can be learned from research on their museum holdings. For example, the catalogue based on an exhibition drawn from the collections of the Cambridge University Museum of Archaeology and Anthropology, held in 1984, concludes: 'Anthropologists who had believed that ethnographic artefacts had no significance apart from their physical and social contexts, have now realised that a consideration of the material world is essential to the understanding of social institutions.' Yet in making this claim, which is common among curators, the authors give no specific examples to explain what they mean. The catalogue itself is organised around ethnographic objects as art rather than as sociological data. The photography, of single objects on vivid backgrounds, conveys the impression that exotic objects are both beautiful and valuable, can be termed 'masterpieces' and hence count as 'art'. The problems arise when the objects are to be interpreted. In his Foreword to the catalogue, Leach claimed: 'The value of social anthropology as an academic discipline is that it makes cultural otherness the focus of attention; the "others"

remain other but they cease to be evil and untouchable . . . Our Museum contains many treasures; but if they are *just* treasures, untouchable, behind glass, stored in boxes, they serve no purpose. But that need not be the case. Photography and tape recording now make it possible, as never before, to put ethnographic objects back into their social context and thus break down the barrier between the observer and the observed.'[34] Thus anthropological objects derive their significance on the one hand from their distance from us and on the other from the efface-ment of that difference. The latter is presented as stemming from techniques for a (supposedly) literal rendering of social life. Reification and identification remain locked together within realist representational practices.

On the basis of what has been said I draw four conclusions. First, it is important to find ways to be more reflexive about our museum prac-tices. Historical perspectives can play an important rôle by provoking questions about the relationships between museums and their parent societies – questions that treat politics, epistemology and aesthetics as necessarily intertwined. Second, our methods for studying museums must address both the material and the psychic levels. This is not to say that the only way of pursuing the latter is through psychoanalysis (although a thorough-going psychoanalytic account of museums would be fascinat-ing), but to indicate the kind of interpretative complexity and depth that is required. Third, it is an illusion to believe that museums can teach their visitors about abstract terms – properly speaking there cannot be such a thing as a museum of mankind, of childhood, or of nature. It is essential to understand the grip which the illusion that knowledge springs directly from displayed objects has upon us. Finally, when we do delve further into the nature of that illusion and its history, we are studying the history of our society. This is because the belief in knowing through looking touches all aspects of social and cultural life. The social and cultural construction of museums demands our closest attention – it is a large and important project, not to be hived off as only of 'specialist' interest. Museums reach deep and far into past and contemporary cul-tures, hence they become crucial test cases through which to develop an understanding of the peculiar preoccupation of modern Western societies with mastering 'objects of knowledge', and then publicly commemorating the victory by putting on a show. We must lose our childish awe of 'treasures' and 'wonderful things' in order to replace it with a measured appreciation of the awkwardness, the limitations, the downright intract-ability of objects that, for whatever reason, we endow with value.

3
The Reticent Object

PETER VERGO

Museums exist in order to acquire, safeguard, conserve and display objects, artefacts and works of art of various kinds.[1] This at least would be a conventional definition of their function. There are, of course, numerous other kinds of activity in which most museums engage. Some see themselves more and more as commercial enterprises – partly because, in this country at least, they have been compelled to do so. Thus, the running of the museum shop or restaurant may occupy as much time, energy and thought as the work of a curatorial department. Education staff now proliferate in nearly every institution that wishes to claim the serious attention of the public, the press and the media, of public or private funding bodies or sponsors. Newly appointed Keepers of Education find themselves torn between the demands of curators whose prime concern is the care and conservation of the objects in their charge, and the expectations of an ever more diverse public: foreign visitors, school parties, ethnic minorities, visiting scholars, art college students. There are also, increasingly, new definitions of what museums are, or should be, as well as new kinds of museums: museums of the moving image, museums without walls, museums – even – without objects. Yet despite the bewildering array of present-day museums, and the range of activities in which they are involved, the principal tasks of most such institutions remain those defined above.

This essay is in any case concerned primarily with conventional museums – indeed, for the most part, with only one aspect of their activity. It is not about acquisition policy, nor about administrative questions. It is not about funding and sponsorship. It is not about conservation, nor the physical security of the objects permanently or temporarily in the care of the museum. Nor do I take into account those secondary activities referred to earlier, such as the commercial side of running a museum, or the work of its Education Department – though all these considerations may, in one way or another, impinge on the subject discussed here. What

does interest me is the display of objects, artefacts and works of art both within and outside the museum context, their public presentation: in other words, the making of exhibitions.

Virtually all museums are preoccupied in one way or another with the display of their collections – or perhaps one should say more accurately, of part of their collections. Such displays are themselves ephemeral: rarely does a decade elapse, even in the most conservative institution, without the rehanging, rearrangement, relocation or even total reconstruction of the 'main' or 'primary' galleries. Moreover, most major museums, alongside what many people would regard as their principal function as repositories of objects, works of art or artefacts, are engaging more and more frequently in the making of purely temporary exhibitions. The Tate Gallery has always done so; the V & A, though it has withdrawn (for the time being?) from the international trade in major loan exhibitions, still mounts a dozen or so smaller 'in-house' exhibitions every year; the National Gallery has begun to include in its programme more and more special exhibitions, albeit on an intimate scale – an activity which will doubtless assume a new dimension with the completion of the Sainsbury wing, giving the gallery, for the first time in its history, a custom-built temporary exhibition space. Then, of course, there are institutions which are not museums, such as the Hayward Gallery or the Barbican Art Gallery in London, which have no collections of their own, but exist solely for the display of temporary exhibitions. In addition to which, there is the commercial sector: the dealers and auctioneers who are in their way just as much occupied with the making of exhibitions as their counterparts in the museums. Indeed, some commercial galleries such as Agnew's and Fischer Fine Art in London, or the Galerie St Etienne in New York, have established a reputation for putting on, from time to time, exhibitions every bit as 'scholarly' as those staged by publicly funded institutions: a record all the more remarkable when one considers that such galleries receive no public subsidy to encourage them to risk staging 'unpopular' shows.

Even leaving aside the commercial sector, the sheer number of other exhibition-making organisations and institutions is immense. Take as a case study even London alone, and think of the Barbican Art Gallery and the Hayward Gallery and the Royal Academy and the major national institutions such as the National Gallery, the Tate Gallery, the Victoria and Albert Museum, the British Museum, the Museum of Mankind, the Science and Natural History Museums, the National Maritime Museum, the War Museum, the Army Museum, to say nothing of the local and

municipal museums, the various independent and 'private' museums and collections, the Courtauld Institute Galleries, the Wallace Collection, the Museum of London, and reflect on how many people are involved at any one time in designing, discussing, putting up or taking down more or less temporary displays and exhibitions of one kind or another, and then attempt to calculate how many people come to see these exhibitions and displays, reminding yourself meanwhile that London is only one city, and that these activities are replicated, albeit on a smaller scale, in towns and cities all over the British Isles. It will come as something of a shock to realise quite how large are the numbers of people involved in the making and consuming of exhibitions. Indeed, given the enormous amounts of time and energy, the colossal human and material and financial resources that are expended on making exhibitions, it is tempting to decide that there can scarcely be another more expensive cultural activity, apart perhaps from the staging of opera.

Yet both the creating and the consuming of exhibitions remain, to my mind at least, curiously unreflective activities. The public somehow assumes that any large town or city, any cultural centre worthy of the name, will have a frequent and varied programme of exhibitions; yet why this should be so is a question that goes for the most part unexamined. Even were one simply to accept exhibitions as a fact of cultural life, it would seem nonetheless pertinent to ask, how do they come about? By what means, and with what resources, are they created? Under what circumstances, and for what reasons? More precisely, what kinds of exhibitions, and what exhibitions, will a particular institution mount? What considerations determine the choice of an exhibition programme, of a particular exhibition within a given programme, the selection of certain kinds of material within the context of a given exhibition? Yet such questions are, by and large, greeted with a singular diffidence, with seeming incomprehension, even on occasion with alarm by those responsible for the making of exhibitions.

There are, of course, reasons for this kind of response, reasons which one can to some extent understand. To examine how, and why, exhibitions are made means taking a magnifying glass to any number of sensitive, often problematic, sometimes fraught relationships: between the institution and its Trustees, its paymasters and sponsors; between the museum (or gallery) and its public; between the public and the objects on display; between conservation staff and curators on the one hand, and imported (by which I mean specially commissioned) makers of exhibitions (sometimes referred to as 'guest curators' – usually scholars or

experts in some particular field) on the other; between the avowed or unspoken policies of the instutition, and the ambitions and enthusiasms of the individual scholar or curator or designer.

These relationships, and the tensions they generate, often play a significant rôle in determining what exhibitions, and what kinds of exhibitions, a particular instutition will choose to put on. But there are other, equally important criteria. There is the specific character of the institution, both as perceived by itself, and as it presents itself to its public. The National Army Museum, for example, is unlikely to mount a show of minimal art. The Tate Gallery, defined as the national collection of British and of twentieth-century art, could equally well mount exhibitions of the late works of Picasso and of paintings by Hogarth (as indeed happened during 1987–8), but it could not, without redefining its character and rôle, put on an exhibition of Caravaggio. Even if the nature of the particular institution does not impose constraints upon the kinds of exhibitions that institution may devise, there may be other, more temporary constraints, for example those of programming. If a proposed exhibition is part of a continuing programme, rather than just a 'one-off', then that programme itself constitutes a context or framework that determines whether the proposal is likely to be accepted or rejected as appropriate or inappropriate. A museum that has just put on a unique exhibition of Ming vases is hardly likely, within the foreseeable future, to put on another unique exhibition of Ming vases.

Even after the subject has been decided, a museum is still faced with a number of choices in staging any kind of temporary exhibition. It may decide to draw exclusively on its own collections, or to arrange what is predominantly a loan exhibition but which includes, nonetheless, a number of items in its own possession, or to stage a purely loan exhibition. Such decisions will be affected by political, or financial, or curatorial considerations, which will in turn have a 'knock-on' effect in influencing the specific character and content of the show. The available budget, and to what extent sponsorship can be relied upon to bridge the gap between aspiration and fulfilment, will likewise play a large part in determining the show's final appearance. And, increasingly, considerations such as security and environmental controls assume a crucial rôle in deciding whether a desired object can be loaned for the purpose of a temporary exhibition. A picture, say, of unique importance or historical interest, by which you set great store, may simply not be available for your exhibition, though to your irritation you may find that it can be made available for someone else's – because they have better security,

a better physical environment for the display of the painting in question or, sometimes, simply more prestige or more money. And then there are what I think of as the 'purely mindless' criteria, such as sheer size. A painting which is simply too large to get through any of the doors or windows giving access to the gallery is, unless one is prepared to take the roof off, ruled out on those grounds alone – however appropriate it might be to the subject of the exhibition.

I have suggested earlier that there may well be good reasons why many of the considerations which play such an essential rôle in the making of exhibitions are so rarely articulated, and even more rarely discussed in public. That they should be both articulated and discussed seems to me essential to the health of the museum profession. To be clear about the criteria which govern our choices in exhibition-making, and how those choices will affect what we are trying to do, is to be clear about our goals and ambitions, our moral or intellectual or political purposes in making exhibitions in the first place. How else, after all, are we to have any measure of the success or failure which attends our efforts (other than the sheer number of visitors who pass through the turnstiles), whether all this time and money and energy has been well spent, save in terms of working towards some precise aim, some identifiable goal, even if that goal is, in the end, self-imposed?

To some, such questions may seem not to matter. Others may take them for granted, to the extent that they are considered hardly worth discussing. This is true, of course, so long as one is creating exhibitions out of unworthy or debased motives. An editorial in the *Burlington Magazine*, which followed hard on the heels of the November 1987 conference organised by the Association of Art Historians under the title 'Why Exhibitions?', spelled out some of the 'acceptable' reasons for exhibition-making: 'to make accessible the rarely seen, to alter or enhance perception of the already known, to unite comparable works', contrasting these with what are all too often the actual reasons for so many 'high-profile', 'prestige' exhibitions: 'to raise money, to celebrate meaningless anniversaries, to cement diplomatic alliances, to promote the careers of museum directors – how often are these the real motives'?[2]

It is, however, probably still the case that the vast majority of exhibition-makers would concede that the activity in which they are engaged is one which is at best both serious and purposive. What they are not in general good at is defining their intellectual or educative or social aims, even if they can sometimes be persuaded, grudgingly, to give some account of why they might wish to include or exclude certain kinds of material as

appropriate or inappropriate to their chosen subject, in terms of some definition of stylistic congruity, of the nature of the medium employed, of historical or social relevance, and so on. Yet, on closer examination, it quickly becomes clear that the criteria for the selection or rejection of material for an exhibition are neither random nor arbitrary – on the contrary, that they are based on an underlying though usually unspoken sense of purpose. If, for example, a particular object turns out to be unavailable for loan, for one of the reasons discussed above, and has to be replaced by another, it soon becomes obvious that it cannot simply be replaced by any other: there will be some objects which, even if their owners will lend them, even if the borrowing institution can afford to pay for transport and insurance, even if they will fit into the gallery, are nonetheless inappropriate to the 'theme' of the exhibition. This point, seemingly self-evident, is important because it makes clear that, in the case of most exhibitions at least, objects are brought together not simply for the sake of their physical manifestation or juxtaposition, but because they are part of a story one is trying to tell. The 'context' of the exhibition confers upon them a 'meaning' beyond any significance they may already possess as cultural artefacts or objects of aesthetic contemplation. Through being incorporated into an exhibition, they become not merely works of art or tokens of a certain culture or society, but elements of a narrative, forming part of a thread of discourse which is itself one element in a more complex web of meanings.

But exhibitions are purposive in a second, more extended sense. Most of us, I think, share some notion that, through the medium of exhibitions, we are *addressing* the visitor, the public, however diverse that public might be; and we also tend to believe that the people who go to exhibitions 'get something out of them', even if we are hard put to define what that 'something' is. Indeed, it would be a very strange kind of exhibition-maker who was indifferent to whether the visitor 'got anything' out of the exhibition or not. Moreover, we would probably all agree that one of the functions of the maker of exhibitions is to offer some measure of elucidation of the material which is being exhibited – even if, in the exhibition itself, such elucidation consists of little more than simple identification, with perhaps a brief note of the provenance of the object displayed, its date, or the material of which it is made. We have also come increasingly to accept that any show with serious scholarly pretensions will be accompanied by a weighty catalogue containing not merely detailed notes on the exhibits, but a succession of essays on various aspects of the subject and even, if we are really lucky, a general introduction explaining the background to the exhibition, and setting

Interior of the exhibition 'Crossroads Vienna', shown in the foyer of the
Royal Festival Hall, London, November–December 1988.

the scene for the show as a whole.

It is, however, worth reminding ourselves that this notion of the func-
tion of display is a distinctively modern one. Kenneth Hudson, in his
admirable *Social History of Museums*, quotes the recollections of an
eighteenth-century bookseller by the name of Hutton who, having gone
to some trouble to gain admission to the British Museum, and having
the temerity to enquire precisely what the objects were past which the
appointed guide was leading the little group of visitors at such speed, was
given clearly to understand that any such explanation was not the function
of the museum's staff. '"What! would you have me tell you everything
in the Museum? How is it possible? Besides, are not the names written
upon many of them?" I was much too humbled by this reply to utter
another word. The company seemed influenced; they made haste, and
were silent.' And Hutton added his own sad comment on what seemed
to him in retrospect a wasted opportunity: 'If I see wonders which I do
not understand, they are no wonders to me. Should a piece of withered
paper lie on the floor, I should, without regard, shuffle it from under
my feet. But if I am told it is a letter written by Edward the Sixth, that
information sets a value upon the piece, it becomes a choice *morceau*

of antiquity, and I seize it with rapture. The history must go together; if one is wanting, the other is of little value. It grieved me to think how much I lost for want of a little information.'[3]

The attitude that objects on display were best left to speak for themselves persisted, however, until well into the nineteenth century; indeed, to some extent it is still with us today. We, from our superior vantage point, tend to look with disdain at what we think of as the primitive educational attitudes of the past. Yet our own attitudes to the question of the educative function of exhibitions (I use the term 'educative' in the widest sense) are, it seems to me, also open to debate. The frequent success of present exhibitions in terms of numbers of visitors and income generated merely masks a profound disquiet within the profession regarding some of the most fundamental assumptions of the activity in which we are engaged. We may, as I have suggested, all agree that exhibitions, in some manner, address themselves to an audience, and that their aim is, in the broadest terms, educational. Yet opinions diverge widely as to how that aim is best achieved – in particular, over the question as to the level of information or explication appropriate or desirable in the context of a given exhibition.

At one end of the spectrum of opinion, we have the proponents of what I shall call for brevity's sake 'aesthetic' exhibitions. For them, the object itself – usually, though not always, a work of painting, sculpture or graphic art – is of paramount importance. 'Understanding' is essentially a process of private communion between ourselves and the work of art; we are supposed merely to 'experience' it, though quite what that experience is meant to consist of, no one seems prepared to say. For such people, any kind of adjunct material, by which I mean lengthy captions, information panels, audiovisual displays, photographic reconstructions and so on, is at best a necessary evil, at worst a jangling intrusion into our silent contemplation of the work itself. If visitors want that kind of information, so the argument goes, they can always buy the catalogue.

At the other end of the scale, we find the advocates of what I shall term, again for brevity's sake, 'contextual' exhibitions. For such people – usually, though not always, historians, archaeologists, anthropologists – the object displayed is of relatively little intrinsic significance, regarded purely as an object of contemplation. Rather, its presence within the exhibition is justified by its importance as a token of a particular age, a particular culture, a particular political or social system, as being representative of certain ideas or beliefs. In such exhibitions, original

objects coexist, sometimes uneasily, with a bewildering variety of other kinds of material: informative, comparative, explicative, much of it in written form – one is inevitably reminded of the American Brown Goode's much-quoted definition of what he called the 'efficient' educational exhibition as 'a collection of instructive labels, each illustrated by a well-chosen specimen'.[4]

Let us consider first the aesthetic view – a view which seems to me seriously flawed in a number of quite obvious ways. It is, above all, an attitude that is both arrogant and uncompromising, which takes for granted a certain level of education and sensitivity on the part of the spectator, making no concessions to visitors from other social and cultural backgrounds, to the intellectually curious but uninformed. The notion that works of art, in particular, should be left to speak for themselves takes no account of the fact that such works are, for most visitors, remarkably taciturn objects. Left to speak for themselves, they often say very little; and a sometimes quite considerable effort is required on the part of the historian, the art historian, the critic or the viewer to coax them into eloquence.

More seriously, the aesthetic view assumes that our visual perception is a somehow coherent, even objective process, as if all that is necessary is to 'see properly', without taking any account of how complicated and problematic a process 'seeing' is, nor how easy it is to misconstrue even the most elementary kinds of visual experience. I am reminded of an example which occurs in a book I first read many years ago, though it is not very fashionable today, Eric Newton's *The Meaning of Beauty*. The author asks us to imagine ourselves entering upon a meadow of lush grass which at first sight appeared to be generously interspersed with buttercups and ox-eye daisies, and the feeling of aesthetic pleasure such an experience might induce, only to be supplanted a moment later by revulsion as we 'saw' that the buttercups and daisies were in fact empty Gold Flake packets and torn-up scraps of paper.[5] Yet neither the phenomenon itself nor our process of visual perception has been subjected to any kind of physical interference; what has happened is that recognition has taken place, a change in our mental apprehension of the phenomenon, and a consequent change in our aesthetic response. How much more complex, then, is our apprehension of works of art – a picture, for example, where what we 'see' is, strictly speaking, patterns and textures of pigment; one is reminded of the Nabi painter Maurice Denis's famous dictum, that a painting, before being a representation of a nude, a warhorse or any other kind of subject, is in essence a flat

canvas covered with colours arranged in a certain order. What enables us to 'see in' (Wollheim's phrase) these patterns and textures representations of natural forms is our knowledge of a certain pictorial convention, without which our visual experience would be limited indeed. And how much more complex still our 'understanding' of, shall we say, paintings by Hogarth such as those shown recently at the Tate Gallery, satirising the manners and morals of eighteenth-century English society – more complex not merely because of the sophistication of the visual witticisms and puns Hogarth so relished, but because so many of the allusions which would have been perfectly obvious to a contemporary audience have been lost to our sight, and need to be laboriously reconstructed, and then somehow conveyed to a culturally and intellectually diverse audience.

Here, I should at least mention in passing one argument that is frequently put forward against supplying this kind of information. It is often said that this cannot be the task of the exhibition itself, that in any case people do not read while viewing exhibitions, or at least will not read texts of more than a certain length – 180 words is the figure often cited in this connection – and that there is a kind of obligation on the inquisitive viewer to read around the subject, by which is meant outside the context of the exhibition, including reading the catalogue. Against this view, it has to be said that certain preliminary surveys seem to indicate that the exhibition-going public is by no means identical with the reading public,[6] and that one certainly cannot rely on a kind of automatic recourse to books and other associated materials as a way of making up for the deficiencies of an exhibition. Moreover, while people may indeed read the catalogue if it is cheap enough, attractive enough, well put together and interesting, they almost certainly will not read it while visiting the exhibition so that, as a way of structuring the immediate experience of exhibition-going, it is virtually useless.

It is the failure adequately to structure this experience for the casual visitor that seems to me by far the greatest failing of the unrepentantly 'aesthetic' exhibition. I cannot help thinking of the fascinating but frustrating exhibition of Scandinavian painting held a couple of years ago at the Hayward Gallery in London under the title 'Dreams of a Summer Night' – fascinating in that it presented a whole range of work few of us in this country had ever seen before, frustrating in its refusal to extend even the most perfunctory helping hand to the viewer eager to make sense of an unfamiliar succession of names, an alien culture, a bewildering variety of dissimilar styles of painting. There were no information panels, minimal captions, no adjunct material of any kind, not even a map of

the Scandinavian countries: most of us have by now had it dinned into us that such things interfere with the pure aesthetic experience of the works themselves – or so the orthodoxy goes. But what about the layout? The design of the exhibition? According to what principles had the paintings come to be on the walls at all, since there was no evident dividing up of work either into chronological groupings, or by artist, or by subject matter, or by national school?

Yet equally unsatisfactory, it seems to me, is the over-contextualised display: musty with documentation, laden with earnest didacticism, any occasion for private meditation drowned out by the whirr and clatter of the audiovisual programme. Certain kinds of material, moreover, demand so many layers of explication that one begins to wonder whether the game is worth the candle. Here, I have in mind not an exhibition that actually happened but one that could easily have happened: an exhibition of medieval art, in which a significant part of the show is taken up with a display of illuminated manuscripts. Imagine that the organisers especially wanted to include one small item, a prayer book, rich in lapis and gold, exquisite in itself but with unusual marginal annotations, some clearly by a later hand. The book is tiny, the Latin text (medieval Latin at that) hard to read, the marginalia even smaller and more illegible. I find it easy to visualise the book in question, even now, since some years ago I was fortunate enough to have just such an item in my hands.[7] The marginalia, interestingly enough, turned out to be observations of a pharmacological nature, including what was unmistakably a remedy for syphilis – though whether from a priestly hand or not it was impossible to say.

The book, as I say, is tiny. It is also extremely valuable, highly fragile, and susceptible to light. It would almost certainly be displayed in an alarmed showcase, behind armoured glass, and exposed to very low light-levels. It would, frankly, be virtually impossible to see. In order to reveal any degree of the detail present in the original, our cunning designer would arrange for an enlarged colour photograph, of the best quality, to be displayed alongside the object. The Latin text, and especially the marginalia, would however still be more or less illegible, because of the handwriting, so it would be important to have a transcription – nicely printed, of course – which could be placed alongside the photograph. Unfortunately, since so few people speak Latin these days, it would also be necessary to have a translation, while a further text might comment on the historical significance of the item in question, the unusual content of the marginal annotations, on matters such as provenance and dating.

At which point, one begins to wonder about the fate of the poor little
object, swamped by adjacent material so extensive, so much larger, so
much more demanding of our attention. Is it really best served by such
a manner of presentation? And if this wealth of adjunct material is really
so important, does one need, one dares ask, to have the original object
physically present at all?

One evident cause of our difficulties, to my mind, is the fact that most
exhibition-makers think too much about the content and presentation
of their exhibition, and too little about their intended audience; indeed,
most exhibition-makers would, I believe, be hard put to define their
audience at all. Yet we will never succeed in making more 'efficient'
exhibitions, to use Brown Goode's phrase, unless we know a good deal
more about the character of that audience, and about the levels of know-
ledge and understanding one may reasonably assume the visitor to have.
Although there have been innumerable surveys of the *numbers* of visitors
to exhibitions and to museums, including identifying their social origins,
very little has been done to determine the mental set, or indeed the
expectations, of that audience. I also think that those of us who make
exhibitions seriously overestimate the extent of ordinary everyday general
knowledge we can reasonably expect our visitors to possess. I am re-
minded of a student at my own university (and university students sup-
posedly represent the intellectual élite of the population) who, it turned
out, was quite unaware that Russia had been involved in the Second
World War. This gave me pause for thought. Not to know which side
Russia was on during the war might be not altogether surprising, since
of course she was at one time and another both ally and enemy. But not
to know that she was involved at all poses problems of a quite different
order for a curator at an institution such as the Imperial War Museum
who might wish to create the kind of display that would make sophisti-
cated and interesting points about, shall we say, the character of wartime
propaganda imagery. If one is forced to admit that it is possible that a
sizeable proportion of visitors to such an exhibition might have no idea
who the protagonists were in this quite recent conflict (other than the
vague notion that they were probably England and Germany), then one's
starting-point in deciding upon the manner of display, let alone what
kinds of information and adjunct material might be appropriate, will be
significantly different. How much more complex, then, must be the
problems confronting the organisers of an exhibition dealing with an
historically remote period: England in the Age of the Plantagenets, the
American War of Independence, pre-conquest Peru?

The second most serious problem contributing to our present difficulties is, in my view, a persistent belief that elucidation must necessarily take the form of words. The same fusty arguments are trotted out again and again, about people not being willing to read anything more than the shortest introductory texts, and about texts generally getting in the way of our aesthetic experience of objects. Even where the designer's imagination stretches beyond the conventional use of wall texts or information panels to embrace such explicative devices as acousti-guides, audiovisual displays or the much-used *petit journal*, it has to be remembered that these, too, rely largely on verbal means, and are thus exposed to the same objections. Yet rarely is much consideration given, as far as I can see, to the possibility of employing other kinds of visual material, other resources in order to make the same points more vividly, more economically, less intrusively. In an exhibition held in Austria in 1984, devoted to the life and times of the Emperor Franz Joseph, one of the rooms including material relating to the Imperial family contained virtually no written information at all but, instead, a small number of objects of great evocative significance, including a beautifully printed family tree, with portraits of the principal members of the house of Habsburg.[8] Such an object, comprising no more than fifteen or so written words, can 'stand for' a whole essay on genealogy, which can thus be safely relegated to the catalogue, to be read at leisure on another occasion, by conveying to the visitor some sense of historical context on setting foot in the exhibition itself.

There are any number of such types of predominantly non-verbal material that one can use, ranging from maps and diagrams, the ephemera of daily life, illustrations and photographs, to slides and films showing, for example, an implement in use, as opposed to in a showcase, or the techniques employed in the creation of the objects or works of art on display. To take, for once, an example which is both 'real' and hypothetical: among the paintings displayed in the exhibition 'Dreams of a Summer Night' were several by the Finnish artist Akseli Gallen-Kallela, rather different from his more Symbolist-influenced work and evidently the product of an intense interest in Finnish folk art. How easy it would have been to juxtapose these paintings with, perhaps, just one costume of the kind shown in the Museum of Mankind's earlier exhibition, 'Folk Costumes of Finnish Karelia'. Vivid and attractive in itself, easily available, affording an obvious point of comparison with some of the apparel represented in the paintings, such a costume would have immeasurably aided the comprehension of the inquisitive but non-expert viewer, by

providing a simple point of visual reference. All that would have been needed would have been a two-line caption; even to make the point verbally, about the influence of folk art, would have been unnecessary. In this instance, the works displayed would indeed have 'spoken for themselves' – the reticent object for once coaxed into loquacity by the efforts of selector and designer.

In the creation of 'efficient' educational exhibitions, the relationship between selector and designer is clearly of crucial importance. Unfortunately it happens all too often that exhibition designers see the kind of high-profile, prestige show so common today as a vehicle for realising their own aesthetic ambitions, rather than as an opportunity for devising the most telling, most instructive, most advantageous display of the objects in question. I find this especially sad because it means that relatively few designers are capable of seeing how truly creative their rôle can be. It is the design of the exhibition, the layout of the material, and the context which the designer creates for that material, just as much as the actual selection of objects, which 'tell the story', and this 'story-telling' rôle carries through into the smallest details: the choice of display lettering, of materials and colours for wall-coverings, the design of the catalogue, of the poster, of related advertisements and publicity material. If, as seems to me essential, the designer has been involved from the outset in discussions with the selector as to the theme of the show, if he has researched the social or aesthetic or historical background, even taken a hand in the selection of the work to be displayed, he will be infinitely better able to capture the attention of his audience, and to hold that attention while he unravels the particular story that is the *raison d'être* of the exhibition.[9] Because, of course, there are any number of possible stories to be told, depending not merely on the nature of the material but also on the particular aims and ambitions of the organisers. The same material can be made to tell quite different stories not just by means of captions or information panels or explanatory texts but by the sequence in which works are displayed, the very way the material itself is divided up, above all the physical and associative context.

Let us take a slightly lurid example: if we peruse the contents of the notorious 'Degenerate Art' exhibition organised by the Nazis and shown in Munich and other German cities during the course of 1937–8, it might seem to us, from our particular vantage point, a truly spectacular display of some of the finest twentieth-century German and foreign paintings, including the work of virtually all the leading Expressionists: Nolde, Heckel, Schmidt-Rottluff, Pechstein.[10] Were the same paintings to be

shown today, what points one might seek to convey about the stylistic evolution of German art in this century, about the use of expressive colour and form, about the influences of primitive and tribal art which provided these painters with a previously unexplored arsenal of expressive means.

Showing these works to their best advantage was not, however, among the aims of the organisers of the 1937 exhibition. Not just the use of slogans and captions, wall texts and quotations from Hitler's speeches, but also the way in which the show was designed and hung, indeed every element associated with the publicising and presenting of the exhibition was calculated to hammer home propaganda about cultural bolshevism and military sabotage, about physical and moral degeneracy, about race, about 'Jewishness' in art. Not only did the title given to the exhibition make specific reference to the 'Jewish demolition' of artistic values: the poster, too, juxtaposed without further comment a mask-like 'Expressionist' head with, immediately behind, a shadowy but unmistakably Semitic, slightly leering countenance.[11] Even the layout of the exhibition, the dividing up of the material section by section, was deliberately both didactic and thematic. Works were arranged, not chronologically, nor by artist, by school, or by any known art-historical principle. Instead, paintings by different artists were grouped together according to 'tendencies' defined in terms of the organisers' perverted political and aesthetic creed: the wilful distortion of colour and form, the undermining of religious belief, incitement of political anarchy and the 'class war', a section which compared the work of the 'degenerates' with that of 'idiots and cretins', and a final section entitled 'Utter Madness' comprising a survey of most of the principal 'modern movements', from Dada and Constructivism to Surrealism.

As Ian Dunlop observes, the 'Degenerate Art' exhibition, conceived as an anti-art demonstration, with its slogans mocking the commercialisation of art, was ironically the greatest Dada event of them all.[12] No less ironic is the fact that, however morally deplorable its aims may have been, it was nonetheless one of the most elaborately conceived, carefully-thought-out 'educational' exhibitions ever staged, every detail calculated to reinforce the intended propaganda message. Only the works themselves remained curiously resistant to this kind of treatment. Embarrassingly, the exhibition, held in the cramped and unsuitable surroundings of Munich's Municipal Archaeological Institute, attracted far larger crowds than the rival showing of officially approved art held at the newly completed Haus der Deutschen Kunst, and inaugurated with lengthy speeches by the Führer himself. Unintentionally, the organisers of 'Degenerate Art' had

Poster by 'Hermann' for the 'Degenerate Art' exhibition, 1937–8
(Hamburg showing).

Interior view of the 'Degenerate Art' exhibition, Munich, 1937.

created an exhibition which produced, on some visitors at least, a quite overwhelming impact simply by virtue of the quality, the emotive power of the works on display. Such a reaction, naturally, was quite unacceptable. Some foreigners, like Cyril Connolly, who paused too long before masterpieces by Kirchner or Nolde, were even shooed away by the guards, who had been given special orders to watch out for members of the public who appeared to show too much interest in the actual paintings, or who didn't laugh loudly enough.[13]

These days, relatively few exhibitions are born out of such overtly, such unashamedly political ambitions. Our own political or intellectual or social attitudes may well exert a significant influence on the kinds of exhibitions we make, and indeed determine to some extent the reactions of the public, the consumers of the product. But just like our educative or didactic purposes in exhibition-making, such underlying attitudes and presuppositions remain unspoken, unarticulated, not least because we have probably thought little about them, relying on 'performance indicators' such as the numbers of visitors, the box-office take, and the extent of commercial sponsorship to gauge the success of exhibitions. The notion of achieving a balance between education and diversion, the sententious aim expressed by the Duke of Argyll on opening the Imperial International Exhibition held at the White City in London in 1909, of

combining 'amusement without excess and knowledge without fatigue',[14] has largely been lost to sight. The old Janus-headed 'instruire et plaire' has given way to bread and circuses.

It may perhaps have struck the reader who has patiently followed the arguments and examples adduced so far that I have repeatedly used the words 'educational', 'instructive' or 'didactic' in order to describe the aims of exhibition-making; to which the exhibition-goer or critic might object: 'Why educational?' Why should the purpose of making exhibitions not be simply to give pleasure, to provide entertainment or diversion, to afford a rare opportunity for reflection or quiet contemplation in our otherwise turbulent lives? One reply might be that it is in any case far from easy to draw a rigid distinction between these various kinds of experience. Certainly, the question of the relationship between instruction and entertainment is one which has vexed generations of exhibition-makers, as Paul Greenhalgh's essay in the present volume demonstrates. One of the many things to emerge from his fascinating study of the Great Exhibitions, Expositions Universelles and World's Fairs which were a persistent feature of cultural and political life during the last half of the nineteenth century and the early years of the twentieth is that, while educating wider and wider sections of the populace remained a significant aim of such exhibition-making throughout the period in question, in general entertainment was found to pay whereas education did not; and that getting the right mix of instruction and diversion was as enduring and intractable a problem for the Victorians and Edwardians as it is for ourselves.[15]

Yet, on another level, it might equally well be argued that, no matter what the aims of the organisers might be, all exhibitions – even those devised principally as entertainment – are educational, in a wider and more profound sense. I have already attempted to define what museums might be, in terms of the various essential activities in which they engage. To Henry Cole, the great founder of what was to become one of the most important educational institutions in the world, the Victoria and Albert Museum, it was equally clear that there were a number of things that museums were not – that they were not, for example, places for 'idle loungers'. Museum-going was not to be equated with mindless gawping. Even the most cursory glance at the objects presented for our inspection, the most private act of communion between ourselves and a work of art represents a broadening of our intellectual horizons, a deepening and enriching of our experience – and hence of our education. The temporary exhibition or museum display will succeed or fail in reinforcing

that experience and making it more vivid, more memorable, more lasting, not in terms of some 'objective' standard imposed from outside, but according to criteria which the exhibition itself and those responsible for its making must propose. To devise a better methodology for defining such criteria is surely one of the more urgent tasks of the new museology.

4

Theme Parks and Time Machines

COLIN SORENSEN

'I would like you to tell me, in the name of what
do you do what you do?'

NADIA BOULANGER

I recall my father, who was, I am increasingly aware as the years go by, a
shrewd observer of the *comédie humaine*, suggesting that in order to know
what someone was really like, one needed to know quite a bit about what
they did with their spare time. Perhaps for this reason and also because,
as Keeper of the Modern Department at the Museum of London, I have
long been a professional student of both the life and character of the
national capital as they have evolved and changed over the last three or
four centuries, I have always been especially interested in popular metropoli-
tan pastimes and recreations, and in particular in the history of what we
now call 'the leisure industry'. Happily, the professional provision of, and
indeed the export of, entertainment continues to be a very important and
distinctive London activity, as it has been for centuries – its variations as
much as its continuity of character a revelation of the tastes and preoccu-
pations of the London audience. They, in the current jargon, were and are
the consumers of the 'product', and the manufacturers – the showmen, the
performers and dramatists – have always had to be closely observant stu-
dents of those tastes and preoccupations. Shakespeare may have been the
'bard of Avon', but it was for an audience drawn from the streets, alleys,
palaces and taverns crowding the banks of the Thames that he wrote.
Because he knew what was on their minds, he knew what would tickle
their collective funny bone, catch their imagination, and ensure a regular
and profitable 'take' at the box office.

Others, too, have consistently found the variety of available entertain-
ments a revealing guide to the popular state of mind. In his great study
of metropolitan popular shows and displays in the age before the institu-
tion of formalised museums, *The Shows of London*,[1] Richard Altick
quotes a note he found in a nineteenth-century scrapbook written by a

Mr A.W. of Peckham: 'Look around you, in this extraordinary Country, and contemplate the various Shows and Diversions of the People, and then say, whether their Temper or Mind at various periods of our history, may not be collected from them?' More eminent observers have reacted in similar ways. Kipling referred to the London music halls as the 'very stuff of social history'; and Lenin also found his visits to the music halls a revelation, commenting in a letter to Gorky: 'There is in them a certain satirical or sceptical attitude towards the commonplace. There is an attempt to turn it inside-out, to distort it somewhat, to point up the illogicality of the every-day.'

Along with the tens of thousands in Britain now engaged in the multifarious branches of show business, those of us who work in museums can hardly be unaware of the changing tastes and preoccupations of the audiences. One marked and almost universal preoccupation, manifesting itself in widely disparate circumstances, is with 'the past'. This is not so much an interest in history, which one might understand as an awareness of the processes of cause and effect in some sort of chronological sequence, but much more an urgent wish to achieve an immediate confrontation with a moment in time, a re-entry into a vanished circumstance when, for a brief moment, the in-the-round 'real', physical, audible and (especially popular) smellable realities of a distant 'then' become a present and convincing 'now'.

Why this should be so is, of course, a subject for some reflection. Is it, I wonder, that the growing depersonalisation of our environment leads to a search for means of symbolising our individual identity – a real or a chosen past? The defiant '*cogito, ergo sum*' becoming the consoling 'I remember, therefore I was'? It is, to me at least, striking how eagerly we seek to be in the past, how often we are encouraged to make visits to the past. It occurred to me the other day that this is very like the 'reminiscence therapy' for which volunteers were being advertised a few years ago in various newspapers. I read: 'Help take part in reminiscence therapy . . . Start by teasing out those details they do remember from the past. Use props, like photographs or memorabilia . . . the objective is to get each person reacting to the others as they did earlier in their lives, so that the patients begin to feel less isolated.' That was described as one widely effective treatment for amnesia – and, incidentally, for senile dementia.

I must admit that, to me, the most intriguing of the contemporary enterprises that engage simultaneously in popular entertainment and in the merchandising of history are the 'historic' theme parks, of which

dozens have sprung up in recent years, and dozens more are promised. Dedicated to evoking a bygone, often rural way of life, they encourage us to wander among their recreated or reconstructed premises entertainingly, instructively, and perhaps thought-provokingly, out of time. Of all the world's such parks, arguably the most famous, the most successful (and most influential) is Disneyland in all its various manifestations. In its choice and presentation of subjects and themes, it constitutes a fascinating revelation of the attitudes of the people who created it towards, among other things, the notion of what it is to be an American. They have provided a bright, attractive conspectus of the nation's memories, stereotypes and fantasies, a shareable childhood for everyone, whatever the individual realities of race or creed might be.

Such theme parks, like museums (their close relatives) have a long history – indeed, they share much of the same history. The classically educated owners of many eighteenth-century estates which had been carefully landscaped to evoke Virgilian echoes employed a 'genuine' hermit to inhabit a grotto picturesquely located in a grove or poised on a rocky crag. Since even in more autocratic times these non-Equity personifications of living history could hardly be expected to spend their nights in such inhospitable surroundings, as dusk fell they threw off their classical draperies and bicycled off (or the equivalent) to the nearest village – just like the aged, heavily beshawled peasant whom I once met in a turf hut at the Ulster Folk Museum, who sat mutely demonstrating weaving in some time-honoured fashion and then, much rejuvenated, nearly knocked me down some five minutes later as she made her precipitate way home in her Morris Minor.

Historic theme parks, or their younger cousins the heritage centres, are usually to be found in one or other of two distinct types of locations. The first type has been evolved from a 'real' place, where sufficient historic buildings and natural or man-made features survive 'on site' to allow, with some not always judicious restoration and doctoring, for their original appearance and associations to be revived and interpreted to the visitor. In the United States, Williamsburg, the one-time colonial capital of Virginia, is a notable example of such a place and such a process. In the nineteen-twenties and thirties the 'Cinderella City' was, as an enthusiastic copywriter claimed, 'recalled to its eighteenth-century self at the behest of John D. Rockefeller Jr'. Huge sums of money were spent on acquiring properties, demolishing or stripping away later accretions and recreating the town as it was believed to have been. 'When you stroll its lanes, great men walk beside you . . . attendant here upon the

Museum of Iron and Furnace, Ironbridge, Shropshire.

birth pangs of the Republic.'

In this country, perhaps the best-known historic site rediscovered and reanimated in a similar way is the small town of Ironbridge at Coalbrook-dale in Shropshire where, after centuries of picturesque partial slumber, hidden in a heavily wooded bend of the River Severn, this important centre of early Industrial Revolution activity has in the last few years been vigorously exhumed, augmented and injected with a new didactic purpose.

The other main type of historic/thematic park does not depend for its location upon historic associations or surviving static relics. Such places are usually entirely artificial – indeed, they generally derive much of

their effectiveness from the freedom with which historic elements from elsewhere can be introduced into the virgin site and deployed or grouped to suit a predetermined theme.

The American pioneer of automobile mass production, Henry Ford, albeit that he is alleged to have asserted that 'history is bunk', nevertheless was at great pains to bring together in the theme park he created, buildings charged with that dynamic kind of historic potency to which he most responded. With its original owners' willing, indeed enthusiastic collaboration, Ford moved Thomas Edison's workshop and all its apparatus (and the very soil upon which it had originally stood) from Menlo Park, New Jersey, to take its place, along with a reconstruction of Ford's own birthplace, as a central feature of 'Greenfield Village' near Dearborn, Michigan. Here, Ford also re-erected the cycle-store home of Orville and Wilbur Wright, painstakingly dismantled and brought from Dayton, Ohio, where the brothers had experimented with gliders and had eventually designed and built the famous *Flyer*, which first flew at Kitty Hawk, North Carolina, in December 1903.

Elsewhere in the 200-acre site at Greenfield Village were a planing mill, a glass plant, beam engines, a cooper's shop and dozens of other industrial installations large and small. There were also such potent symbols of small-town American life as a typical pioneer log cabin, a school house and a tin-type photographer's studio. For presumably similar, potently thematic reasons Ford included a replica of the Philadelphia Meeting House where the revolutionary leaders voted to break with Great Britain, and the bloodstained chair in which Abraham Lincoln had been shot at the Ford Theater in Washington. Henry Ford's great heritage centre, with which he hoped to inspire future generations of young Americans, was a park dedicated to the theme of national genius, the proven virtues of thrift, inventiveness, ingenuity and, above all, of get-up-and-go self-help.

In this country, with a dedication and a visionary enthusiasm at least equal to that of Henry Ford, or John D. Rockefeller, Jr (though by no means having their financial resources), the tireless museum director Frank Atkinson has, over the last two decades, assembled on a 264-acre site at Beamish in County Durham his own passionate, evocative celebration of the day-before-yesterday in the North-East of England: an already impressive and ever-expanding collection of buildings and artefacts that has been brought together to recall the way of life, and the tribulations and triumphs, of that distinctive area of the country.

What do these and the many similar theme parks have in common?

Well, obviously, many things. For one thing, they are all places out of time – anyway, out of *this* time. They are visits to times past. They allow, encourage, us to play, for a time, in another time. In order to do this, some of them, rather worryingly to some of us, play *with* time. Death and decay are, it seems, denied. Strangely and paradoxically in the context of institutions nominally preoccupied with the passage of time, these phenomena are not allowed to occur. This denial of the realities of time, this artificial omission of any interval between then and now leads to the ready assumption, indeed the implication that then and now are very similar, and that *we* and *they* are, except for a few superficial differences, very similar also. We have but to don a mobcap or a nylon wig and the centuries roll away. It is only the artefacts that, unaccountably, are quaint and old-fashioned.

'The past is a foreign country; they do things differently there' – the probably all-too-familiar quotation from L. P. Hartley is nevertheless true and relevant. We must not deny the thousands of differences in belief, knowledge, assumptions and aspirations of past generations; even if physically our ancestors may have been similar to ourselves (although photographs of only a generation ago would seem to contradict such a view), the world in which they lived cannot be re-entered. Surely it is misleading and a gross distortion of any true appreciation of history to suggest that it can.

In these changing and disturbing times, historic theme parks and heritage centres probably tell us as much about ourselves as about the past – indeed probably far more. Certainly, one reason for their great and increasing popularity would appear to lie in their contemporary social rôle. This often extends beyond the intended blend of instruction and entertainment to something much deeper. The Scottish Museum of Fisheries, at Anstruther in Fife, is an instructive example falling into this category. Small though it is, so effectively does it suggest what it meant to be a fisherman, particularly in the age of sail, that local people began privately to approach the curator, asking if they might bring things to put in the museum: not additional objects to add to the collections, not tools of the fisherman's trade to augment the displays but, for example, something as simple as a small vase of flowers to decorate a windowsill. They wanted privately, anonymously, to commemorate loved ones, fishermen who had died at sea, sometimes many years before. I find that both very moving and very illuminating. It was a tribute to the museum, which had so effectively identified the nature of the experience – the life of the fisherman – that it had become for certain visitors a celebration,

a visible commemoration of the dead. The living clearly felt it was an appropriate place for their loved ones to be remembered in. Eventually a room was put aside where relatives could pause for a moment in recollection. This thematic museum is clearly a great deal more than just a stylish assemblage of artefacts.

So the historic theme park/museum curators or the heritage centre administrators are all in some ways representative of a new secular priesthood – without, clearly, any problems about the ordination of women! (During one memorable and uplifting week a year or so ago, I heard one museum official encouraging his colleagues to extend their 'pastoral care', another asking for galleries that created 'total immersion experiences', and a museum director extolling the near-mystic insight to be derived from 'hands-on' contact with the exhibited relics.) As is to be expected, their approach varies. Some favour an astringent puritan Romanticism, others a thrusting business-efficiency Evangelism. There are the advocates of the blow-your-mind audiovisual Counter-Reformation Baroque – and in some of our most successful temples dedicated to the elements of fire and water there is, for all the accompanying technology, a strong and unmistakable undercurrent of animism. It's not only latter-day druids or wandering tribes of macrobiotic hippies who need to find a Stonehenge of their own choosing, to borrow or recreate a symbolic focus for their concocted rituals. I recall standing somewhere with other visitors before the long-chilled husk of an historic blast furnace, its once-mighty roar and the glow of its germinal fires now wheezily evoked by primitive electronics, listening to a sonorous recorded commentary that aimed to elucidate the 'meaning' of this place and these peculiar automated rites. Strange experience though it was, I was puzzled why, since I had never been in this place before, it all seemed so familiar. Then I remembered reading about how the priests at Delphi were thought to have cooked up a brew of smoke and flame behind the scenes to help convince the credulous pilgrims who had come to the shrine to witness an appearance of the Oracle, before that elderly crone, high after munching bay leaves, eventually climbed on to her tripod, indecorously perched over the 'prophetic cleft', to give ambiguous utterance. So the curator of theme park, heritage centre or museum is a representative of one of the oldest, if not the oldest, professions.

These exhibits and places contrived to take us 'out of time' are often extolled as 'time capsules', 'time warps', or 'time machines' – 'buzz' phrases one hears almost as much as 'heritage'. Probably the first and certainly the best-known description of such a time-travelling device is

that contrived by the unnamed scientist in H. G. Wells's great allegorical novel *The Time Machine*, originally published in 1895. This time-traveller, seated in his miraculous machine, does not trundle or sway past inanimate tableaux of days gone by but, fictionally freed from the limitations of gravity and time, passes into the future as easily as into the past. By a truly remarkable coincidence, it was in the same year that the most potent of all modern time machines was publicly demonstrated in Paris. This was no work of fantastic fiction, but a practical device that could apparently capture time, play with it, and if required reverse it. On 28 December 1895 the brothers Auguste and Louis Lumière demonstrated their *Cinematographe* at the Grand Café, 14 Blvd des Capucines. In doing so, they introduced not merely a scientific toy, but a revolution in communication, a world-wide transformation of art and entertainment and, as we can now see, a resource of immense potential for the historian.

However, it would seem that comparatively few historians or antiquarians sought to understand the new medium, to think about what it might mean, or what it might be made to do – how it might enrich and expand their fields of activity, and extend the range of what could be recorded. When still photography had been perfected, over half a century earlier, there had been any number of historically-minded users. In London, for example, in the eighteen-seventies and eighties, the group of friends who constituted the Society for Photographing Relics of Old London had made a – now invaluable – record of some remaining vestiges of the ancient city, which they knew were soon to be swept away. Collections of such intentionally antiquarian photographs were often lodged in museums, but it seems that they were seldom anyone's special responsibility, being uneasily related to the topographical collections of engravings and drawings. And, though clearly interesting and informative, they were not generally regarded as being of distinctive aesthetic consequence.

Surprising as it may seem, this situation lasted until quite recently. I well recall that when I was on the committee of the exhibition that was held at the Victoria and Albert Museum in 1970 to commemorate the centenary of the death of Charles Dickens, I proposed that we should illustrate each novel with contemporary photographs of London – Fox Talbot's early London views, for example, being almost of the same date as *The Pickwick Papers* and Dickens's earlier novels. In the event, I had a very hard job indeed finding original examples to use. I eventually found some of the most interesting photographs in one of the world's

most famous museums, in a cupboard next to that in which were stored the museum's supply of mopheads.

In the year following, 1971, Colin Ford, now the curator of the Museum of Photography and Film at Bradford, and then a member of the staff of the National Portrait Gallery, spent a lot of the latter institution's money on an album of Julia Margaret Cameron's portrait photographs of notable Victorians. This greatly surprised those who had not previously thought of old photographs as being of particular value. But the popular press made much of the event, and then, predictably, the climate began to change. Everybody suddenly seemed to be looking out their old photographs, or starting to collect them. At last, museum curators began to regard photographs with a new seriousness. I suppose it was partly that such historic photographs had now achieved a new financial value – but they had also become established in the general consciousness in a new, special way. The attitude towards photographs is now so different that it is hard to realise how recently this significant change occurred. In the phrase of the *Antiques Road Show* pundits, old photographs are now agreed to be 'very collectable'.

By an interesting coincidence, in the same year – 1971 – I went to Exeter to attend the annual Museums Association conference. On the last day, two of my particular heroes were due to appear. Neither was a museum person, but they were really heroic figures to me – great achievers in their own fields of historic research and recording. One of them was Sam Hanna, a retired grammar-school master from Barnsley in Lancashire. Sam Hanna had pioneered the use of film in recording the skills of craftsmen and tradesmen, partly in order to preserve them for posterity, but equally to use them for teaching children in his school about the vanishing ways of life of the locality in which they lived. The other hero of mine who was to appear was Sir Arthur Elton. Sir Arthur Elton was, of course, one of the prime movers in establishing our new appreciation of the industrial past and, with his friend Francis Klingender, one of the fathers of the industrial-archaeological revolution. Perhaps his best-known monument is the great library and collection of prints and drawings that he collected, relating to the early years of the Industrial Revolution, now housed under his name at Ironbridge.

It has often surprised me that comparatively few of those who rightly honour Sir Arthur Elton as a pioneer historian, writer, editor and collector seem to be familiar with the other side of his busy and creative life. Not only was his work concerned with a dramatic period in the past, he was also a distinguished investigator and recorder of the present.

Still from *Housing Problems* (Anstey/Elton, 1935).

Indeed, he was among the great pioneers in the evolution of the British documentary film. With Edgar Anstey, Elton was the director of one of the most influential of British documentaries, *Housing Problems*, made in 1935 for the Gaslight and Coke Company. In this remarkable film, for the first time ever ordinary people were persuaded to speak straight to camera and tell the viewer just what it was like to live in the slums of East London. There they are still, on the screen, showing us the rat-infested houses they live in: they are certainly not actors in costume, or animated waxworks, and they are not standing about in authentic room reconstructions, with a voice-over commentary. Their words remain startling, genuine, real. It was something only film could do, and this was the first time that it had ever been done. Elton was truly an historian who also saw that it was essential to recognise that history is happening now – and to record it perceptively.

So there, at the museums' conference in Exeter, was Sam Hanna, a pioneer of film in history and education, sharing the platform with Sir Arthur Elton, the co-director of *Housing Problems*. Their theme was to be how film and other audiovisual media could be of use to and, just as importantly, be used by, people in museums. These two distinguished men

were appearing, as it were, as an evangelical double-act, hoping to widen the techniques and range of awareness of the professional curators and historians. Only nine people came to hear them. But that, of course, was many years ago!

Nor was it only the professionally-made documentary film that failed to attract the attention of those whose purpose in life – their professional life, at least – was supposedly the charting of history – including contemporary history. Although by the nineteen-twenties and thirties amateur film-making was widely practised, it seems that very few within the museum profession took much notice of it, or recognised its significance. Those fascinating fragments of film which frequently turn up on television, showing street scenes or family life at home and on holidays during the twenties and thirties, were almost without exception the work of amateur film-makers. Few of these home-movie enthusiasts had any sense of 'living history' or awareness of creating an historically significant record of daily life. What they were understandably fascinated by was the ability of film to record time and to play it back, if only so that they could enjoy again a holiday experience or recall the children's faltering first steps. But what these fragile reels have now acquired, as is always the case with artless memorials of time past, is a different and more lasting significance.

It is something of a dictum that 'museums are collections of things'. The concern is with the tangible thing and the supportive word, or alternatively the primary word and the illustrative thing. The study of material culture, it is held, should concern itself chiefly with material evidence. The unique ability of what we now call the audiovisual media to recall the living context from which the objects come appears to have had little appeal. Few seemed to acknowledge that the arrival of a means by which such contexts can be recorded could radically alter the purposes of collecting such material evidence. I was told that when, some years ago, a museum in Scotland wanted to amplify its gallery display on stone-quarrying and set about searching for some film to demonstrate the industry's vanished skills, it was unable to find any. Those ancient skills had been widely practised in the district until very recently, but no one had thought of using a movie-camera to record them. All that remained was, perhaps reassuringly, a showcase sufficiency of objects: the raw material, the samples of worked and unworked stone, tools, and transcriptions of the recollections of surviving practitioners of the old craft. There was no chance of seeing them at work 'in context'.

It is certainly not my wish to transform museums into galleries of flickering screens. The introduction into static museum displays of 'time

machine' technologies is fraught with considerable problems, above all of aesthetic sensibility and taste. If it would be valuable to relate the record of the 'living context' to the material that once inhabited it, this should nonetheless be managed in a mannerly way. But, equally, we surely cannot leave such a wealth of living evidence to others to deal with. We or our successors are going to need the information, and we should be skilled in collecting it. Just as we seek to learn to communicate with our ever-changing audience by speaking and writing in a way which will be generally understood, perhaps we should learn to understand these newer 'time machines' and employ them in a comparably lucid manner. We might even evolve our own audiovisual language, if we are not too inhibited by the 'art of film'. Museums are, after all, temples of the muses. Is there really to be a limit to the number of muses allowed in the temple?

When one puts forward such ideas in the museum world, the response is often that we don't want to, and couldn't afford to, move into the business of making television programmes. But, in reality, we don't need to make hour-long epics or a thirteen-part half-hour series. A well-made two or three minutes may be all that is called for. We shouldn't think of 'commercial outlets' or 'getting on the telly' – remunerative though this is assumed to be. Rather, it seems to me that a broader, more comprehensive record of action and context might have a proper and lasting influence on what is collected – and that, eventually, neither the individual object nor the record of its use or context would be considered of superior value or significance – although, on occasion, the record of a context or circumstance might well be regarded as the more preferable acquisition. So often an artefact is presented alone, out of its place and time, and expected to perform unaided the immense task of explanation and evocation – a totemic symbol of an otherwise unrepresented complexity. I remember once seeing in a gallery, standing in splendid isolation, a petrol pump. It represented, I was told, the oil industry.

Perhaps, as I have implied earlier, one of the most important parts of our job is to try to call up ghosts. I have already quoted from L. P. Hartley's *The Go-Between*, and I think that a go-between – between the living and the dead – is not a bad definition of an essential part of the job. But usually in the museum profession, we call up ghosts under very strict conditions. It seems to me that we don't want to meet and try to comprehend them. We usually call them up in order that they should help us to understand the artefacts – to show us how the 'things' work. Our interest seems primarily in the objects, rather than in the

human context out of which they arose. I am often disturbed that, in our materialistic, object-orientated preoccupations, we appear to suggest that people were ennobled by the mechanisms they operated, by the tools they used, rather than vice versa. And this seems to me in its implications truly appalling.

It is not that I want to take the 'fun' out of the job of the museum professional. Nor would I wish for one moment to dampen the zeal or dedication of the enthusiastic collector. But the study of living history and the recording of it should be based upon other criteria than the professional paralleling of the acquisitive preoccupations of the hobbyist. We have, or should have, a – dare I say it – more serious purpose in mind. There is now seemingly no limit to what it is legitimate to collect – that is, other than the practical limitations imposed by the sheer bulk of material which is being accumulated, and the necessity to store it, conserve it and so on, which can quickly mount up to an impossible expenditure. The change of focus, the broadening of interest and social sympathy which now makes 'Everyman' – and of course Everywoman – the chief heroes in the heritage stories has had a marked effect on what we recognise as having 'historic' meaning – and therefore on what we collect in order to illustrate it. Indeed, so marked is this revolution in awareness, coupled with, I sense, a bittersweet recognition, born of a general social uncertainty, of the ephemeral nature of our surroundings, that there is virtually no item in general daily use, no familiar part of our world, which has not become a subject of study, research and collecting. But is this really the best and most realistic solution to our task? Should we not be looking very seriously at what we are trying to achieve, in order to see whether the accumulation of more and more comparative examples of 'material evidence' is the proper thing to be doing? In Ibsen's *Peer Gynt*, Peer symbolises his search for the central truth which lies at the heart of his experience of life by peeling away the skins of an onion, layer by layer, only to realise at last that the onion has no inner heart, but is all layers wrapped within each other. It seems to me that we are in danger of reversing Peer Gynt's symbolism, attempting to add more and more 'skins', layer upon layer of inanimate material evidence, in the belief that the more we have, the closer we shall be to embodying – now and for the future – the essential truths of the times which produced it. Instead, shouldn't our aim be to send our 'time machines' (our multi-artefact and multimedia collections) into the future as comprehensively and illustratively stocked with as wide a variety of useful materials for their after-life as were the tombs of the Pharoahs or the

burial ships of the Vikings, which subsequent generations have been delighted to disinter for information and insight?

However, it would appear that, for the present, popular effort is directed elsewhere – to be precise, in the opposite direction. We are as a nation much absorbed in a usually selective, sometimes sentimental retrospection, much of our collections one vast accumulation of memorabilia – stimuli to the recreation of a just-vanished age which, evidence suggests, exerts an unparalleled hold over the imagination of its successor. So much of our collecting seems intended for no other purpose than to stock a huge toyshop, the contents of its shelves fascinating to visitors of all ages eager to play for long periods of time in the 'just-past' – '. . . where all the family can spend a day in the land of yesteryear'.

Might it be that Frank Atkinson's splendid conception and achievement of the great theme park/heritage centre at Beamish will be seen as being as much a symbol of our time as the Temple of Abu Simbel is of that of Rameses II? The latter is a symbol of an inflexibly structured, deeply religious society much concerned with preparations for the afterlife, while the former is a similarly telling indication, in our less religious and convinced age, of our preoccupation with the life of the past – or at least the life of the day-before-yesterday. It will surely be thought-provoking to people in the distant future to realise how, in our time, we have spent a lot of time creating places in which we could be together in large numbers in another time.

Is it too fanciful to suppose that, should this current enthusiasm for the creation of historic theme parks and heritage centres take a firm and lasting hold upon the popular imagination – as did church building in the Middle Ages – as generation succeeds generation, valley after valley will be colonised by recreations of the then day-before-yesterday – not our day-before-yesterday, but the days-before-yesterday of people yet to come? Perhaps one day adjacent theme parks will stretch across the land, each dedicated to the life and times, the trials and tribulations of a different generation's grandparents. It is salutary to read in *The Rape of Britain* by Colin Amery and Dan Cruikshank that 'already in Britain there are people who have no memory of their birthplace, no links left with the generations before them.'[2] The role of the yesteryear theme parks of tomorrow may yet take on a special significance. Across a landscape already dotted with long barrows and redundant churches, our ancestors will still be invoked.

5

Education, Entertainment and Politics:
Lessons from the Great International Exhibitions

PAUL GREENHALGH

In these times of desperate financial pressure, the major museums of
Britain more than ever before are concerned with their public rôle. To
justify themselves, they have to generate large attendances and attract spon-
sorship. In short, the museum can no longer exist simply as a receptacle
guarding our heritage, or as a haven for scholars. It is also compelled to
be a place of enhanced interest to the general public, which is increasingly
seen as a main source of funding for the scholarly and conservation activity
the museum takes part in, by contributing at the door and providing a
target for commercial sponsors. The economic and social situation of con-
temporary museums thus resembles that in which the Great International
Exhibitions thrived, whereby all motives, regardless of their merit or lack
of it, were tempered by the overwhelming need to fill the site with people
and to win sponsorship. The fact that they succeeded with such staggering
effectiveness more than anything else makes them of continuing interest.

In this essay I will explore the rôle of the contemporary museum in
relation to its public, by comparing my perception of museum policy at
the present time to policies formulated by those who created the Great
Exhibitions. My study will concentrate on English exhibitions held in
the decades running up to the First World War, using the Parisian Expo-
sitions Universelles for comparative material, although much of what I
have to say could easily apply to the rest of Europe and America. My
intention is to expose some of the patterns of thought which went into
the making of the Great Exhibitions, in the belief that these will prove
surprising to those enamoured of the idea that the spirit of Prince Albert
lived on into events after the Crystal Palace Exhibition of 1851. The
aims, objectives and methods of Great Exhibition impresarios between
1870 and 1914 may well seem brutal and crude to us, but as exemplars
of a particular cultural outlook they remain of marked significance.
Especially interesting is the manner in which organisers treated those
parts of the exhibition that could be considered educational, in relation

to those which could be defined as entertainment. Bound up with this particular dichotomy was the presentation, both consciously and otherwise, of political ideals. Some important exhibitions from the decades running up to the First World War which have fallen into undeserved obscurity will be exposed as a by-product of the discussion.

There are two distinct phases in English exhibition activity between 1851 and 1914, the divide coming in 1871. In tandem with shifts in the social, economic and cultural climate of Britain in general, the exhibitions began to change their organisational structure and philosophical outlook after that date. From 1871 the size of exhibitions tended to be truly epic; the Crystal Palace of 1851 would indeed have seemed like a very average event in 1890, in terms of its expenditure, its attendance figures and its acreage. If a European perspective is taken, the exhibitions of 1851–70 seem even more modest. In terms of organisation, in 1871 the 'serial' system came to the fore in England, changing the character of the events themselves. After 1886 English exhibitions made the final rift with the earlier phase by introducing entertainment facilities on a large scale. It was between 1851 and 1871, however, that all the ingredients of succeeding events were invented and first exploited. It was then also that most of the advantages and problems of the exhibition medium were exposed, especially in relation to education, politics and the masses.

The creators of the Crystal Palace realised, apparently without planning or forethought, the potency of exhibitions as mass-educators. Commentators at the time were struck by the seriousness with which the artisan classes treated the exhibits. Henry Mayhew wrote:

. . . every other man you rub against is habited in a corduroy jacket, or a blouse, or leathern gaiters; and around every object more wonderful than the rest, the people press, two and three deep, with their heads stretched out, watching intently the operations of the moving mechanism. You see the farmers . . . with their mouths wide agape, leaning over the bars to see the self-acting mills at work . . . But the chief centres of curiosity are the power-looms, and in front of these are gathered small groups of artisans, and labourers . . . all eagerly listening to the attendant as he explains the operations . . . The fact is, the Great Exhibition is to them more of a school than a show.[1]

This apparently contrasted with the disdain with which much of the gentry treated the objects on display, the size of the show encouraging boredom rather than excitement: 'what was a matter of tedium, and ultimately became a mere lounge for gentlefolks, is used as a place of instruction by the people'.[2] The various methods used to explain the exhibits, including well-informed attendants, working machines with

operatives and explicatory bill-boards, appeared sufficient to hold the interest and enthusiasm of the crowds.

The Great South Kensington Exhibition of 1862 followed the pattern of its illustrious predecessor, this time education being much more part of the professed objectives, in tandem with commerce and industry: 'The public are benefited educationally, socially and morally by such displays; and that the manufacturers derive a direct profit from them is proved by the constantly increasing number of exhibitors.'[3] Both in 1851 and 1862, ethical and commercial concerns were not in any sense seen as contradictory or exclusive. For a nation enjoying massive wealth accrued almost entirely through trade, the material aspects of life seemed absolutely consistent with more abstract ones. Commerce did not conflict with morality, nor with educational goals, nor, even, with religion. The exhibition showed, 'from about the commencement of the second half of the nineteenth century, the progress civilisation is making over the globe; and every educational phase in which this appears – religious, social and mental – declares the dependence of the creature upon the Creator'.[4] Thus these first two exhibitions appeared seamless, without contradiction or inconsistency, for a general public able to harmonise every aspect of its material, intellectual and theological life. They established an educational pattern which strikes us even today by the ease of its success. The objects were displayed, people explained and worked them, the masses thronged to listen. To a considerable degree the social and historical context guaranteed success. These were massive, virtually unprecedented displays, in buildings specifically designed to take the breath away with their size and opulence. The stunned and intimidated crowds which strolled around the South Kensington Exhibition of 1862 gazed in awe at sights which they had never encountered before in the whole of their meagre lives. The first international exhibitions had the advantage of novelty and unlimited resources, the need for educational philosophy being slight inside buildings appearing as Aladdin's Caves to the crowds.

The forty years running up to the First World War were the golden age of the genre throughout the world. Compared to the three Paris shows held in the last quarter of the nineteenth century, British exhibition activity was modest, but it would be a mistake to assume that exhibition fever had dissipated after the Crystal Palace. The Great Exhibition of 1851 boasts a far greater literature than all the exhibitions held between 1870 and 1914 added together, but to read historical significance into this would be an error, for in a very real sense the period was the heyday of large temporary exhibition sites in Britain. The secondary literature normally presents the

Crystal Palace as the most successful exhibition ever held; many sources suggest that there were no exhibitions of note after 1862. This is not just a reflectior of the poor state of British art and design history; it is also indicative of the reluctance of scholars to work on events that overtly combined pleasure facilities into their make-up and which were held away from the usual centres of excellence, at places like Earls Court or Shepherds Bush. Of the endless monographs on British art and design in the first decade of this century, almost none mentions the single most important cultural event of the period, the Franco–British Exhibition of 1908. Its obscurity as an historical event is due, more than anything else, to the mass popularity it had at the time and the strategies its organisers used to make it popular. The same could be said of many other exhibitions. Class-consciousness in art and design history renders certain modes of practice inappropriate for study. Anything pertaining to popular entertainment is unlikely even now to receive attention from these disciplines.

Around thirty major events were held in temporary facilities, over half of them boasting greater attendances than the Great Exhibition of 1851 and all of them enjoying larger sites. The most important events were as follows:

1871 International Exhibition, South Kensington
1872 International Exhibition, South Kensington
1873 International Exhibition, South Kensington
1874 International Exhibition, South Kensington
1883 International Fisheries Exhibition, South Kensington
1884 International Health Exhibition, South Kensington
1885 International Inventions Exhibition, South Kensington
1886 Indian and Colonial Exhibition, South Kensington
1887 American Exhibition, Earls Court
1888 Italian Exhibition, Earls Court
 Liverpool International Exhibition
 Glasgow International Exhibition, Kelvingrove Park
1889 French Exhibition, Earls Court
1890 German Exhibition, Earls Court
1895 India, A Grand Historical Spectacle, Earls Court Olympia
 Empire of India, Crystal Palace, Sydenham
1896 India, Ceylon, Borneo and Burma Show, Earls Court Olympia
1897 Dublin International Exhibition
1899 Greater Britain Exhibition, Earls Court Olympia
1901 Glasgow International Exhibition, Kelvingrove Park
1904 Bradford Exhibition
1907 Dublin International Exhibition
1908 Edinburgh National Scottish Exhibition
 Franco–British Exhibition, White City

1909 Imperial International Exhibition, White City
1910 Japan–British Exhibition, White City
1911 Glasgow International Exhibition, Kelvingrove Park
 Festival of Empire, Crystal Palace, Sydenham
 Coronation Exhibition, White City
1912 Latin–British Exhibition, White City
1914 Anglo–American Exhibition, White City

Each exhibition commanded audiences of at least two million; the largest two, the Franco–British and the Glasgow International of 1901, admitted around 10.5 and 11.5 million respectively. All had the salient features of Great Exhibitions: a sprawling site, at least a third of the space given up to foreign products, a wide range of categories of produce (even at the specialist South Kensington exhibitions of 1883–6) and very vocal government participation. Eleven of the exhibitions can be treated as major events of the first order; these were the South Kensington shows of 1871 and 1874, the 1886 Indian and Colonial, the Italian Exhibition 1888, Glasgow 1888, the French Exhibition 1890, Glasgow 1901, the Franco–British 1908, Imperial International 1909, the Japan–British 1910 and Glasgow 1911.[5] Whilst the other exhibitions were popular and in the main successful, they tended to slide into parochialism in relation to these eleven and to comparable ones on the Continent.

The two most distinguishing features of British activity during this period were the firm establishment of an exhibition tradition in Glasgow,[6] and the curious preference for London events to be held in series on the same site. That is to say, in four instances, semi-permanent facilities were built, which were reused at least four times in immediately succeeding years. Thus, the South Kensington site was kept intact after 1871 to house the exhibitions of 1872–4, new facilities were built and maintained between 1883–6, after which the plans for permanent museums on the site were brought to fruition.[7] The Earls Court complex was built in 1887, and was used for the American, Italian, French and German extravaganzas, afterwards evolving into the permanent show centre it is today. At Shepherds Bush, the White City was opened in 1908 for the Franco–British Exhibition. This most impressive of venues contained events up until the First World War and, until recently, the White City Stadium stood as the only remaining feature of it. The serial exhibition phenomenon occurred nowhere outside of London; inside Britain it clearly had an effect on the structure and policies of the museums and galleries it anticipated.

The remarkable achievement of the South Kensington series of 1871–4

was the sustained quality throughout; a wide range of international participants over the four years also contributed to keeping the audience size consistent. Only the fine-art sections began to look tired after the first two exhibitions, due mainly to the increasing reluctance of owners to loan paintings. All four events, apart from having the usual spread of exhibits within the conventionalised sections, also had two or three specialist themes each year, to take up new issues in culture and technology. After 1874 this emphasis became far more important, as the serial exhibitions moved firmly towards specialisation. At the exhibitions held between 1883 and 1886, buildings were constructed to hold events with specific themes. In 1883 came the Fisheries Exhibition, in 1884 the theme was Health, in 1885 Inventions and, in 1886, India and the Colonies. These themes would normally have been more appropriate to a trade fair than an international exhibition, but the profile was kept up by having sections on the fine and decorative arts as they related to the theme.

As a whole, these exhibitions collectively revealed a shift in thinking amongst their organisers, away from the idea of public education and towards the enhancement of the professions. Equally, the exclusive emphasis on commercial, industrial and imperial subjects showed a decisive step away from the notion of the exhibition as a mass event and towards that of specialist educator and informant. The British public had temporarily been downgraded as a priority in an attempt to use the medium to heighten awareness of management and skilled workers. It is difficult to gauge the effect of these exhibitions upon the areas of practice to which they addressed themselves, but as shows in the widest sense, only the Indian and Colonial of 1886 lingered in the popular imagination. At that point in time, with Germany and Italy newly united, American industry growing day by day, and the scramble for Africa well under way, Britain wished to use its exhibition tradition to explore new possibilities for the development of its economy. Needless to say, with the exception of the Indian and Colonial, attendances at the 1883–6 series were low compared with all other events of the period.

Specialisation took a different turn in 1887, when the organisers of the new Earls Court complex determined to have an exhibition containing every conceivable type of produce, but from one nation only. At this series of exhibitions, the size of the attendance was seen as critical to the success of the event. The American (1887), Italian (1888), French (1890) and German (1891) exhibitions were unique in this regard. Each event had the normal range of categories for an international exhibition,

18. VENEZIA - Molo dal Rio della Paglia.

'Reconstruction of Venice', Italian Exhibition, Earls Court, London, 1888;
contemporary postcard.

six in all, including Agriculture, Mining and Metallurgy, Machinery, Manufactures, Education and Science, and Fine Arts. Each had extensive committee structures, juries, prizes, and thousands of private and public exhibitors. The site was conceived of by John Robinson Whitley, a successful businessman-turned-philanthropist, who wished to promote international understanding by bringing the culture of other great nations to London. Whilst the Earls Court exhibitions were riddled with commercialism, political propaganda and generally sharp trading, they can be marked out as the last of the Great Exhibitions held anywhere in the world boasting paternal philanthropy as the main driving force.

The Earls Court site was strategically chosen by Whitley and his advisors. At West Kensington, it stood to benefit from the pedigree of Kensington as an exhibition centre, without having to pay the high rents South Kensington had now begun to command. Philanthropy aside, Whitley's main motive was profit, allied closely to personal prestige. The site he purchased, to do him credit, needed extensive development before it could conceivably hope to be used: 'I may briefly state that four months before the great exhibition opened, the site at Earls Court and West Brompton was a cabbage garden. We had more than 2,000 men in two gangs – one set working by day, and one by night. I was a navvy, clerk, host, and cicerone

[*From a photograph by the* LONDON STEREOSCOPIC CO., LTD.

THE "WILD EAST" (ARENA).
(FRENCH EXHIBITION.)

The 'Wild East Arena', French Exhibition, Earls Court, 1890;
from *Four National Exhibitions* by Charles Lowe (London 1892).

by turns, and occasionally found myself fast asleep, from sheer fatigue, as I stood.'[8] His aim was to fuse elements of high cultural standing, such as the fine and decorative arts, educational displays of science and technology, anthropology and geography, with trade fair stands and an amusement park. His models were international exhibitions he had seen in Europe and America, especially those at Vienna (1873), Paris (1878) and Philadelphia (1876). His decision to have only a single foreign nation, with virtually no British artefacts, was probably provoked by two factors. The first is the most obvious: expense. Foreign nations were great crowd-pullers at exhibitions, but to deal with more than one at a time was a costly administrative nightmare. The second factor relates to British participation. Had he, as an expatriate Englishman (much of his life had been spent in America), attempted to organise a substantial display of British goods in London, in the form of an international exhibition, he would have had to contend with interference from the British Government. Most certainly he chose to avoid that. To have one nation only was a pragmatic compromise, but in the event it proved very successful.

Whitley, without realising it, provided the model for the last internationally significant exhibition site in England. The Franco–British Exhibition of 1908 was the first of five held in the White City facilities in the years running up to the First World War. In all its dimensions it rated

well in the context of the tradition as a whole, covering a 140-acre site and boasting modern train and bus services to connect it to Central London. It was a spectacular affair, with opulent pavilions in a mixture of styles, an artificial lake and endless entertainment facilities. Restaurants, fair-ground rides, sideshows, theatres, shops and a huge sports stadium were interspersed amongst the fine- and decorative-arts buildings, the science and technology halls and the administration blocks. Miniature trains and boats carried people around the site, and the superb gardens echoed to the sounds of orchestras and brass bands playing in the numerous bandstands. Art and science gave the whole a sound pedigree. The Palace of Fine Art in particular attracted comment for four superb displays, of French Art 1200–1800, Modern French Art, British Art 1300–1800 and Modern British Art. Imre Kiralfy, the entrepreneur who conceived of and then constructed the site, had spent his formative years as an exhibition organiser at Earls Court and had learned important lessons from John Whitley. He had also visited some of the best foreign expositions ever to be held, such as the Chicago Columbian (1893) and Paris (1900). His site at the White City owed little to anything that had occurred in Britain prior to Earls Court; more than any other exhibition so far held in England, it had the atmosphere of the Parisian Exposition Universelles and American World's Fairs.

Through the period certain ideological structures make themselves appa-rent in the creation of the English sites. By far the most important of these is the dichotomy of education and entertainment. Resolutely and consis-tently, education and entertainment were understood to be not the same thing. The one was inextricably bound up with work, the other with pleasure. By the time of the first serial exhibition at South Kensington in 1871, the novelty of exhibitions was just beginning to wear off in England. No longer was the audience passively amazed by whatever the organisers produced. Commentators, more self-conscious than ever of the educational mission of exhibitions, were noticeably disturbed by evidence that the masses were taking hold of the occasions and transforming them into holidays: 'It must always be remembered that the main object of this series of Exhibitions is not the bringing together of great masses of works, and the attraction of great holiday-making crowds, but the instruction of the public in art, science and manufacture, by collections of selected specimens.'[9] Well-meaning though this writer was, he was mistaken. The public was well on its way to appropriating the medium for its enjoyment, not for intellectual betterment. Thus the audiences for international exhibitions in Britain after 1862 often did not attend for the reasons the organisers

The Flip-flap and Spiral Railway, Franco–British Exhibition, 1908;
contemporary postcard.

COLLECTOR
FAIRGROUND THE WIGGLE WOGGLE
 Japan/British Exhibition, White City 1910 COLLECTORCARD C5114
 Croydon CR0 1HW

The Wiggle-woggle, Japan–British Exhibition, 1910;
contemporary postcard.

intended, and a rift opened up between producers and consumers as to
what the rôle of the exhibition was. Predictably, when the organisers of
the 1883–6 series opted for specialisation, the crowds at South Ken-
sington fell away. When entertainments were finally incorporated into
site facilities by 1887, they were understood to be an expedient to get
people on to the site, and therefore as something alien to the main
purpose of the event.

By 1900 an awkward balance between entertainment and higher cul-
ture had more or less institutionalised itself into the fabric of English
exhibition policy. Few would visit an exhibition unless entertainment
was offered, and yet education had to be a prominent element if the
event were to receive official patronage and achieve the necessary cultural
standing. The Duke of Argyll, in his inaugural speech at the Imperial
International Exhibition (White City, 1909), observed that 'the citizens
have known how to make these grounds into a peaceful holiday place
where every man, woman and child has found amusement without excess
and knowledge without fatigue'.[10] So the pattern was set: entertainment
without lewdness, information without struggle. At the same exhibition
a reporter from *The Times* noted that many of the educational displays
were not ready for the opening, but that all of the entertainments were
open and running: 'The instructive part of the exhibition appears to be
in rather an embryo condition. But Mr Kiralfy (Director-General) knows

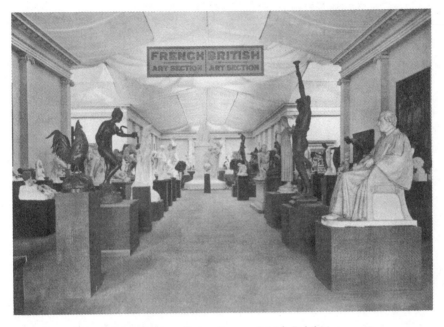

One of the sculpture galleries, Franco–British Exhibition, 1908.

his public. And his public prefer Bi-planes, and Water-whirls, and Witching-waves, and Wiggle-woggles, and Flip-flaps, to all the instruction in the world'.[11] There was no ambivalence on Edwardian exhibition sites; in some areas one enjoyed oneself, in others one received 'instruction'. The entertainment facilities attracted the crowds and subsidised more culturally acceptable areas – including the fine arts – which in turn lent seriousness and status to the exhibitions. So, what had been an ambivalent and then negative attitude towards entertainment at English exhibitions up to 1886, became a naturalised feature of them by 1908. Basic attitudes towards it, however, had not changed. One can constantly detect a certain shame and embarrassment overcoming organisers in this respect; almost all the official literature to come out of the exhibitions after 1886 fails to mention the entertainment facilities which occupied a large proportion of the site. The 'Wiggle-woggle', 'Flip-flap' and 'Witching-waves' might be vital moneyspinners, but for decency's sake they had to be consigned to historical oblivion.

There was clearly a class hierarchy affecting the construction of the sites, the way they were apparently used and certainly the way they were later recorded by historians. Practices were codified and allocated status not in terms of intrinsic merit or popularity, but through their social

standing. So much is predictable and the same prejudices are ever-present in the major institutions for education and display today. Class was not the only element at work, however, with regard to the fulfilment and denial of pleasure at exhibitions. The separation of education from entertainment in Britain was emblematic of the divide between work and pleasure and as such it had been a seminal issue for moralists throughout the nineteenth century. It was clear by 1900 that the higher arts were perceived by the middle-classes as a kind of cultural duty – a form of work which was necessary to maintain status – and that art of any kind was barely perceived at all by the working-classes. Therefore, not only was the relation between education and pleasure problematic, but also the boundaries of what properly constituted pleasure. John Stuart Mill, the greatest of the utilitarians, had agonised endlessly over the relation between what he termed the higher and lower pleasures.[12] The higher pleasures represented the arts, humanities and all areas of human endeavour; the lower pleasures were associated with the base functions, including sexual activity. It was Mill's contention that those who were in the knowledge of both high and low pleasures would naturally always choose to indulge in the high. For him, the reason the majority did not opt for higher kinds of pleasure was because they had been denied experience of it, and so were alienated from it. Education, he believed, would give them this experience.

Mill's perception of education and of the higher pleasures related far more easily to the idea of work than it did to that of leisure. Continuing the moral tradition exemplified and fired by Thomas Carlyle, he positioned work at the core of consciousness, finding it impossible to conceive of life as worthwhile in the absence of structured struggle towards known targets. John Ruskin equally espoused the ideology of work, seeing in it the only real chance of joy for the majority, and after him William Morris centred his theory of social transformation on the radical restructuring of work, as opposed to any other mode of activity. Important for him was the need to overcome the divide between work and pleasure, in order that the one could become the other. Thus an English ethical tradition grew alongside, and informed British attitudes towards, the displaying of cultural produce in the second half of the nineteenth century. This tradition saw work as the central, if not the sole, means of achieving ultimate satisfaction in this life; for Carlyle the work might be heinous, for Morris it should be elevating, but for both it had unmistakably to be work. This attitude was the single most potent one within British culture throughout the latter half of the nineteenth century

operating ideologically both on the right and on the left, informing socialists just as much as the worshippers of high capital.

The concept of work, by 1851, had gone well beyond its immediate economic definition and had infiltrated into the humanities. Work appeared, by implication at least, in most forms of human activity. It meant puritanism and moral suffering, sacrifice in anticipation of an ultimate joy, common sense and respectability. Most of all it meant an emphasis upon production rather than on consumption. Cultural activity signified knowledge, knowledge signified education, education signified work. In effect, work was at the basis of everything worthwhile; it was the route to God. The effects of this upon the organisation of international exhibitions were two-fold. First, everything displayed had to suggest, however obliquely, that the audience would benefit in some way from seeing it, and secondly, it inculcated in the audience the idea that they should attend the exhibition at least in part to study. The actual presentation could not be conceived of in the absence of work, and so intellectual and moral improvement facilitating work had to be constantly considered. The projected purpose, for example, of a gallery of steam engines at the South Kensington Exhibition of 1862, or one full of paintings, was to improve the ability of the audience to live their lives along lines which put work at the highest premium. Everything was there to elevate or inform, practically and ethically. Display items, or at least those over which the organisers had some control, had to read as icons of a better mode of existence; naturally, life was superior when led through the execution of purposeful endeavour. Thus, in 1862, the organisers at South Kensington carefully excluded those items which hinted at amusement or frivolity.

Anything which stirs the public mind to the same extent as the present exhibition is sure to produce a host of eccentric proposals, some of them verging on the confines of madness, others displaying, through all their extravagance, a certain calculating selfishness. The first exhibition had a great forcing power in the bringing forth of these curious proposals and suggestions, but the second exhibition has had a greater.[13]

Excluded from the exhibition were such things as a comprehensive display of coffins, the oldest loaf in the world, a man-powered flying machine (the proposer wished to fly around in it inside the building) and the remains of Julia Pastrana, half-woman, half-baboon. As often as not, the exclusion came not on any grounds other than the fact that the rejected items resembled popular entertainment rather than objects of a higher culture. Many of the objects actually exhibited such as electronic

leeching machines and top-hat ventilators, were no more sane, but they did not have the connotations of entertainment. Perverse as it may seem, major grounds for exclusion of objects from the exhibition appear to have been that they would offer disinterested pleasure to their audience.

After 1886, when leisure came into consideration in the planning of English exhibitions, some areas of the sites nevertheless remained quite impervious to the idea that they might be there in order for the public to take pleasure in them. The surprisingly low attendances in the fine-art areas of most exhibitions are interesting in this regard. Even though the figures compared well with art exhibitions that were not part of an international show, the fine arts normally fared poorly compared with the rest of the decorative arts and the machine halls at the exhibitions in which they were included. Obviously the pleasure facilities commanded most attention. Indeed, the fine-art sections were the most ambivalent on exhibition sites in Britain, mainly because the ideology of work contained within them ran counter to the core motives behind fine-art practice. There was no space for unbridled hedonism, for the open expression of pleasure on the part of the audience. The tone and atmosphere of the fine-art sections remained at a constant dryness throughout the nineteenth century, due to the influence of Ruskin and the Pre-Raphaelites on the one hand, with their moral haughtiness, and to the Royal Academy on the other, with its self-conscious imperialism. The mode of display enhanced the mood of the selected works, as row upon row of double-hung images, labelled and framed in careful uniformity, attempted to elevate the visitor with their anecdotal virtue. At the same time, of course, these rows contradicted what many then considered – and still do consider – the actual rôle of painting to be, which is intimately bound up with the expression of human joy, love, dignity and tragedy. The potential for aesthetic consumption was sacrificed to fulfil maxims of the Victorian schoolroom.

When museums sprang up in large numbers in Britain between 1890 and 1920, basic attitudes as to their rôle had therefore already been determined. If they had a pleasurable dimension, it would nevertheless be defined in terms of work, however subliminally. Museums and galleries would advance and improve their audiences. This notion has largely remained at the philosophical core of museum outlook, despite the glaring inconsistencies it contains for our own age. Work on every level, from the most abstract idea as to the meaning of existence, through to the number of real jobs available to the eligible population, has changed beyond recognition. The idea of work as a key to purity, once believed

emphatically, is no longer felt to hold any a priori truth.

The French exhibition tradition unfolded alongside the English in the second half of the nineteenth century, providing us now with interesting comparative material. In fact, the French had held large national exhibitions since 1797, but only determined to make them international, with a complete range of produce, after the Crystal Palace Exhibition of 1851. From 1855, when the first Exposition Universelle was held, some such event was staged in Paris roughly every eleven years.

The Exposition of 1867 was the one which in various respects set the pattern for all the others, especially in the realm of mass education. The event was heavily under the sway of the Saint-Simonians, the most prominent of these being Raymond Le Play, one of the key figures in the whole tradition. It was by him that the idea of the *Encyclopédie* was first applied to the exhibition medium in earnest, his Exposition aiming to be a stocktaking of civilisation, a physical realisation of all previous knowledge. The site was organised so that the visitor could move logically through all the categories of produce from all nations with the minimum of confusion. More than anyone, Le Play, with his fellow organisers and allies, Jules Simon and Michel Chevalier, made educational idealism into a permanent ingredient of the Expositions Universelles: 'The very poorest student in the poorest school, the most incapable, the most ignorant, the least gifted is, after all, a man, and since he is a man, he has the capacity to recognise the truth and live by it.'[14] The 'History of Human Labour' section at the Exposition exemplified his aims, being a complete survey of the work of all nations throughout time. Believing in the possibility of a total view of any given subject, Le Play set the ambitions of the Expositions so high that few outside Paris were ever able to match them.

The last quarter of the nineteenth century witnessed a dramatic evolution. The Paris Expositions Universelles of 1878, 1889 and 1900 dwarfed everything which happened on the other side of the Channel. The ground that had been prepared in Paris in 1855 and 1867 had come to extraordinary fruition. These three Expositions have often been seen as the most splendid in the whole genre and, indeed, it is difficult to deny their claim to being the greatest exhibitions of any kind ever held.

The Exposition Universelle of 1878 saw the building of the Palais de Trocadéro and the laying of ornate gardens and fountains in front of it on the Chaillot Hill. Socially and politically, however, it was a reactionary affair, due mainly to the shift to the right brought about by the Franco–

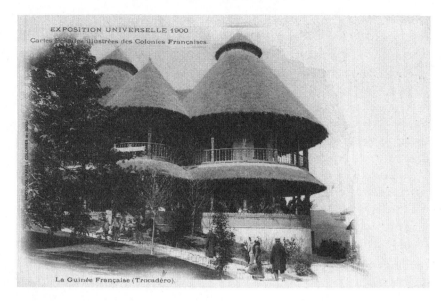

French New Guinea Pavilion, Exposition Universelle, 1900.'

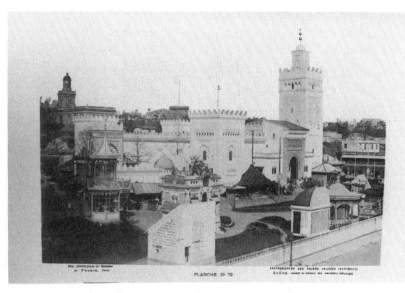

Algerian Bazaar and the Rue de Caire, Exposition Universelle, 1878;
from L'Album de L'Exposition de 1878 (Paris, 1878).

Prussian War and the Commune. Nevertheless, the idea of the *Ency-clopédie* remained, applied to ever more lavish constructions. The first ever 'Rue des Nations' was invented, where every participating nation went to enormous care and expense to construct a building characteristic of its culture. An Algerian village and bazaar were built, and a 'Rue de Caire'. In the main part of the new Palais de Trocadéro an extensive exhibition of the history of the Gauls, complete with exact reconstructions of tombs, explained to Frenchmen their ethnic origins. These features were all in addition to the dozens of pavilions dedicated to the arts and sciences. More than anything, the Exposition of 1878 finally established the idea that reconstructions and working displays were the natural way to educate. If it was considered needful to tell the public about Ancient Gaul, Egypt, steam pumps, Louis XIV, tropical diseases or chair design, then the best way to do so was by creating the exact environment in which those things occurred and letting the audience watch them happen.

In 1889, at the following Exposition Universelle, the most striking educational feature was the 'History of Human Habitation', a long street of exact reproduction houses intended to convey, as one walked along, the history of the house in all nations throughout time. There were thirty-nine houses, all designed by Charles Garnier, architect of the Paris Opéra. These included the Troglodytes, the Age of the Reindeer and Irish Elk, Stone Age, Polished Stone, Lake Dwellers, Bronze Age, Iron Age, Egyptian, Assyrian, Phoenician, Hebrew, Pelagian, Etruscan, Hindu, Persian, Germanic Races, Gauls, Greeks, Roman-Italian, Huns, Gallo-Roman, Scandinavian, Charlemagne, Medieval, Renaissance, Byzantine, Slav, Russian, Arabic, Turkish, Swedish, Japanese, Chinese, Lapp, Eskimo, African Savage, Redskin and Aztec.[15] The Rue des Nations, Algerian Palace and Rue de Caire reappeared, in addition to dozens of palaces dedicated to the various colonies of the European powers, with tribes of primitive peoples actually living in authentic dwellings on the site. Again, these features were in addition to the arts and sciences. The entire site was concerned with spectacle, with the creating of an illusion that the whole world was indeed present. Even a subject as apparently dry as engineering science was transformed into dynamic display, in the form of the Eiffel Tower and the Galéries des Machines.

The picture at the 1900 Paris Exposition was very similar; in addition to those features present in 1889, several new displays were created. 'Old Paris', a reconstruction of the entire medieval city centre, complete with hundreds of people in authentic costume 'living in', was the major

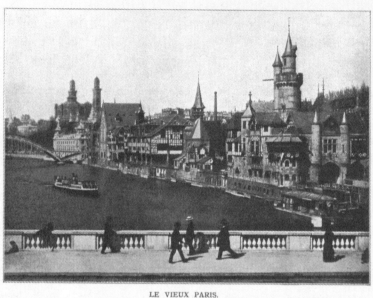

LE VIEUX PARIS.
(Reproduction autorisée par L. BASCHET, Éditeur, concessionnaire).

'Le Vieux Paris', Exposition Universelle, 1900; from
L'Album Photographique d'Exposition 1900 (Paris, 1900).

attraction. A 'Celestial Globe' was built to one side of the Eiffel Tower; this was an enormous planet-like structure which contained various exhibitions, including some kind of early planetarium. An electrically powered moving pavement carried people around a site which had become too large to traverse on foot. The whole of the city was involved in the Exposition, which sprawled over hundreds of acres of prime site: an entire urban centre temporarily transformed into a museum, with its population functioning as a proud but unpaid staff.

The French attitude towards exhibiting was most noticeably different to that of the English with regard to the function of pleasure, especially in its relation to education. The duality of education and entertainment was far less evident in, and even absent from, much of France's exhibition tradition. The pioneering work of Le Play in 1867 instilled into succeeding events the notion that the divide was neither necessary nor desirable. Due on the one hand to his Saint-Simonianism, and on the other to Napoleon III's deep desire to woo the masses, the Expositions Universelles were given an injection of egalitarianism which they never shook

off. It was understood by 1878 that success in the widest sense demanded the creation of facilities that the crowds could take pleasure in. All other motives, including educational ones, became integrated into this initial premise and carried some of its verve. Ultimately, the overriding feeling of the French Expositions was of festival, and a rather earthy, raucous one at that. In this they differed from even the most popular of British events. G. A. Sala's descriptions of the 1867 Exposition reveal the relaxed hedonism of a site basking in confident enjoyment. The Exposition was for him, more than anything else, a grand revelry:

> . . . we dined merrily, and I came back to the Exposition grounds with content-ment in my heart and a cold in my head. By this time the cafés and restaurants in the outer zone had all concluded operations. Where were the crowds of eaters and drinkers of all nations who have lingered in these places of entertainment until the closing hour – ten o'clock? They were all gone, and in the empty cafés great piles of chairs turned on end looked like sepulchral monuments raised to the buried hopes of French, Italian and Spanish proprietors who, with rueful countenances, stood at the doors jingling keys in their pockets instead of halfpence . . .[16]

The Expositions were fêted for their entertainment value, their exuber-ance and their naughtiness. An English guide to the Exposition of 1900 highlighted these aspects of both the exhibition and the city itself:

> It suggests sparkle, colour, sun-burnt mirth, and spiritual intoxication as volatile as ether. Beautiful, artistic and Bohemian Paris! Who would not go that had the chance? Bright, light-hearted, merry Paris! The prospect of treading its mercurial pavement sends a subtle spirit of rapture tingling through the veins. Luxurious, wanton, and – aye, alas! wicked Paris! Still, the British are a brave people – we go.[17]

Such lines could hardly have been written about any of the British exhibitions held during the course of the nineteenth century, and few in the twentieth. Despite the open acceptance of the supreme importance of the Exposition for all those interested in high culture, the overwhelm-ing anticipation of both writers quoted above is of sensuous gratification, of enjoyment, as opposed to self-improvement; the fact that both assumed this lends an air of impropriety to their comments, hinting at something wrongfully seductive about Paris and its Expositions Universelles. They were torn between divergent attitudes towards the consumption of cul-tural artefacts. As typical London figures of cultural repute, they could not quite dissociate pleasure from sin or learning from culture. Underly-ing their obvious joy in Paris as a metropolis there was an implied condemnation of its hedonism, for, ultimately, few British intellectuals

in 1900 could reconcile what they perceived to be pleasure and what they believed to be high culture. This is still the case today.

If hedonism constituted a parting of the ways for the two nations, there was one thing they had in common, and this was the willingness openly to present and integrate political themes into displays. Every international exhibition in France and Britain had a political driving force behind it, giving it direction and meaning. At most British exhibitions held after 1886, one theme dominated all others: Empire. Second to this, but closely related to it, was the celebration of high capital, as enhanced by machine technology. The European Expositions and American World's Fairs reflected the same themes. The organisers did not hide their interests, no one was ashamed of the imperial idea, millions celebrated it with gusto and panache, using the exhibition site to bathe in the glory of conquest. In order to facilitate this, the site provided the most important element: spectacle. Massive buildings, gardens, towers, arches, all dramatically lit up at night; every type of modern technological wonder, in vast quantities; foreign peoples, present either as visitors or exhibits; the largest possible fine- and decorative-art shows; machine halls and colonial pavilions; an endless acreage of restaurants and cafés. The dominant political idea would appear in most of the features in one form or another. It motivated the scale, and the scale seemed to imply that the political message was true. The two were interdependent, and between them they guaranteed the success of the event. Obviously this is not to make any kind of positive comment on the morality of the ideas expressed – before 1914 these were often repulsively arrogant, aggressive, greedridden and racist; it is simply to assert that the medium had a definite social intrusiveness because of its open commitment to political ideals. After 1889, privately funded pavilions often enriched the rhetorical noise by striking up a note of opposition to the prevailing discourses. Thus it is not the meaning or tone of the various dogmas which remain of interest – this was rather predictable – but the relevance of these to the public they harangued. The exhibition sites were important for people's lives; therein lay their success.

As visitors meandered around the site, they would be continually bombarded with arguments as to the function of the State and its various offshoot institutions, the buildings, art objects and entertainment structures gradually becoming fused in their minds with these messages. Perhaps this is the single greatest difference between the international exhibitions and contemporary English museums, where an atmosphere

of artificial neutrality is generated and maintained. Political objectivity, however it may be defined, is deemed appropriate partly to protect the objects on display from the harshness of the contemporary world, and partly to assuage those in Government who provide the funding. Neutral museums are, presumably, harmless. In populist terms, they are also tragically inadequate.

Quite apart from having the effect of dividing the museum off from the world, this striving towards objectivity has no philosophical platform, especially in relation to public cultural activity. Most curatorial staff are committed to the idea that the general public should feel better and more knowledgeable about the world after visiting the museum than it did before. But a statement even as broad as this one implies the presence of a political position. Britons as a national community do not agree about what constitutes knowledge, or what makes people feel better about the world. Thus the curator is forced either to make a guess at the ideological status quo in any one situation, or simply to present his or her own world-view through the exhibition medium, under the pretence of objectivity. If the museum stands any chance of ever winning a large audience and conveying a coherent message once it has achieved its goal, curators must recognise that political neutrality is a fiction, and that open political discourse should take place at every level of cultural activity. That is to say, museums are an intensely political phenomenon and we should acknowledge this fact with panache and honesty. To make claims to objectivity in the socio-political arena is to fly in the face of all the evidence.

In museological terms, however, political honesty is not the only issue at stake; honesty in itself does not make for interesting exhibitions. Rather it is a question of the energy which might be generated if organisers and curators believed unreservedly in a cause. The amazing success of the international exhibitions was largely due to their overt commitment to, and presentation of, a political stance all over the site. Everywhere the political climate and disposition of the day rang through. This in turn generated debate and led to an intellectual vitality capable of reaching out to the general public. The difference between the Franco–British Exhibition of 1908 and the Victoria and Albert Museum of 1989 is the same as that between a sporting event where a trophy is at stake and one where there is not. Regardless of the skills displayed, the calibre of participants, or any other factor, an event having overt energy of purpose will always be more interesting than one which is lacking in it. This is the real key to the popular triumph of the international exhibitions: not

only were they not neutral, but their organisers had little idea of what neutrality meant. Domestic and foreign policies were presented, the audience was wooed, propagandised and shocked by the exhibits. Foreign nations came, ostensibly in the spirit of friendship, but normally in bitter and envious rivalry. Because of this, the exhibitions mattered in ways which went well beyond the sum of the objects they presented. Commercial companies, who were in effect outside the control of government organisations, clamoured to take part because of the custom these audience figures generated. The more worldly the exhibitions, the more successful they were; thus Earls Court and the White City received better press notices and higher attendances, with less official patronage, than the majority of the South Kensington Exhibitions held between 1871 and 1886. It would also be a mistake to assume that they were more successful merely on a popular level. The displays they put on of fine and decorative art, science and technology deservedly received great critical attention.

In short, the international exhibitions recognised the socio-political climate of their time and they responded to it. Indeed, they existed because of it. This placed them at the centre of the populations they served. More than anything else, the exhibitions up until 1914 bristled with a sense of purpose, with a knowledge as to why they had been created.

Unlike the English, the French have kept political ideology alive and vibrant in their museums. To compare the Centre Georges Pompidou, the Musée d'Orsay, the Halles de la Villette, the Musée des Arts Populaires and the redevelopment of the Louvre to their English equivalents is to realise the terrible gulf between the cultural policies of the two nations. The Centre Georges Pompidou, conceived and built amid a political storm, by a centralised government utterly committed to a particular cultural policy, is the natural successor to the Expositions Universelles. Iconic, outrageously popular, vibrant, loud, contemporary, it has taken over the rôle of the Eiffel Tower, the great icon of the Expositions, as the emblem of the city. Yet one is still able with comfort and ease to see in it some of the greatest masterpieces of twentieth-century art. The Musée d'Orsay takes up another aspect of the Exposition tradition in using monumentality to impress and woo. The crowds are mesmerised by the scale, the expense and the commitment to art and design. The exhibiting policy at the Musée d'Orsay was the centre of a political row between the Socialists and the Conservatives in a way which would never happen in England, where apparent neutrality prevents discussion.[18]

An atmosphere of excitement and of festival animates these institutions and engages us in debate as to their meaning and their effect upon the crowds.

Perhaps a single example will suffice to show the gulf which exists between France and Britain – or, more specifically, Paris and London. In 1980 a large retrospective exhibition of the work of Salvador Dali was held at the Centre Georges Pompidou, after which it travelled to the Tate Gallery.[19] In Paris, the opening was sensational. The museum staff had gone on strike for more pay and better conditions, but rather than boycott the private view, hundreds of them gathered on the fourth-floor balcony and showered Dali and his entourage with confetti, each piece inscribed '*grève*' (strike). Dali waved and roared with laughter, thousands chanted, both parties perceived the building and the occasion as appropriate for such action. Inside, a twenty-metre-long spoon was suspended in the air, with a Volkswagen in its ladle; adjacent was an Art-Nouveau Métro station. A mountain had been built inside the foyer, which one had to walk up to see some of the works. A cinema upstairs showed some of Dali's films, music played, the paintings and drawings were comprehensively displayed. One had to queue for hours every day to get in; the expenditure of the exhibition was recouped on the door-takings.

In London, on the other hand, there was no spoon, no mountain, no cinema, and little back-up information about the artist and his life. The pictures were neatly arranged in rows, in respectful austerity. Famous as Dali was, nobody had to queue to get in. The Parisians treated the exhibition as a festival; it was politicised, joyous, and, most important, distinctly surreal. The London show had pretensions to seriousness and learning, yet by deliberately moving away from the Parisian policy, it hermetically sealed Dali off from the world. It was as though there was a conscious attempt to reduce the pleasure one might take from an event allocated high cultural status, or at least this was the view taken by many of those who had experience of both shows. The London organisers actually denied their audience the chance to learn about Surrealism in the best possible way, that is, by experiencing a Surrealist environment. The French, it seems, had remembered the lessons of their Exposition tradition; the English had not. Worse still, the English had kept alive the subliminal obsession with work which had reduced the success of their own Great Exhibitions.

The international exhibitions by no means enjoyed unrelenting success in their cultural and social strivings, and as an exemplar they should be

used cautiously by today's museum curators. But they did show that it was possible to have popular and high culture in close proximity, and even that the one was capable of becoming the other. Equally they demonstrated that the vibrancy of the contemporary socio-political scene should not be shied away from if the exhibition medium is to have a full public rôle. On the negative side, the English tradition reveals a seam of paucity, emanating from the sad and pathological insistence on dividing pleasure from learning; at best they were conceived of as a pragmatic but unhappy duality. Most of all, the international exhibitions were loud, aggressive and tempestuous, defying the inherent passivity of the visitor. One shudders to think how impresario Imre Kiralfy would boost the attendance figures of major London institutions if he were alive today and in the executive, but one has little doubt that it would be vulgar, noisy and electrifyingly successful. There are dark sides to a career such as his which we should never ignore, but his egalitarianism remains a lesson to all of us.

6

On Living in a New Country

STEPHEN BANN

I am waiting for a bus in Perth, Western Australia, when a young man hands me a piece of paper. It is in the form of a letter ('To whom it may concern'), dated and signed, from a local address, and it carries at the top an indication of its subject matter: 'RESEARCHING HISTORY'. The letter has been carefully composed and typed out, and though it is handed to me by the person I presume to be its author, it evidently takes the place of any more direct possibility of communication. 'Dear Sir or Madam, I am writing this letter to you in respect to a request for infor- mation on my "Family Heritage". I have been researching my family of the 1800s in Bendigo, Victoria and Kalgoorlie, Western Australia since I commenced in January 1982.' There follows the brief tale of an Austra- lian family, from the patriarch, with six sons and six daughters, who 'lived four miles north of Eaglehawk, Bendigo, Victoria . . . between 1875–1890', to the time of the First World War. Three of the sons of the family journeyed to Western Australia to join the gold rush, one of them being killed in a mining accident, the other (the writer's grandfather) settling down as a self-taught electrician, and the third dying in faraway France during the First World War (this brother was 'renown for his wonderful singing and wherever he was, seemed to make people happy'). The letter ends:

I would appreciate any assistance from people who may be able to send on photocopies of information regarding the history of Victoria and Western Australia, between 1875–1930. I trust you may be able to help in my research to enable a book to be completed on my family history that I am endeavouring to have published.

This story, or rather this message (which I am transmitting, out of a sense of discretion, without the proper names), seems to demonstrate in its very fragility an aspect of historical memory which is curiously timeless – although, of course, the very techniques and modes of representation

through which it seeks to instantiate itself are themselves closely bound up with our own particular moment in history. My bus-stop interlocutor has been captivated by the model of academic historiography, of 're-search'. He has learned the lesson that research is carried out with the aid of contemporary technology, and wants 'photocopies of information'. He sees in the eventual publication of his research its final validation, although the difficulty of achieving that result is not minimised ('that I am endeavouring to have published'). Still, if we exclude these important elements which give a kind of social consistency to the project, it comes out in a particularly pure form: the memorialisation of the family, in the patriarchal mode certainly (no woman is mentioned by name), but leaving room for the expression of a brief idyll. The great-uncle who was killed in the First World War 'wherever he was, seemed to make people happy'.

In this essay, I want to approach the issue of museology by way of the slightly devious track that this message and this analysis seem to suggest. Much of my earlier work on museums and collections has con-centrated on the rhetorical analysis of these forms of representation, within a determinate historical context.[1] It takes for granted the cognitive status of rhetoric, and assumes that we can analyse the form of an institution like the Musée des Petits-Augustins or the Musée de Cluny as a fully achieved communication, in which particular configurations of objects affect the visiting public in highly specific ways, giving them concrete notions of 'the fourteenth century' or 'the age of François Ier'. But it is a confusion of ends and origins, I would suggest, to hold that the publicly registered achievement of such an institution is all that is needed to explain it. Du Sommerard did, indeed, offer the Parisian public of the July Monarchy a notably intense experience of a carefully com-posed milieu that they sensed as historical. But what was the imaginative and psychological Odyssey that led him to this end?

It is to answer a question of this type that I have been drawn to investigate what might be called fragmentary or incomplete expressions of the museological function. Now that notions like the 'museum without objects' are becoming fashionable – now that the dynamic aspects of museology are receiving more attention than the mere conservatorial and institutional aspects – it seems opportune to look more carefully at the complex mediations which exist in the individual's relationship to history, and the way in which these achieve or fail to achieve public expression.

A second example to place beside my Australian acquaintance comes

from the very forcing ground of the modern museum, in the turbulent times of the seventeenth century. John Bargrave, Canon of Canterbury Cathedral, was the creator of one of the most interesting (and luckily one of the best-preserved) of the 'cabinets of curiosities' that are generally held to be direct ancestors of the modern museum collections.[2] Yet John Bargrave was also the last representative of a family which had been established at the estate of Bifrons, in the parish of Patrixbourne, before the Civil War, and died out as a result of the conflict. He took care to commemorate this fact in a splendid inscription which can still be found in the south aisle of Patrixbourne Church, though parts of it are sufficiently worn away to make decipherment difficult:

Per totum hoc sacellum sparsa est generosa Bargraviana terra
cuius familiae armigerae Johannes Bifrontis conditor et haeres eius Robertus
sub hoc marmore una cum uxoribus iacent.
Bello civili [. . .] regiis stetit et cecedit familia
Amen lugens scripsit filius et frater Johan.
Eccles. Christi Cant. Praeb.

Through this whole vault is scattered the generous earth of the Bargraves, of which armigerous family John the founder of Bifrons and his heir Robert lie beneath this marble at one with their wives. In the Civil War the family stood for the Royal cause and died. Amen wrote in grief their son and brother John, Priest of the Church of Christ at Canterbury.

What is the relationship, if any, between the Bargrave of this inscription, and the Bargrave of the cabinet of curiosities? It would be a hazardous thing to try to push the point beyond conjecture. But it must surely be said that there is a kind of imaginative symmetry between the two enterprises. Bargrave the grieving son and brother inscribes for all to see the tragic curtailment of his armigerous family: he fixes, in the carved stone and in the diffuse yet wonderfully moving material metaphor of the 'generosa Bargraviana terra', the memory of a once flourishing stock of which he remains the chief representative. The elder John Bargrave was the 'founder' of Bifrons: he built a house and developed an estate in the expectation that his children and their descendants would live in it. His intentions have been cruelly frustrated, and the second John, from his vantage point in the great, abiding cathedral church at Canterbury, contemplates the ruin of his family. And what does he do? He sets up a cabinet of curiosities. Heterogeneous objects of all types – stones, rings, statuettes, 'the finger of a Frenchman' – are placed next to each other in the specially designed piece of furniture, each of them meticulously labelled. It is as if Bargrave were peopling again, in fantasy, the family

vault, but this time with the sure control that would guarantee him against loss: the family of objects endures, being symbolically engendered by the collector, and not subject to decay or accident.

How then does history impinge upon the memorialist and collector? The Civil War cannot but seem, in Bargrave's inscription, a brutal interruption in the course of family history, although it is in a sense appropriate that the Bargraves should have fought and died for the King (they are ethically qualified as 'generosa', and functionally qualified as 'armigerae'). In the Australian example, the First World War intrudes brutally, but also senselessly, into the life of the uncle with the 'wonderful singing voice': 'he was shot in the leg, being wounded so badly his leg had to be removed, but through lack of medical attention died soon after.' In both cases, there is a sense in which the family history can be seen as a kind of projection of the infantile omnipotence of the self, which has to reconcile its desire for infinite ramification with the reality principle of history, imposing either a tragic denouement (the end of the Bargraves), or a bitterly ironic reversal (the avoidable death of the Australian singer).

Neatly placed between my seventeenth-century and my contemporary example, I might cite the additional case of a creative figure of titanic achievement who also concretised his desire for a family history in an obsessional and repetitive way, though not precisely in the form of a collection. Victor Hugo used the medium of the ink sketch and the wash drawing (with further elaborate technical embellishments) to prefigure the site of his legendary family origins: the Burg of Hugo Tête d'Aigle in the Vosges.[3] Towards the end of his life, exiled in Guernsey, he managed to concretise the struggle between the would-be omnipotent ego and the countervailing forces of chaos through his use of castellate stencils and anarchic washes of dark ink, sedulously counterpoised. Here there is an apparent paradox. Hugo had no authentic medieval barons for ancestors. On the other hand, he had a perfectly good Napoleonic peerage from his father. To the dignity which was conferred after the revolutionary break of 1789, he clearly preferred the more nebulous dignity of medieval origins, no doubt because they could become the stake of a creative investment.

Up to this point, my examples have been taken from mediations of history which elude (though they may also in a certain sense precede) the institution of the museum. The Bargrave inscription is a pre-echo of the Bargrave collection. The Hugo study in stencils-and-wash perhaps secures an imaginative identity which is then asserted in the abundant medieval recreation of his plays, poems and novels (though it would be

foolish to look for any evidence of cause and effect). The Australian letter 'Researching History', written with a view to a publication that will almost certainly never materialise, achieves its slight, unpretentious effect through the way in which the individual's desire for a past is concretised around trans-individual motifs: the dominance of patriarchy, the regime of dates, the factor of geographical scattering (from Bendigo to Kalgoorlie) and the intrusion of a faraway war, offset by its tenuous idyll. Let us take these three examples, chosen as they are across a wide spectrum of time, as an index of possible stakes in the past, and now attempt to feed them back – as far as the axes which they establish will allow – into the experience of a range of types of museum, English and Australian. The question of a lived relationship to the past – the issue of family history, and that sterner history that scatters and obliterates the family – will be paramount. But of no less importance will be the specific theme that is raised by my title: 'On Living in a New Country' – how does the past function, and in what way is it represented, for example by museums, in a 'New Country'?

Before I can begin to answer this question, it is important to clarify one of its presuppositions. I take my title, of course, from Patrick Wright's admirable collection of essays, *On Living in an Old Country*.[4] But I have no intention of forcing this reference to support a banal binary system: England versus Australia, the Old World contrasted with the New. This is, in effect, what emerges in a rather crudely schematic form in the writings of the Australian sociologist Donald Horne, *The Lucky Country: Australia in the Sixties* (1964) and *The Great Museum: The Re-presentation of History* (1984). In the earlier study, which is a justly popular and penetrating analysis of Australian society in the post-war period, it is effectively argued that Australia has a blank where its historical consciousness might have been. 'Small nations usually have histories to sustain them or futures to enlighten. Australia seems to have lost both its sense of a past and its sense of a future.'[5] In the study which comes two decades later, Europe (East and West) is seen as being annexed by a rampant museology that converts us all into tourists:

Devotees of the cult are often to be seen in the great churches of Europe. You know them by the long, thin books they carry, bound in green or maroon . . . The books are *Michelin Guides*. The devotees are tourists. They are trying to imagine the past.

They are engaging in that area of the great public display of a modern industrial society, that has turned parts of Europe into a museum of authenticated remnants

of past cultures, resurrected so richly and professionally that the people of those days would probably not even recognise their own artefacts.[6]

The difficulty with this type of analysis is that it soon shades over from fine irony into patronising depreciation – and this is not avoided by the author's frequent assurances that he is a fully paid-up devotee of the cult, at least on his European sabbaticals. Let us just stop at one of these fine phrases: 'They are trying to imagine the past'. What is almost entirely excluded from *The Great Museum* is the question of *why* people should try to imagine the past, and indeed what 'imaginary' operations are necessitated by this complex cultural process. One of the underlying assumptions in Horne's study is that, at some stage in history – let us say before the Industrial Revolution – there was a broadly shared relationship to the past which did not have to negotiate the regime of representation so egregiously exploited by the tourist industry. But, as David Lowenthal has reminded us, a relationship to the past (what I have called 'historical-mindedness') is inevitably a constructed relationship.[7] When Alois Riegl decided to add 'age-value' to the other criteria for identifying and valuing historical objects – and when he asserted that the most simple peasant could detect such a quality – he was not implying that the perception of the signs of age was a natural human property, common to all ages and cultures. He was simply celebrating the conjunctural fact that a cultural value, nurtured by the soil of Romanticism, turned out to have a broad, democratic resonance.

Donald Horne's *The Great Museum* therefore tells us virtually nothing about the phenomena that he is describing, and this is fundamentally because there is no real attention given to what might be called the phenomenology of tourism – how it might be experienced from an individual *Lebenswelt*. By contrast, Patrick Wright treasures the individual case history – of a building like Mentmore, a resurrected object like the *Mary Rose*, or a person like Miss Savidge – and succeeds in reconstructing in each case a nexus of historical affiliations which is all the more striking for being so special. At the same time, he is keenly aware that these different forms of investment in history are themselves historically determined: the saga of Mentmore by the ideological confusions of the Callaghan Government, the epic of the *Mary Rose* by the values of the incipient Thatcher era, and the sad tale of Miss Savidge by the inflexibility of modern planning policies. This does not stop him from asking important questions about the general character of the contemporary use of the past, which inevitably arise out of the rich

particularity of his examples. For example, he considers at length in an Afterword the suggestion made by a French commentator, Philippe Hoyau, in his analysis of the 'Patrimony' policy of Giscard d'Estaing, that contemporary emphasis on the national past 'derives less from a will to preserve and value a "monumental" and academic past than from the promotion of new values articulated on a largely transformed conception of inheritance and tradition'.[8] As Patrick Wright sums up the argument, awareness of the past needs to pass through several different modes of enhancement – almost like a signal passing through an amplifier – in order to achieve a collective expression. '"The past" may still be an imaginary object, but it is now organised around three major models: the family, conviviality and the countryside.'

The question of the museum in the 'New Country' is therefore one that eludes simple binary categories: it is no more assimilable, in short, to the idea of an Australia that has lost 'its sense of a past' than it is to a Europe metamorphosed into 'The Great Museum'. It cannot afford to forego as its basic postulate the undeniable fact that individuals seek to obtain knowledge of the past, 'Researching History', like my bus-stop acquaintance, but that they do so through a matrix imposed by collective pressure: even such private and intimate concerns as 'family history', and indeed particularly those private and intimate concerns, can be thematically aggrandised to provide the content of the historical display.

This can be seen on several levels in the museums and other installations, many of them sponsored by the History Trust of South Australia, which exist in and around the city of Adelaide. Far from losing 'its sense of the past', South Australia seems to have conspicuously worked to mobilise it in the last decade or so, with a series of imaginative ventures culminating in the South Australian Maritime Museum, which opened in 1986 with the proud boast that it was 'Australia's newest and biggest'. The Maritime Museum is located close to the ocean, at Port Adelaide, and comprises a well-restored group of port buildings as well as the museum proper, installed in the Bond and Free Stores of 1854 and 1857. But the largest concentration of museum buildings is in the centre of the city of Adelaide, along North Terrace, where facilities like the Art Gallery and State Library are juxtaposed with 'social history museums' like the Migration and Settlement Museum, and historic sites like the Old Parliament Building.

Adelaide has, indeed, something approaching a museum quarter, and has resisted the tendency (visible in Perth, Melbourne, Brisbane and Sydney) to regroup cultural facilities on new sites at a certain distance

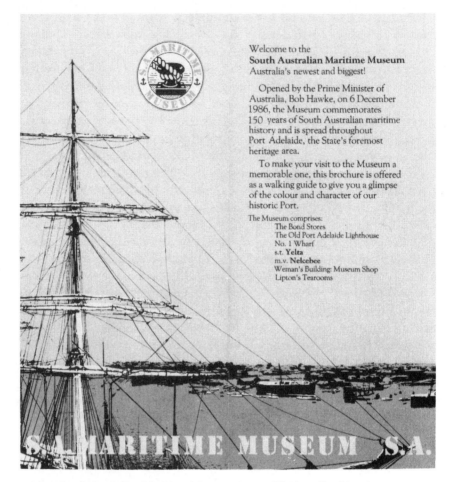

Welcome to the
South Australian Maritime Museum
Australia's newest and biggest!

Opened by the Prime Minister of
Australia, Bob Hawke, on 6 December
1986, the Museum commemorates
150 years of South Australian maritime
history and is spread throughout
Port Adelaide, the State's foremost
heritage area.

To make your visit to the Museum a
memorable one, this brochure is offered
as a walking guide to give you a glimpse
of the colour and character of our
historic Port.

The Museum comprises:
 The Bond Stores
 The Old Port Adelaide Lighthouse
 No. 1 Wharf
 s.t. **Yelta**
 m.v. **Nelcebee**
 Weman's Building: Museum Shop
 Lipton's Tearooms

South Australian Maritime Museum, Port Adelaide (official brochure).

from the centre. An effect of historical density is achieved, with a rich
sequence of nineteenth-century buildings stretching from the Parliament
House and joining the close-packed quarter of the University of South
Australia (itself also maintained on its original site). The sequence may
not be as architecturally distinguished, or as well endowed with monu-
ments from the early period of colonial settlement as Macquarie Street
in Sydney, or Collins Street in Melbourne.[9] But it is, after all, a series
of places to be visited, rather than a row of spectacular façades to be
seen. It also reflects, with a degree of coherence which is certainly not
accidental, a kind of programming of the past which is integrally linked
to the special historical experience of the South Australian community.

The programme can be picked up from the two prime examples of spectacular representation which are to be found on the site: the multi-screen audiovisual display installed in the Old Parliament House (which is otherwise devoid of all but its original furnishings) and the mid-nineteenth-century panorama of the building of Adelaide which is displayed in the State Library. The audiovisual display has a rollicking signature tune whose chorus returns frequently to the words: 'It's a country, South Australia, a country not a place'. Appropriately enough for this theme, the projection tells the story of South Australia in terms of the diversity of its pattern of settlement, and the increasing maturity of its political institutions as they succeed in coping with the different economic conditions affecting the whole of Australia. The splendid panorama, however, makes its point more soberly and economically. Composed of successive photographic images extending about 360 degrees, it displays the site of Adelaide in the process of construction. All over the pre-established grid, which was laid down by Colonel Light, scaffolding serves as a midwife to a group of heterogeneous buildings, commercial, civic and religious. There is a vivid sense of a city in the making.

This panoramic view gains a greater significance if we place it in a more precise historical context. The original plan of Adelaide was to have included an Anglican cathedral at the centre of the grid, as in the city plan followed through at Christchurch, New Zealand, and still preserved to the present day. However, protestations from the different religious groups which were already strong among the settlers succeeded in eliminating this symbolic act of confessional favouritism. The various places of worship which can be picked out on the panorama are scattered across the structure of the grid, with no indication that any of them has a special place in the overall plan.

These two varieties of spectacle – the nineteenth-century historical document and the contemporary promotional slide show – thus indicate two poles of the South Australian experience: the principled but forbidding diversity of a society which has agreed to differ, and the frenetic conviviality of a society which has pooled its differences to achieve a higher unity (I am talking, of course, about the effect of these two representational strategies, and not about any natural property of the South Australian mind). It is possible to conclude that the coherent plan of the museums proper (and of the History Trust of South Australia) has been one of celebrating the extreme diversity of settlement, rather than stressing any rôle played by the British Government in initiating the

Migration and Settlement Museum, Adelaide, South Australia (official brochure).

political development of the area. One museum exists in the vicinity of Adelaide which could be called hegemonically English: it is the pleasant mansion of Carrick Hill, Springfield, which still preserves in its furnishings, its collections of pictures and *objets d'art*, and its surrounding gardens, the unmistakable aura of a cultivated anglophile family, living in the idyllic aftermath of the Pre-Raphaelite movement.[10] The guiding themes of the other museums are very different.

First of all, the Migration and Settlement Museum, housed in the buildings of the former Destitute Asylum, stakes its claim to be 'Australia's first multicultural museum'. The experience proposed to the visitor is two-fold: 'collect your ticket of passage . . . and slip back into the nineteenth-century', but also learn to supplement the thrill of time-travel with the sense of a vicarious participation in the founding of the community. 'Find yourself in a port of departure packing to leave for South Australia.' The greatest effort in historical verisimilitude goes into the establishment of the scene of departure, *c.*1850. The museum offers a diorama of a narrow, winding, cobbled street, with figures in nineteenth-century dress standing at opposite sides. It goes without saying that this is not a 'convivial' scene, or even a homely one. The two adult males on the left-hand side go about their separate business in a lethargic

way, while a small boy possibly attached to one of them shows signs of distracted attention. On the right, a presumed family group stands in anticipation of the call to the New World: the cares of the Old World are already amply sketched out on the faces of the young boy and his cringing little sister. From where we stand, notionally offshore, these poor people have nowhere to go, certainly no asylum in the squalid, constricting street. Their one chance lies in vaulting out of the confines of the gaslit scene, into the future.

This is the historical base-line from which the theme of the museum develops. It does so partly through photographs, which supplement the theatrical verisimilitude of the diorama with their more intense effect of the 'this-has-been'.[11] The family motif is again invoked, but on this occasion the very act of crossing the gangplank seems to have welded the family group together with an accentuated sense of destiny and purpose. The museum also develops its theme through an intensive documentation of the ethnic diversity of the immigrant groups. 'Eight South Australians, from different backgrounds, give a personal view' of their society, in an audiovisual programme which is liberally spiced with attractive and colourful items of folklore. Finally, and perhaps most originally, it develops its theme through invoking the participation and 'feedback' of computer technology. The visitor, in this case implicitly the South Australian visitor, is invited to 'trace the listing of [their] national group on our computer terminals' and 'to register [their] place of origin on our map of the world'. Having retraced the patterns of migration and settlement, he or she is invited to leave a tiny statistical trace in a bank of accumulating information.

It goes without saying that this is a historical museum organised around Hoyau's three concepts of 'the family, conviviality and the countryside' (in this case, the colourful myth of the peasantry, epitomised in such images as a 'waistcoat from Eastern Europe, c.1920s', largely subsumes the third of these). Australia is portrayed as a refuge from the internecine historical conflicts raging in the Old World. ('To the menacing roar of distant guns, re-live the horror of two world wars.' 'Escape from the chaos of war-torn Europe to a makeshift migrant hostel in South Australia.') A special emphasis is placed on the development of the Italian community, sprung from a country which was at war with Australia from 1939 to 1945 but nevertheless incarnates the theme of the enduring family and the convivial spirit which persists against all odds. 'Italian family reunion', a scene in which five glasses are raised, by five physiognomically similar men, beneath the benevolent smile of a matriarch, is

South Australian Maritime Museum, Port Adelaide.

the concluding image of the museum brochure.[12]

The Museum of Migration and Settlement has a story to tell, and it does it both imaginatively and efficiently. Addressing the South Australian community, it decomposes the aggregate of subnational groups into separate strands, and brings it together again under the sign of a lively ethnography.[13] But it does not, perhaps, address the visitor in personal terms: converting their name to a token of ethnic origin, or a trace on a map, it foregoes the possibility of a deeper identification. Having begun this essay with a trio of individuals whose stake in the past expressed itself in vividly concrete terms, I am forced to admit that this museum does not correspond to their specific needs. My bus-stop acquaintance, researching from Bendigo to Perth, would not find information here, even if his family history had passed through Port Adelaide at some stage. On a more fundamental level, he would not, perhaps, find any strong metaphorical compensation for his sense of the loss of history, and its imaginable retrieval.

This point can be made without a hint of disparagement because the second major museum opened in recent years by the History Trust of South Australia caters very specifically for this need. The South Australian Maritime Museum is, in fact, part of a quarter of Port Adelaide which has been substantially restored in the last few years. Lipson Street,

where the museum proper is situated, is now 'the heart of the Heritage Area', with a 'virtually unchanged nineteenth-century streetscape'. There is therefore a pleasing effect of continuity between the restored but still functioning buildings of the port, and the Bond and Free Stores (with some adjacent places) which have been adopted by the museum. That we are entering a museum, in the latter case, is however very clearly marked by the vast proportionate size of the objects installed there, which include a number of substantial boats. The Maritime Museum does not attempt, like the Museum of Migration and Settlement, to organise its materials into a unified narrative, and it has a much higher quotient of rare and wonderful objects in their own right, as opposed to historical reconstructions and didactic displays. At the centre of the largest space, however, is a historical reconstruction of the holds of two immigrant ships. The visitor enters these confined spaces, particularly oppressive in the case of the earlier vessel, sits on the rough, straw-filled palliasses and (most important of all) hears the regular creaking of the ship's timbers. The dimly lit hold seems almost to rock backwards and forwards as the straining of the wooden joints continues its plaintive chant. We are involved in a rite of passage, somewhat disquieting but absorbing at the same time.

At the exit from the second ship's hold (a more modern, soundless specimen), the computer lies in wait for the visitor, on this occasion with a full program of passenger lists from the history of South Australian shipping. There is a good chance that you, or your South Australian host, will be able to trace the particular list on which their ancestor was featured. The print-out can be taken away and kept. After the compelling synecdochic rhetoric of the creaking hold – which stands for the whole ship, but also, in a more covert way, for the womb-like transition to a new life – this banal but efficient operation introduces a touch of irony. Yet the combination of the two experiences works especially well. The imaginative extension of the self through an empathetic response to a strong psychological stimulus is counterbalanced by a crudely literal celebration of ancestors. Each testifies to an individual investment in the otherness of the past.

Enough has surely been said to show that the 'New Country' of South Australia is trying to develop its 'sense of the past' in coherent and impressive ways. I will forego the obvious dialectical argument that it is the very lack of a past that provokes this enterprising cult of 'heritage' and history, or the equally obvious point that such responses as I have evoked are not necessarily the responses of the average visitor. Such

suggestions do not, in my view, impugn the integrity of these museum displays, which do explicitly construct a past according to a particular thematic programme, and which also manage, in the process, to construct an ideal visitor, implied in the very mechanics of the representation. Yet this group of examples cannot really be gauged for its true significance without a counter-example from another culture, whose history and lines of development are less transparent. The contrast between an 'Old Country' and a 'New Country' is implicit in the whole argument which I have been making, and though it need not involve the sharp binary distinction made by Donald Horne, it must be tested further in this study, with reference to an example that is complicated rather than clear – to an extreme degree.

Littlecote, which stands a few miles from Hungerford in Berkshire, is a Tudor manor house of considerable charm, built between 1490 and 1520. It was strategically situated during the Civil War, when it was defended staunchly by the private army of its owner, Colonel Alexander Popham. But its central historical moment came after the Restoration, in 1688, when Prince William of Orange paused in the vicinity of Hungerford to conduct the extensive discussions with the English Whigs that were to conclude with the withdrawal overseas of the Stuart King James II, and the installation of the joint monarchy of William and Mary. Lord Macaulay, whose *History of England* attached the highest significance to the reasonable and bloodless way in which this 'Glorious Revolution' was carried through, lost no chance of enhancing his narrative with vivid touches which would tend to accentuate the historicity of Littlecote. After his first meeting with the King's Commissioners, Macaulay tells us, the prince 'retired to Littlecote Hall, a manor house situated about two miles off, and renowned down to our own times, not more on account of its venerable architecture and furniture than on account of a horrible and mysterious crime which was perpetrated there in the days of the Tudors'.[14] The scene is set, then, through anchoring the scene of political discussion within another discourse – nothing less than the full-blooded historical romance of Sir Walter Scott.[15]

Littlecote has been vested with a historical dimension, and Macaulay does not lose sight of it when he subsequently stages the crucial meeting between the Dutch prince and the English Commissioners. It is as if the whole history of England from medieval times onwards, metonymically represented by armour and by portraits, were breathlessly caught up in the debate which was to result in the repudiation of armed conflict as

View of Littlecote House, Wiltshire. Reproduced from Macaulay,
History of England (illustrated edition: London, 1914).

the only method of reconciling political differences:

On Sunday, the ninth of December, the Prince's demands were put in writing
and delivered to Halifax. The Commissioners dined at Littlecote. A splendid
assemblage had been invited to meet them. The old hall, hung with coats of
mail which had seen the wars of the Roses, and with portraits of gallants who
had adorned the court of Philip and Mary, was now crowded with Peers and
Generals. In such a throng a short question and answer might be exchanged
without attracting notice. Halifax seized this opportunity, the first which had
presented itself, of extracting all that Burnet knew or thought. 'What is it that
you want?' said the dexterous diplomatist: 'do you wish to get the King into
your power?' 'Not at all,' said Burnet: 'we would not do the least harm to his
person.' 'And if he were to go away?' said Halifax. 'There is nothing,' said
Burnet, 'so much to be wished.' There can be no doubt that Burnet expressed
a general sentiment of the Whigs in the Prince's camp.[16]

Macaulay's superbly crafted narrative is devoted to displaying the
theme of non-violent debate as the supreme political value, at the same
time as it stresses the historical 'local colour' of the scene. This crucial
meeting need not have taken place at Littlecote, but the fact that it did
so enabled Macaulay to enhance his ideological analysis with the rep-
resentational values of historical authenticity. It does not seem at all
anomalous that the 1914 edition of the *History of England* – published
well before the young Herbert Butterfield had exposed the inadequacies
of 'Whig History'[17] – should have contained a full-page illustration:
'View of Littlecote House, Wiltshire. From a photograph'. This intrusion

of an indexical record of place might appear, from our point of view, to raise inconvenient questions. When, precisely, was the photograph taken? Specifically for this publication? And yet in fact it complements Macaulay's narrative most appropriately, since the *History of England* is both an ideological discourse – concerned with political choices and values – and an ontological discourse, gesturing towards the past through 'reality effects'.[18]

Of course there is no need to share Macaulay's trust in the continuing beneficence of the 'Glorious Revolution' in order to appreciate the coherence of the codes that he is using.[19] My point is simply that Littlecote has been constructed, in this important nineteenth-century narrative, as an authentic historical scene, representative of past history as well as of the seventeenth century, functioning mythically and poetically as well as playing host to political debate. Is this an achievement which is specially characteristic of the Victorian period and its aftermath? Or do the same codes operate in our own day?

The point of asking this disingenuous question is to suggest that they do not. If the museums of South Australia concentrate upon the simple but relevant theme of immigration and the diversity of national origins, the English museum which aspires to historical seriousness must surely have to reckon not only with a multicultural perspective, but with the political debates that have given significance, at different times, to different versions of 'Our Island Story'. Viewing British history in the light of the myth of the 'Glorious Revolution' is no longer the clear option that it was for Macaulay, and the contemporary historian must take into account the lengthy and productive reinvestigation of the ideological history of the Civil War that has taken place in the last half-century. But what must also be taken into account is the more recent academic revisionism which points out how far the Whig ideology managed to survive underground, even when it had been expressly repudiated by historians.[20] In fact, this is probably true for South Australia as well, since the multicultural display in the Old Parliament Building cannot wholly hide the fact that political evolution is about political values, and not simply about the blending of diverse ethnic groups in a harmonious society. My own opportunity to visit the museums of South Australia took place on the occasion of the launching of a Centre for British Studies, whose first official engagement was a lecture by Christopher Hill: 'The place of the seventeenth-century revolution in English history'.[21] It would be tempting (and not too idealistic) to hope that a forthright statement of one position in the debate (such as Dr Hill

provides) might have ramifications beyond the academic study of English history, and deepen the self-scrutiny of the museologists engaged so vigorously in representing the Australian past.

But this is a digression which leads away from Littlecote, and the question posed about its representation by Macaulay. It is to Littlecote that we must briefly return – or rather, to 'The Land of Littlecote' as it has been dubbed (in Gothic type), intimating more than a suggestion of that paradigm of imaginary ethnic and historical recreations, Disneyland.[22] Breaking out from its sober uniform of a Tudor country house to be visited, Littlecote now displays itself in a wide variety of guises, many of them designedly historical. At one end of the extensive river valley where the house is situated, the remains of a substantial Roman villa with fine mosaics are freely accessible to the visitor, who can exercise imagination on the bare clues which archaeology supplies. In the manor house itself, however, imagination is given less free rein. The main reception rooms have been stocked with life-size soldiers, servants and family of the Civil War period, who loll at Jacobean tables, disport themselves by the fire, pore over maps and do other mildly active things associated with their historical predicament. The Cromwellian chapel, described in a countrified accent over the loudspeaker as 'the only one of its kind in existence' is, however, exempt from these straw colossi, as is the Great Hall, where coats of arms still look down as in Macaulay's narrative, but on this occasion are representative of artistic rarity rather than of the national conscience: they form 'the unique collection of Cromwellian armour belonging to the Royal Armouries'.[23]

The domestic space of Littlecote has been narrativised, but the narrative is curiously contingent. Colonel Popham is wondering whether to send his wife into the comparative safety of Bristol, and the various orders, in their appropriate rooms, are about to assume their places in the dangerous plan. The loudspeakers inform us of this, in sequence, and they look forward into the future (Mrs Popham was not to survive the ingenious measures taken for her safety). But no real sense of the character of the Civil War conflict, let alone of the political values pitched against one another, is allowed to pierce through the moving little story. Littlecote narrativised becomes the heir to the late Victorian cult of sentimental domesticity against a historical decor, epitomised by the painting *And when did you last see your father?*, rather than to the Whig seriousness of Macaulay.[24] The Great Hall, scene of the momentous exchanges between Burnet and Halifax, is devoid of any historical recreation, except that the lady supervisor has been persuaded to put on a long dress.

Yet William of Orange, for a few days Littlecote's most distinguished resident, does put in an occasional appearance. Over the weekend of 23 and 24 July 1988, his arrival at Littlecote 'on his historic journey from Torbay to London' is re-enacted by a local dramatic company in conjunction with the English Civil War Society. The lawns at the front of the house are crowded with people in seventeenth-century military costume. The sound of distant drums echoes from the Hungerford road, and the prince's colourful procession comes into view, at 12.30 sharp. He says a few words about the menace of French power to a detachment of riflemen who are intent on keeping their fuses dry during a torrential downpour of rain. Then he bows out in favour of a court masque. Before reviewing his troops once again and departing for London, he is engaged to attend a jousting tournament. Meanwhile, in the Medieaval [sic] Garden, children are contributing their parents' money to a series of local charities, receiving in return the right to participate in 'lots of exciting activities . . . Bouncey Castle, Face Painting, Coconut Shy, Chairoplanes, Spinning in the Rare Breeds Farm and lots more . . . '

The theme of 'The Land of Littlecote' is perfectly innocuous. History is reconstructed through the guiding notions of 'the family, conviviality and the countryside'. Ethnography may not come in overtly, as this is a celebration of Englishness, but it creeps in covertly through the language of uniqueness and difference ('unique collection of Cromwellian armour', 'Spinning in the Rare Breeds Farm'). Of the historical events that have taken place in and around Littlecote, there is little trace, except in the scaled-down, domestic story of the Popham family, or in William of Orange's progress through a farrago of anachronisms. Is this the 'Great Museum' – Europe as a convergence of corrupted codes, which convert those who consume them into mentally evacuated 'tourists'? There is perhaps only one sign that it might not be, but that is an important one. As the visitors mingle with the troops awaiting the arrival of William of Orange, a strange phenomenon is occurring. There is no central organisation of space, no 'scene' of historical action, no amplification of William's speech, when it occurs, to a pitch which dominates the area (as in the narrativised rooms of the manor house). As each soldier from the English Civil War Society seeks to light his powder, and fire his salute, the question arises as to what he thinks he is doing, not as a member of a squad, but as a person of the 1980s who has dressed up in seventeenth-century costume. What is he doing in this Brechtian drama of estrangement, as the rain pours down? Some people would have a

WELCOME TO LITTLECOTE PARK

23rd & 24th July 1988

In 1688 Prince William of Orange stayed at Littlecote on his historic journey from Torbay to London, and this weekend the Littlecote actors in conjunction with the English Civil War Society (ECWS) will be re-enacting the events of that time.

PROGRAMME OF EVENTS

11.00	-	FALCONRY DISPLAY
11.30	-	DRILL BY ECWS
12.00	-	ROBIN HOOD PLAY (in Medieaval Garden)
12.30	-	ARRIVAL OF PRINCE WILLIAM & HIS COURT, REVIEW OF THE TROOPS
1.00	-	COURT MASQUE ON THE STAGE (by Popham Arms Tavern)
2.00	-	DRAGON OF WANTLEY PLAY ON THE STAGE
2.30	-	FALCONRY DISPLAY
3.00	-	DRILL BY ECWS
4.00	-	JOUSTING TOURNAMENT IN PRESENCE OF PRINCE WILLIAM
5.15	-	PRINCE WILLIAM REVIEWS TROOPS & DEPARTS
5.30	-	FALCONRY DISPLAY
6.00	-	PARK CLOSES

This weekend we are also pleased to welcome three childrens charities on-site, who are raising funds for very worthwhile causes. The charities are: Dr. Barnardos, National Childrens Homes and Make-A-Wish. They are situated in the Medieaval Garden behind the Restaurant and have lots of exciting activities for children to join in with - Bouncey Castle, Face Painting, Coconut Shy, Chairoplanes, Spinning in the Rare Breeds Farm and lots more do take a look, your support will be much appreciated!!

(The Management reserve the right to alter the programme of events without prior notification.)

'The Land of Littlecote': handout listing events for 23 and 24 July 1988.

simple, even a discreditable answer ready to hand. I find the phenomenon hardly less mysterious than that of a scarred Australian who hands out letters 'Researching History' at a bus stop.

7

The Quality of Visitors' Experiences in Art Museums

PHILIP WRIGHT

There is an obvious and direct connection between 'being free' to make a choice and 'being able' to make it. Unless we are able to act, the right to act loses its value. The relationship between liberty and resources is exact. The greater the resources possessed, the greater the freedom enjoyed – as the lifestyle of many millionaires demonstrates. Not everyone can possess sufficient resources to make them wholly free. But more people can be made more free by the provision of both extra opportunities and the material ability to make liberty a reality. That is why liberty and equality cannot be separated.

ROY HATTERSLEY, MP 'The real meaning of Liberty'
in *The Observer*, 25 January 1988

It is easy, costs little, and perhaps even wins plaudits from non-museum-specialists, to express concern about the quality of visitors' experiences in art museums. Museum specialists who attempt to grapple with this issue know that the expectations and levels of prior knowledge and experience which visitors bring with them on a museum visit vary more and more in range and depth. There is no such thing as 'the typical visitor', and there is no single level which can be expected and then addressed.[1] The museum has to cater for increasingly fragmented publics who want to learn and do different things at different speeds. Further, the body of knowledge that could be imparted in museum displays is continuing to grow, and in certain instances it can be very complicated and even contradictory. For museum specialists who attempt to address the issue of imparting knowledge, their methods will be continually undermined by frustrating compromises which will rarely, if ever, be satisfactorily resolved. It is like trying to reach the horizon: however far one goes, the ultimate goal will always be beyond one's grasp. Could this therefore be the reason why, with very few exceptions, art museums – led from the front by the most important national institutions – seem reluctant to tackle the issue?

For them the quality of visitors' experiences appears not to be of

major concern. The real issue is the quality of the works of art their museums possess, because it is assumed that this quality is self-evident and, ipso facto, synonymous with the quality of the experience that can be derived from contemplating such works. My aim is to encourage those responsible for curating such museums to examine more critically how this attitude arose, and to embolden them to rebalance the priorities within the services of their museums. It is my premise that art historians/art specialists know how to look after themselves. They have the privilege of education to seek out and sort out what they need, in almost any set of circumstances. Satisfying their own needs and expectations should be a low priority for such a public service as an art museum, and indeed they should be served last. Catering for generalists (non-art specialists, who do not work full-time in art) should be the first priority, followed by that of developing new audiences. Neither should providing services of sufficiently high quality wait on that unfortunate day when a museum is forced to introduce entrance charges. On the contrary, a museum should behave towards its visitors as if it were a paying museum, even if it is not. Free admission should not be an excuse for shoddiness, or shoddy treatment of visitors. Numerous recent studies have shown that visitors would be willing to pay, and return to pay again, if the experience is believed to be, or has proven to be, worthwhile. Increasingly, it is not simply value-for-money but equally the sacrifice of precious free time and the reward or gratification gained which potential visitors evaluate when making a decision between the range of competing attractions that take them out of their homes (to cinemas, shops, restaurants, zoos, the countryside, sports, a stately home or a museum).[2]

If I shall appear to concentrate, by implication even if not by naming them, on (London's) national art museums, it is not because I do not recognise the quality of major art collections elsewhere in the UK – in Barnard Castle, Birmingham, Cardiff, Edinburgh, Glasgow, Liverpool or Norwich – or the innovative work which has been essayed outside the metropolis – in Bradford, Manchester, Newcastle or Southampton. It is because these national art institutions (especially the National Gallery, the Tate Gallery and the Victoria and Albert Museum) set an example to the art-curatorial profession, and often represent the goal and culmination of a successful museum career. It is also because the governing Board of Trustee-system encapsulates that powerful conjunction of The Great and The Good in the public and private sectors drawn from the political Golden Roladex in Number Ten (who not infrequently are well-to-do collectors or patrons themselves) with senior career artists,

distinguished art historians, and possibly also an art critic or two, and excludes – by oversight, I hope, rather than by design – any voices that may disturb a consensus over what the rôle of an art museum should be.

I am not under any great illusion that what I shall write about is particularly novel, or that it is objectively accurate. Several types of elaborate visitor surveys have been carried out, and anguished articles written from within as well as outside museum institutions, over the last twenty-five years.[3] Considerably more have looked at non-art rather than art museums. Nevertheless, many insiders still admit that little hard evidence has been marshalled that is of use to the latter. There may be several reasons for this. Beginning with the most obvious: the more difficult the subject – in the case of art, one which deals with feelings, impressions and personal perceptions far more than with material and objective facts – the more lengthy and costly the study is likely to be. In the end, its conclusions may still be scarcely enlightening. Next, and less obviously, such evidence is not of major concern or interest to those running art museums, because they have neither been trained to value it, nor are they committed to act on it: it does not represent a professional 'plus'. Third, and most peculiarly English (rather than British), it will almost certainly lead towards those dangerous and sensitive activities of revising history, probing the nature of Establishment values, and raising issues which are now written off as the domain of the Looney Left: class differences, the history and methods of acquiring wealth, subterranean but nevertheless pervasive racism and, to a lesser extent, the preponderance of men's values over women's in determining cultural values and priorities. But before the reader assumes that this is to be another neo-Marxist tract, let me outline what I believe is offered at present in art museums, and what guides the thinking behind their presentation of art.

There are several published histories which examine the development of museum types and of their organisational methods.[4] But in order to understand why art museums present themselves as they do, and how this might be changed, it is necessary to understand who is principally in control, and with what ideology they approach the task of running museums. The 'corporate culture' of art museum curators will be alluded to later in this essay but stasis or change in a museum is jointly the responsibility and the prerogative of the director and/or the curator (henceforth referred to solely as the curator) and the museum's governing body. The background, education and beliefs of unpaid members of such governing bodies have shaped the way our art museums are run with, obviously, the collaboration or the – usually short-lived – disagreement

of the full-time paid officials. It is possible that any serious re-examination of why art museums show what they do, in the manner that they do, could not be carried out without disturbing the apparent coincidence of interests between art historians, collectors, artists and art critics (not to mention the pressures of the art-dealing world, which occasionally both assists and exploits this coincidence of interests).[5] Such disturbances seem to occur, if at all, in some of the more politically-motivated local government-funded institutions, and occasionally also in the 'independent' (i.e., private-sector) museums, both of which have a more developed awareness of the publics whom they wish to serve.

Art museums are still fundamentally the working tools of the art historian's trade, and the grounding for the art collector's business. They act as a warehouse resource

- to define individual artist's oeuvres, stylistic groupings of 'movements' and '(national) schools', and to trace the threads of master-pupil relationships in a posited sequence of stylistic developments;
- to teach hierarchies of quality in subject matter and in technique;
- to justify a triumphalist, still-Vasarian canon in the search for (visual) truth as constituting The History of Art;
- to conceal or gloss over the originating circumstances of the works.

It is a set of priorities which would have served both Berenson and Duveen, in their partnership together, very well.[6] It finds its most characteristic expression in a search or chase for 'unique masterpieces'. The curator is permitted his modicum of fulfilment and his display of professional skills in the 'gallery hang' – often tasteful, occasionally 'challenging'.[7] Tasteful, that is, to those who know how to savour the telling juxtapositions; challenging, in that the most up-to-date art-historical theories can be tried out in occasionally unexpected and unconventional groupings. Thus, the visiting public is offered

- an opportunity to look at what those-in-the-know call 'treasures' or 'masterpieces' (i.e., what the museum has amassed);
- an insight into the conventional/current view on the sequence of the history of art (of a certain school of studies following the principles of a distinguished scholar such as Berenson, Bowness or T. J. Clark; from a certain perspective in gallery hanging fashions, such as a purist, white-walled, Leavisite fifties, or an antiquarian Cliffordian eighties[8]) on take-it-or-leave-it art historian's terms (where no explanation is

offered for the sequential arrangement), and/or

- a personal view of that history of art by a (rarely named and even less often publicly known) curator, and/or
- an anthology of one artist's – or a group of artists' – selected/edited creative production (e.g., the Turner Gallery, the Norwich School of Painters), and/or
- an anthology of works of a certain medium/period/style/nationality selected/edited to a particular theme (e.g., A Hundred Years of British Watercolours, Constructivism in Poland, Masterworks from American Private Collections, etc.).

This is what art historians are trained to do. Their corporate culture requires of them that they demonstrate their skills by devising (new) art histories and – given the chance – try them out in museums and galleries.[9] Because of the 'pure' scholarship of so many art historians' training, they are often unaware of the history of the development of public museums, their original associations with the whims and pleasures of the ruling or wealthy classes, and their differing methods and purposes today. As Kenneth Hudson has pointed out, in the seventeenth and eighteenth centuries 'visitors were admitted as a privilege, not as a right, and consequently gratitude and admiration, not criticism, was required of them. This attitude persisted long after the widespread establishment of public museums in the modern sense'.[10] Sometimes art historians show little sensitivity to the undocumented but nevertheless real social and economic vicissitudes which have, in the past as they still do today, influenced the production of art in the studio. They show little feeling for the schizophrenia of modern artists, caught between a desire to be publicly recognised by critics, art bureaucrats and curators so that their works might enter public collections (at most, one or two works to each different institution, during an artist's lifetime), and the need to cultivate a sufficient number of private collectors who have adequate wealth-in-excess to enable them to buy enough of an artist's work to give him or her a living. And it is often the case that, once on the career ladder, curators rarely afford the time, or the opportunity, to study other subjects that they might discover to be important to their work, such as sociology, cognitive psychology, man-management, twentieth-century media, or other such new-fangled disciplines. The result is that many other possible angles of scholarship and interpre-tations of relevance to an art museum are neglected or brushed aside.

Dr Pieter Pott[11] also proposed (to a meeting of the International Council of Museums, back in 1962) that museum curators must have 'pluralism of interest and flexibility of imagination'. They must, above all, know how their subjects are being treated in the media, and thus not appear to be offhand with their visitors, or to be ignorant of the channels whereby museum visitors will have acquired other views and insights from non-museum sources beforehand. In recognising the duty to run the museum in a way that meets the needs of modern people, he suggested that curators must address the nature of the educative process today. For this process is not restricted to the acquisition of factual information, but needs to foster the growth and development of the complete person.

To some observers of corporate curatorial culture, it might seem that many curators actually fear or despise the new technologies, current developments in the media, and trends and fashions in period rediscoveries and revivals. Extended or permanent displays often seem to be oblivious to the more recent productions in book publishing, to 'blockbuster' exhibitions, to the general public's opportunities to travel to other cultural capitals abroad, and to the influence of entertaining if not also authoritative programmes on television, such as Kenneth Clark's *Civilisation* itself, let alone its riposte in John Berger's *Ways of Seeing*, the rather in-jokey tone of Robert Hughes' *Shock of the New*, or the novel, three-cornered combat between film direction, artist's statement and traditional storyline of Sandy Nairne's *The State of the Art*, not to mention the carefully worked out *Painting in Focus* series of exhibitions mounted by the National Gallery, and its counterpart series on television, presented recently by Lady Wedgwood. Danielle Rice summarised the current orthodoxy as follows:

Two notions of art are common to museum cultures. One is the concept of art objects as valuable pieces of property. The other is the belief that seeing equals understanding, or that one has merely to look in order to appreciate art. . . .

The irony of people who devote their entire lives to studying art proposing that all one has to do is to look at art in order to understand it is not lost on museum critics. . . .

To the uninformed eye, the fragments of other times and other cultures, removed from their original settings and rituals, are mere curiosities made by unknown people who are suspect because they are so different from us.[12]

Danielle Rice's observations are borne out by the considerable majority of permanent displays of Old Masters in art museums where, for example, there is hardly ever any discussion and/or illustration of the Weltanschauung

(the attitude to, and concept of, the world as perceived in a certain epoch) of a region, a kingdom, a court or a so-called 'national school' of the time; or of the shift of balance between religious and secular values; or of the relationship between the patron, the art market, and the artist's task or ego; or of the society, the politics, and the personal circumstances of creators or patrons; or of the ritual and social meaning of the works of art; or of the prevailing circumstances of war, peace, or the economic situation in society or of the individual at the time of a work's creation, and so on. And in displays of the post-Romantic period, there is hardly ever any visible reference to the industrialisation of Western society, to the impact of the New World and of new scientific discoveries, to the importation of outside-European artefacts or to the importance of 'design' to artists – without which a grasp of the motivation and inspiration behind many modern works of art is made doubly difficult.

What is shown is a history of style, as written by those-in-the-know, divided up by media (oil paint, watercolour, printing, etc.), subject, schools and movements, nationalities, and occasionally by individual artists or patrons. It is alleged that this best 'allows the works to speak for themselves', but to those who lead busy lives outside the confines of full-time art history, it must at times seem as if the intent is deliberately to conceal the several meanings of works of art, by offering hardly any clues to those who are not fortunate or privileged enough to have studied them beforehand, and who do not carry them all in their mind's eye (as art historians do). It is doubtful if any but the most knowledgeable visitors to an art museum grasp the thought, scholarship, and several possible meanings of a gallery 'hang' – other than the most obvious, such as an assemblage of paintings by Rembrandt, or by the Impressionists – and scarcely any art museum in the UK seems to have attempted to find out if visitors want to, or do, grasp those meanings. For example, would visitors today be that familiar with the historical personages or the stories derived from the Old Testament, which so often form the subject matter of Old Master paintings? Would they understand the differences in techniques of oil painting employed before the twentieth century? Is their skill in attributing paintings or in grading quality – ostensibly a major objective at present for art museums – being effectively enhanced? Do visitors really carry comparisons with the Louvre's or the Prado's version of . . . in their mind's eye? Do they even know why they are being shown precisely this sequence of works? Are they conscious that they are usually only looking at white man's, post-'Scholastic' period,

Western art in the Western world's 'art' museums, while old Chinese, Islamic and Indian art usually goes into museums of archaeology (along with the 'dead' cultures of Greece, Rome and Anglo-Saxon England), and African and native North and South American art – frequently a source of inspiration for twentieth-century Western artists – usually goes into museums of anthropology, or even joins up with natural history . . . ? Do they think, or are they helped or encouraged to think, of the culturally divisive and racist implications of such categorisations?

The experience of a visit to an art museum often still seems to be, in Kenneth Hudson's phrase, 'a preparation for an unseen exam'. This humiliation and punishment inflicted on visitors to many art museums might be plausibly traced back to the sense of 'favour' being granted by aristocrat-owners or -collectors of Old Masters to those of lesser fortune, who were permitted to enter their private home or their newly designed 'public' gallery. But, since the Second World War, a new group of mainly Courtauld Institute-trained art historians seem to have amalgamated the pretence of visitors having a Kenneth Clark-like, natural, if privileged, ease in discerning quality in art, with their own fifties, Leavisite high seriousness and diligence to keep art museums pure from anecdote – even if that anecdote may have the potential to connect with a wider number of visitors' life-experiences. The work 'must be allowed to speak for itself', so that few or no texts, no other kinds of images (film, video or even still photography) and no mixing of media (such as design, anthropology, natural history, engineering) are permitted in art museums, however much they might assist understanding. Enlightenment or enjoyment is not – in the Leavisite view – fostered by information on the personality, motivation, history or situation of the artist. References are certainly not permitted to such personal circumstances as the artist's physique or health, wealth, family and friends, collectors and dealers, religious and political beliefs, sexual preferences, or experiences of holidays, travel or war.[13]

If this is not misleading enough for the visitor, consider how little the public is told about most collections of works of art themselves. Art museums purport to show a seamless historical sequence of rooms of pictures, with no explanations added, gaps pointed out or apologies offered. Because the works belong to a public collection, many visitors, since they are less well-informed, tend to see all the works as of good quality and worthy of attention. But, in truth, works of art end up in public collections for a variety of different reasons, and of course vary greatly in quality. They were acquired as much to complete a 'notional'

Print of Rubens' *Samson and Delilah* in its exhibition setting.
National Gallery, London.

The Early Victorians' Room (theatre). National Portrait Gallery, London.

Pre-Raphaelite Room in new display (as arranged by Timothy Clifford).
Manchester City Art Gallery.

history of art ('The collection desperately needed a . . .') as by chance
donation. They may have entered the collection because of national or
local interest (an artist was born/lived and worked/died here), or because
of financial circumstances ('We couldn't afford a painting by . . . , so we
got a print', or 'So-and-so offered us a . . . in lieu of Capital Transfer Tax.
It was an opportunity we couldn't pass up.'). The collection may have 'out-
standing' or undistinguished examples by famous names, but severe omis-
sions where examples are needed to form a more balanced representation

of the contemporaries of those famous names. It may have a poor representation of work by internationally known 'masters', but exceptional collections of work by local artists, and so on. This is practically never admitted, even more rarely explained in full. But then, for example, even in our national institutions, it is never explained why 'Italian Art' appears to begin with Cimabue, but 'British Art' begins three centuries later with 'The Cholmondeley Sisters'.[14]

The implications of these standards of 'communication' with visitors are worrying. In a private (i.e., commercial) gallery, the language of an apparently haphazard assemblage of whatever works of art a gallery may own at the time, with minimally informative labels, has a purpose. It is deliberately meant to intrigue and 'challenge' the one or two private collectors-who-know, who may come by during the day, and who may buy something (without being permitted to compare the quality of what is on show with any rivals). It also serves a very useful purpose in discomfiting and humiliating – and thus effecting the exit of – the unwanted non-collector visitor, who may be blocking a potential purchaser's view. Potential purchasers usually like to see and 'absorb' works in isolation, and unhindered (and then to discuss prices without being overheard). One could scarcely believe that this presentational language is also appropriate for a gallery in the public service, but nevertheless it appears to be the one most favoured in the art museum. It represents a form of snobbery reminiscent of Marie-Antoinette's 'Let them eat cake'; an attempt to intimidate the less knowledgeable by confronting them with what are said to be 'masterpieces', but which appear to need no explanation as to why they deserve awe, respect, and submission to the canon of values they embody. If perplexed visitors do not know what they are looking at, and what makes the masterpieces such, then they are to be left to find out on their own. This means that until they have raised themselves to the level of knowledge of the art historian or connoisseur, they will not be permitted to get as much out of art museums as art historians and connoisseurs do.

It is certainly not an approach which aims to make enthusiasts out of neophytes, or which acknowledges the patterns of social behaviour, learning methods, and media practices of the late twentieth century. But then perhaps – in the spirit of Leavis – art museums should serve as bastions against the spread of those methods and practices – as repositories for rigorous, if not also traditional, private, rich, connoisseurial values, which have grown up over the last five hundred years of Western art. Is this approach wise, intellectually truthful, just and, above all, democratic for institutions in the public service? Unfortunately, in a period of Thatcherite

values (pay-for-what-you-use), art museums could be forced to turn somersaults – chasing endlessly sensational 'blockbuster' exhibitions, or embracing the dishonest farrago of pretending that bronzes from Benin or marble reliefs from Greece constitute our 'national heritage'. – in order to establish or retain a supportive constituency – if they do not already see it as part of a duty to serve a wider audience than those who know best how to help themselves.

None of these somersaults are necessary, since much research and fresh thinking has been done in other types of museums and in other fields of informal learning and recreational activity, which may be of relevance to the immediate future needs of art museums striving to provide a richer experience for their visitors. In his keynote address to the 1987 Museums Association annual conference Bob Tyrrell, director of the Henley Centre for Forecasting, asked whether museums actually wanted to attract a more representative cross-section of the public, or if they were satisfied with their present range of visitors. What, in fact, do art museums already know about their visitors, their motivation, their aspirations and expectations, and whether and in how far these are met satisfactorily on a visit?

The habitual response of some art museum curators to critics of gallery hanging and interpretation has been to say that these aspects are 'catered for' by their Education Departments. This not only misses the point but, I fear, demonstrates an ignorance of, or possibly a disdain for, the lives and social habits of the majority of visitors. It also glosses over the important distinction that while the museum is a place of work and study for its paid officials, it is a place for spare-time, and thus by definition recreational, activity for the majority of visitors. Most of those visitors see education, with its overtones of possibly-tedious-but-at-least-good-for-you, as being what is done to you at school. Nevertheless, many adults are capable of using information resources – if they are offered in an appealing and non-condescending manner, and if those adults are interested – and educating themselves. But these resources have to be made available, attractive and, increasingly, easy to absorb in brief, concentrated messages.

At the 1987 Museums Association's conference, Tyrrell went on to explain his Centre's analysis of trends in social behaviour:

With society becoming increasingly middle-class, it is no longer enough for people to aspire to appear rich; they must also be seen to be clever – with less emphasis on status emanating merely from occupation. People desire 'savoir-faire' in their life-styles.[15]

He described what he later termed 'connoisseur-consumer' behaviour, and contrasted it with a counterbalancing growth of the quasi-illiterate 'moronic hedonist', who equally seeks pleasure and gratification, who may share a capacity to absorb information, and may also be genuinely interested in a wide range of – often tele- – visual imagery, but is loth to read for leisure, or even at all. These publics, with their late twentieth-century habits of 'harassed' leisure consumption – of cramming as many, preferably concentrated, non-work experiences as possible into the spare time available to them – now constitute a reality which is unlikely to disappear. It would be paternalistic and arrogant of museums to seek to determine precisely on what terms these publics shall have access to knowledge and enjoyment of the works of art which they hold in trust for the public.

Museums must face up to the fact that film, television, video and popular access photography have irretrievably altered, if not actually undermined, that hierarchy of images that museums own and display. The desirability and methods, too, of unlocking the meanings of these images have also been irreversibly affected. In his seminal essay, devoted in the main to the achievements and implications of film, 'The work of art in the age of reproduction', Walter Benjamin quoted the early twentieth-century French author Georges Duhamel as already noting: 'I can't any longer think the thoughts I want to: moving pictures have taken over from my thoughts.' It was an unusually prescient insight into the power of moving images to over-layer what might be termed 'objective' reality with another pattern or sequence of events, which seems virtually capable of substituting for, or obliterating, that 'objective' reality. It is now a cliché that first Hollywood, and latterly television in general, has been able to sow in many people's minds patterns or sequences of images of events, so that they may recall, if not directly experience, an event in which they participated in terms of previously absorbed moving images and the emotions they aroused. Indeed, by the late twentieth century the moving image has spread an extraordinary range of prepacked, edited knowledge and experience across Western societies and beyond.

The few audience surveys that have been carried out, whether in Europe or the USA (if such a generalisation be permitted), tend to confirm that the majority of visitors to art museums are still in the main middle-class, and already fairly well educated. They also indicate that formative, or persuasive, influences to visit art museums come less through full-time primary or secondary schooling, as is customarily believed, than through tertiary education courses, acquaintance with friends, or simply from

shared family and/or class habits.[16] In an unusual recent study on 'how social ties between visitors enhance exploration of museum environments', the American Lee Draper has also underpinned – for museums – what leisure managers and consultants already know well: that visiting is a social, and indeed at times an unconsciously performed, self-exploratory activity:

75 to 95% of all visitors are accompanied by friends . . . only 5 to 25% at most come to museums alone. The museum visit is fundamentally a *social* experience. . . . Many leisure-time pursuits have become a search for personal identity and affiliation. . . . [Even] if a visitor has placed highest priority on the aesthetic experience, it does not exclude the social dimension. . . . [Indeed] for visitors, the dichotomy between social interaction and learning does not exist. They have made a strong correlation between exploring the museum and sharing the company of companions.[17]

In addition to the social function of museums, the visitor's desire to learn – but in easy and accessible stages – suggests different priorities in display techniques. Once the museum can afford more than the basic accrochage of its holdings on its walls, it may begin to address itself to visitors' motivation and to the dynamics of visiting and learning from exhibits. It may try out targeting particular types of audience, such as what is possibly the largest group amongst its visitors: the 'self-educating' adults. In seeking to assist and stimulate them, two interrelated considerations would need to be tackled at the outset of a display – on the assumption that the curator's ideas about what he or she wants to convey (which are discussed below) are already clear. These are the additional information needs of visitors, and the level of thinking skills that will be required of them, because informal, self-motivated, self-educational visiting is not the same as school-teaching. As Judith Huggins Balfe has pointed out:

Adults have been beyond the reach of formal educational instruction for longer periods [than children] . . . ; educational programs directed at such people tend to focus on descriptive questions, on 'the facts': What is it? How does it work? The emphasis is appropriate for youngsters, and it is what their parents and teachers bring them to museums to learn. But it is far less appropriate for adult learners, who are usually more interested in going directly to general analytical principles: Why does it work? What does it mean to me in my work? . . . For adult learners the question is: What is this knowledge for? Knowledge for the sake of knowledge, art for the sake of art, may be the prevailing ideology of the museum curator or researcher, but such a perspective is unlikely to attract most busy adults to make the effort to learn. Presumably, given the disparate backgrounds adults bring to the museum, the more interdisciplinary and contextualised the presentation

of the material to be learned, the more probable that such learning will occur. Then the adults may be able to go on to appreciate the art, the history, or the science for its own sake.[18]

Having tentatively suggested a different perspective on the work of museums – that of meeting the needs of visitors as users of the art museum as a priority, rather than of granting curators a space in which to illustrate the latest construct of art history – these observations ask serious questions about the philosophy behind museums and the tasks they set themselves, and have important implications for the layout of galleries and the design of exhibits.

Over the last ten years or so, a substantial number of museologists have set out clearly their views on the ranges of expectations that visitors may bring to museums.[19] These views have been summarised or published in the mainstream specialist journals, and are thus available to curators and to the governing bodies of their institutions. For example, while working at the Museum of Fine Art in Toledo, Ohio, Marilyn Hood identified six major attributes shaping the use of leisure-time, culled from interviews with the public conducted – it should be emphasised – outside the museum itself. They ranged from the desire to do something worthwhile, including participatory and informal learning activities which took them beyond their habitual experiences, through the socialising factor of being among people, to the psychological need for congenial rather than impersonal or anxiety-generating surroundings.[20] These six attributes already provide some clear directions for the guidelines to designing and programming museum activities for the benefit of visitors rather than for scholars-in-the-know. They also coincide with Lee Draper's observations on the linked social and educational purposes of museum-visiting. More specifically, he suggests that:

Museum visits do not occur spontaneously. They are planned events. No matter how 'spur of the moment' the decision is, even a few hours allow the individual to consciously construct the visit. Almost every aspect of the visit has been designed, consciously or unconsciously, before embarking on the excursion. Expectations shape
 1. the selection of the companion(s),
 2. the selection of the place,
 3. when and how the visit will take place,
 4. the constellation of activities that will occur along with the visit,
 5. the goals for the experience,
 6. the criteria for evaluating the 'success' of the visit,
 7. the manner in which a visit is integrated into a person's life.[21]

Once inside the museum, as Kenneth Hudson remarks of the under-
standing shown of visitor psychology at the Delvaux, Ruskin and David
D'Angers (art) museums, three assumptions should be addressed by the
museum:

First, that the visitor has come because he wants to, that he is genuinely interested;
second, that he does not see the museum in terms of problems and difficulties
and, third, that he knows nothing about the subject when he arrives and expects
to receive value for money during his visit. He considers himself as good as the
next man, and the museum does nothing to discourage the idea.[22]

Furthermore, in addition to the assumptions about planning for visitors,
making sure that they feel they have received value for money, and
building in 'rewards' for the 'effort' they will put into learning, which
museums must anticipate, visitors may also expect to be guided, or at
least to be assisted to find their way around, to find high standards of
service and to pay for them if necessary, and indeed to have the oppor-
tunity to spend money on themselves, and to go away satisfied.[23]

Of course – sadly, in the case of many art museums even today – this
begs all sorts of questions. The first all-encompassing question must ask
whether curators actually have a basis for knowing how their visitors
gauge the experience of a visit to their museum. If and when they conduct
surveys to find out, how do they respond to the findings? Do curators
at least have certain elementary communication goals for the displays
they mount, and do they find out whether these displays achieve them
effectively? Do they in any way match the expectations, or indeed alter
the perceptions, of visitors? On present evidence, I fear that many
curators do not view the overriding goal of their institution as being to
communicate and share knowledge with its visitors, and thus to bring
about a diffusion of power and privilege from the specialist to the non-
specialist.

In a recent article for the *Museum Studies Journal*, the American
industrial psychologist Robert Wolf referred to Anthony Robbins' book
Unlimited Power:

Robbins maintains that the key to power in today's information society is
knowledge.
Museums are truly wonderful places for knowledge to be shared and con-
templated. ... museums hold an important key to *empowering* the public.
Visitors often are stifled in their pursuit of knowledge, however, because the
material on display is not augmented by the kind of interesting information that
people seek.[24]

The point made in the introductory quotation from Roy Hattersley's article, 'The real meaning of liberty', seems to coincide quite closely with Wolf's opinion, and even more so with that of Danielle Rice. Implicit in her view is the need for a shift of power inside the museum as well as outside it. Within the museum, the curator needs to learn how to share control with those responsible for interpretation and education. In the wider perspective – that is to say, how art museums are perceived to be behaving by the general public – the obsession with 'masterpiece-chasing' (preserving 'art as property') needs to cede ground to the more neglected aspect of making manifest, and relevant, the ideas carried by works of art to audiences of today (so that visitors can eventually make informed decisions for themselves):

The goal of museum education, as I see it, is pleasure through enlighten-ment. . . . If we begin from the premise that art is primarily about ideas and that museums, as institutions devoted to preserving art as property, inadvertently obscure this important concept of art, the moral duty of the educator takes on a special significance. For the task that falls to the educator is to navigate through institutional contradictions in order to bridge the gaps between the value systems of the scholars who collect and exhibit art and those of the individual visitors who come to the museum to look at, and perhaps to learn about, art. . . . In showing that it is people who structure and control institutions, rather than the other way around, and in helping people to analyze the decisions by which aesthetic and other value judgements are made, we empower people to act with greater awareness.[25]

If it is agreed that this sharing of knowledge should be the primary concern of museums – and few curators would not pay lip service to this – several specific design and display imperatives come into focus. For their objective will no longer be merely the exposure of the current holdings and latest acquisitions-as-trophies, within an alleged historically and politically neutral academic construct sanctioned by the governing body and agreed by the curators, but a range of displays with subjects to tackle and stories to tell, in a manner that is both attractive and comprehensible to a range of audiences.

In the article referred to above, Wolf also wrote:

The critical dimension in helping visitors gain the 'power' they seek (through increased knowledge) is to help to orient them more effectively to the experience. . . . a strategy for conceptual *and* psychological orientation that not only helps to counter the feelings of confusion, anxiety, and boredom that often result from disorientation in museums, but one that actually leads to a more enjoyable, productive, and enhanced opportunity for learning. The key is to make the public more comfortable with their surroundings . . .

The first essential is to recognise that the majority of visitors have a limited amount of time for their visit – unlike those who protest loudest at museum entrance charges, who 'pop in regularly for half an hour to look at their favourite pictures' but who do not make up the majority – even though that majority may not be once-only visitors either.[26] It would be unwise to assume that most visitors know where they want to go or what they want to see.

The curator and the museum's governing body might therefore begin by agreeing what the overriding philosophical and museological principles of the institution's internal organisation are to be, and which are the most important experiences and services it will offer its visitors, *and then publicise such information.* This may sound simplistic, but in practice it is not so, nor is it often done.[27] Its aims and objectives might most conveniently and effectively be communicated in a major, purpose-(re)built reception and/or orientation area.

The museum could begin by setting forth some of the facts about the institution itself:

- the origins of the building, the collection, and its endowments and donations: purpose-built or an adaptation/conversion, and the suitability or otherwise of the building for its purpose; bought initially as a private collection and donated, or assembled from the start as a public collection, from one or from several sources; the jobs and personalities of the donors;
- the original and the present strengths and weaknesses of the collection: its claim to fame at its inception, and its subsequent major acquisitions and gifts; how and why it grew, and perhaps also what it missed acquiring, and why; its present particular identity and innovative stance;
- the personality and achievements of its staff members: their curricula vitae, scholarly achievements and personal views of their professional duties as public servants (because they most certainly have such views!);
- the identity and attitudes of the present members of the governing body: the reason for their appointment, their professions and recreations, and the contribution they hope to make to the institution.

Such facts would help to illustrate both the history and the humanity, and the changes in fashion and taste, which are at the core of the rôle and functioning of a museum as an institution.

The museum could then enlighten the visitor about the principles by

which the collections were, and are now, organised and displayed. Again, it should not be assumed that every visitor can deduce these on his or her own. Although art collections are usually organised and displayed in the mode of a sequence of 'progressive' stylistic developments – i.e., 'movements' which make up the history of (Western) art – they may also be in the mode of 'national schools', or of subjects, themes, or genres, or of the 'international mix' with second-rank indigenous/local art relegated to a subterranean or attic display. All too often the visitor stumbles from a gallery display in one mode into a display in another mode, without a word of warning. While art historians have been trained to make deductions from the evidence in front of their eyes, and to order that evidence with the help of the style-analytic framework they have learned, the effect of such sudden shifts in modes can be quite disorientating for non-art historians. Following an explanation of the museum's principles for the organisation and display of work, times could be recommended for setting aside to view certain sections or highlights of the collection, so as to ensure that visitors depart feeling that they have received some satisfaction, rather than the museum leaving this to chance. A specific itinerary might be offered: 'If this is your first visit to the museum . . . ', or 'If you are particularly interested in the following subject or theme . . . ' It might also be explained if and why the displays are divided into fine-art media (painting and/or sculpture, but excluding drawings and prints), or if into such media/categories as manuscripts and books, decorative arts, design, classical or non-European arts; or why moving or still photography have been incorporated into displays and, if not, why not.

Such divisions are increasingly less self-evident to, and less justifiable for, non-art historian visitors, as their general cultural and experiential knowledge broadens. The inclusion and cross-referencing of non-fine-art media may be used to promote an understanding of the background and context to an individual work, or to a particular oeuvre or movement, precisely in order to amplify the several possible meanings of the work itself, its relationship to the individual (artists, patrons or other social groups that are implicated) and to society – then and now. Such cross-referencing might help to sharpen visitors' criteria of quality, relevance, and so on – by open-ended, truthful and, if necessary, ambiguous comment and discussion. All this presumes, of course, that the philosophy of the museum is to stimulate the visitor's interest to see and think further, to explore its collections in greater depth – as well as those of other museums – to encourage them to return to visit again, and to give them

the tools to 'empower' them to make independent judgements about what they can see, learn and experience.

In order to achieve greater 'openness' and 'truthfulness', the museum would need to monitor fairly continuously its visitors and their reactions to the displays, in order that it should itself learn if it is succeeding in 'communicating' – in sharing – the knowledge of its staff. Deploying methods to monitor 'communication' presupposes an awareness of visitor psychology in equal proportion to a knowledge of the history of art. It implies the need for a reversal of the curator's traditional, even if unspoken, assumption that if visitors do not appear to grasp the meaning of a display, or the nature of a development in style, they must be left on their own until they change their perception. It requires museums to change their approach and methods in order to accommodate the speeds and styles of learning of today's visitors, because the clock cannot be turned back to the spirit, and the attitudes, of early nineteenth-century museum visiting.

The curator's task of organising displays should also take into account the nature of the physical strain as well as the psychological barriers which affect visitors' attitudes and behaviour. The use of an 'advance organiser' – a display or device to set visitors thinking about what they are going to see – should come at the outset of a sequence (and even more so at the beginning of 'blockbuster' temporary exhibitions).[28] This is because – as innumerable 'tracking' studies have shown – there is a pattern to most visitors' fatigue, which sets in soon after the first few rooms, and often leads to quasi-drunken ambling past the final displays. This fatigue and consequent loss of attention is frequently exacerbated by the general uniformity of display patterns, the at times obsessive symmetry of 'hangs', and the effort needed to read labels. It is further aggravated by a studied curatorial inattention to high and low points in significance – supposedly because 'one should not tell visitors what to think', but more probably because of a belief that the peer group should be permitted to savour the 'challenge' of forming opinions on its own – and by the frequent failure of displays to anticipate points where visitors will be obliged to bunch together. Instead of providing a helpful 'synopsis' of the display-to-come in the first or second room, in order to assist visitors to pace themselves, displays are usually extended over a lengthy series of rooms, each of equivalent importance and near-symmetrical appearance. It is as if the curator imagined that visitors would arrive in each room with a fresh, invigorated eye and no one to get in the way of their viewing. The only people who ever enjoy such conditions

to perfection are curators – before or after opening hours to the public!

The synopsis of the display-to-come might also indicate the organisational principles of the sequence of rooms, and of the hanging, the reasoning behind these principles, and how the rooms will be labelled. The sequence might be interrupted by 'reorientation' rooms, and/or rooms for rest and discussion in order to alter the pace of the viewing and enable visitors to ask questions (of themselves or of others), to check that they have grasped what the curator intended them to, and if they have not, to catch up on it rather than risk losing the thread entirely. Key points in displays could be highlighted, or even isolated in rooms with tiered seating, in order to allow visitors to contemplate one or more works at their ease, without interruptions or obstructions. While acknowledging the general shortage of space to show enough of museums' holdings, there is an equally pressing need to recognise and cater for fatigue, and to offer opportunities for recollection. Alternatively, and especially in the case of large works, pictures could be raised from eye-level viewing to a height above visitors' heads, so that more people could see them unhindered at the same time.

The question of labelling needs careful consideration, too, and there are already a great number of studies which address this. Several non-art museums have experimented successfully with the range of possibilities – size and colour of type, length of lines, and the nature of information – in order to make the absorption of a concise text as effortless as possible, without altering the text's purpose as a stimulus to looking (again). The physically exhausting, conversation-killing and visitor-humiliating process of searching for the minuscule label which, when located, provides only taxonomic information, is only ideal for the most exclusive and expensive of commercial galleries (and those artists' studios which only the committed are allowed to frequent, and curators who like Courtauld-Institute-degree standards of picture tests).

Because these considerations are little more than the banal devices of display techniques to accommodate human frailties, they are often ignored by curators. But it is the manipulation of content – or perhaps I should say the suppression of context – which is equally detrimental to the quality of visitors' experiences. Franz Schouten warned against failing to provide a sufficient connection to the visitor's viewpoint, since ignorance of viewers' 'cognitive structures' (i.e., the way they assimilate information and order it in their minds) could lead to oversight or rejection of the visual narrative which is being offered. Quoting Levin, he explained that, ideally, in order to impart new information, the visitor's stock of

knowledge needed to be 'unfrozen, moved and refrozen' by first stimulat-
ing curiosity, then imparting new information in carefully gauged mea-
sures which the visitor could take in, and concluding by situating the
new information in the wider context which had resulted. Or, as Tilden
of the US National Parks Service has proposed, there could be five simple
points to guide any museum interpretation/visitor relationship:

- to relate interpretation to visitor experience;
- to reveal the life behind the artefact;
- to present the interpretation imaginatively;
- to provoke the visitor's thought rather than simply instruct;
- to draw the larger picture in your interpretation.[29]

Not unjustifiably, curators may object that this would call for more
skills than they at present possess. However, while this may be true, it
should not be a reason *not* to learn about more effective ways to meet
visitors' expectations, and to aim for broader contextualisation. At one
of the leading American museums of material culture, the Strong Museum
in Rochester, New York, a new extended temporary exhibit (designed
to remain installed for more than a year) – 'American Dining [in the
later nineteenth century]' – was jointly

planned by a team consisting of a curator, a designer, a historian, and an
educator. . . . The objectives were written in measurable terms: what visitors
were to do, under what circumstances they would do it, and what the outcome
would be. We wanted to find out if the exhibition taught effectively, what it
taught, whether the artefacts and interpretive materials were presented in a
manner which enhanced learning, and what behaviours the visitors engaged in.
 To find out, visitors' traffic patterns were tracked and recorded on a floor
plan of the exhibit to determine the attraction and holding power of key artefacts.
Visitors' understanding of the main concepts was tested through a questionnaire.
. . . Did the artefacts and the methods by which they were displayed motivate
visitors to spend time looking at and reading labels in the gallery?[30]

Recognising the primacy of the artefact itself, the Strong Museum has
adopted an in-house rule that no label should be longer than sixty-five
words, but its close juxtaposition of object and text is deliberate. One
of the purposes of the museum is to ensure that

visitors who are usually attracted first to the artefact will find it easy to under-
stand something of the cultural meaning embedded within those materials . . . we
see material culture as a physical manifestation of some fragment of the culture's
intellectual or ideological position . . . these ideas embedded in material reality
are not necessarily consciously known by the individuals who made or used
them, but they are present nonetheless.[31]

The Strong Museum's approach is not that novel. Indeed, some readers may be surprised to be reminded that such attention to visitor behaviour and to 'communication objectives' has been more widely applied in non-art museums, and has been written up in some detail in the Museums Association's *Manual of Curatorship*.[32] Also, the development of a broader setting for works of fine art has a longer history than the experience of most of today's curators. In its modern sense, it can be traced back to the installations of the new Kaiser Friedrich-Museum in Berlin in 1904, under the directorship of Wilhelm von Bode (who himself had been inspired by those of the Victoria and Albert Museum in its pre-1909 arrangement). This manner of the broader setting was continued by Bode's assistant W. R. Valentiner, later to become director of the Detroit Institute of Art in 1921, and then by Sherman Lee, who moved from Detroit to become director of the Cleveland Museum of Art, retiring in 1984. Drawing on the traditional method of presenting non-European – in this case Far Eastern – arts and the rearrangement of the sequence of Western art galleries in 1970–75, Lee aimed

to use consistently the one crucible that unifies seemingly disparate objects into a meaningful configuration – history, the placement of the object with its peers in space and time. The artificial separation of works of art by media – painting, sculpture, decorative arts, prints, drawings – has long been used in most museums, including our own. But the simple fact remains that, for example, an Italian painter of the Quattrocento was influenced by sculpture, prints, metalwork and other media – indeed the painter may also have been a sculptor, a designer of metal objects, and an architect. The common factors in the art of any period are the forms of art known to the artist – the artist's motivations, the accepted fund of vision, imagination and thought. These make up what he took for granted as well as what stimulated him to change in the constant metamorphosis of styles of art. Thus it is essential that Renaissance bronzes be *near* paintings, stone sculpture, drawings, textiles, furniture – all equipment in the artist's train.[33]

One might go on to surmise that – in order to promote the non-specialist's grasp of the sources of inspiration and the history of twentieth-century art – it could also be enlightening to situate works of our century near to, or occasionally in the middle of, some of their sources of inspiration and/or their contemporary surroundings. Thus, not only might such works be joined with architect-designed furniture but also with African masks, Japanese haiku, Indonesian ikat, or film and photography, typography, precision engineering, and so on. A possible loss of mystery for some of the more connoisseurial visitors might be more than compensated for by a gain from contextualisation for those less knowledgeable.

Further, and more unusually, with the objective of promoting the understanding of the several levels of meaning to which works of art may make allusion, one could imagine a series of semi-permanent displays, running concurrently in the same museum, which used works by the same artist, school or style, in different contexts.[34] Thus the principal rooms of a museum, traditionally devoted to an exposition of the history of art by means of whatever is in the permanent collection, and habitually arranged chronologically into styles and schools, might be shrunk into a small core display, so that those who needed to refresh their eye for stylistic signatures denoting authorship and 'ism'-labels could do so with brevity and concision. In the meantime, the major part of the permanent collection thus released would be being continually — that is to say, possibly every two or three years — resited in different thematic contexts, and accompanied by reasonably priced publications, each elaborating on possible cultural meanings in fresh juxtapositions, which need not be restricted to fine-art media in isolation.

The objective of such a rearrangement is one which doubtless would be shared by almost all curators: that of conveying to visitors, and thus trying to share with them, an awareness of the meanings, life-enriching qualities and possible relevance to their own lives of works of art which museums hold in trust. It is my opinion, for which there is practically no contrary evidence, that thus far not many art museums have begun to achieve this aim through their traditional methods of private gallery/ private collection style of hanging — even for those who do venture inside their doors. Furthermore, there is still a large majority of the British public that never ventures inside because, given the art museum's enigmatic presentational language, 'it is not a place for the likes of us'.

Evidence of the effectiveness of present displays or of deliberately innovative approaches could only be gathered if art museums were to begin, regularly and consistently, to survey both inside and outside their doors, while simultaneously experimenting with displays and with variations in methods of publicity, and to analyse and evaluate the changes in the responses of habitual visitors, newcomers and the museums-shy. It is true that a potentially useful amount of research appears to have been carried out inside museums — though consideraby less in *art* museums — but very little has been followed through, or has noticeably altered curatorial behaviour or curatorial career goals. For example, how many art museums in Britain know about, and have attempted to broaden, the profile of their visitors? How many visitors come once only, or how many, in any significant sense, visit repeatedly; and of the

latter, how frequently do they return (this information would also be of value in making sense of visitor figures)? How long do these visitors aim to spend, or how long do they think they like to spend, on any museum visit? What did they think they were coming to see? Did they find it, and did it match, exceed or disappoint their expectations (and whatever the outcome, what will the museum do in response to these findings)? In 1987, Gayle Kavanagh could still write:

The truth is that we know relatively little about what draws people to museums and what they get out of them. What research is available to us would appear to suggest that visitors have a fairly low expectation of museums. Because of this, people will visit museums, taking a fairly uncritical stance on what they see. . . .

This lack of criticism and direct response from visitors leads to a number of assumptions, not necessarily justly held. The first of these is that the public are a uniform mass of people who are of like mind to the people who put the museum together. The second is that the visitor is there to receive the information and absorb the view offered by the museum. The third is that the public is satisfied with what is on offer and therefore implicitly cannot or will not cope with more challenging subjects or ideas (by which I do *not* mean longer labels). Each of these are essentially flawed assumptions.[35]

It is also a matter of the museum posing itself the right questions. The institution would have to decide what issues need answering before it formulates some of its questions. Then it should try a test run to see whether the answers to these questions are relevant and useful, and whether they will help it to address the problems or uncertainties that have been uncovered. As an instance of a prosaic but nevertheless telling discovery while evaluating 'American Dining', the Strong Museum found that:

12 of the 14 visitors interviewed, however, missed the abstract ideas of the exhibition. For example, they demonstrated no understanding of middle-class Americans' need to master the rules of etiquette in order to gain social mobility in the nineteenth century. In fact, most visitors did not know the meaning of the word *etiquette*. . . .

As a result of the pilot project . . . we decided that front-end and formative evaluation would be more efficient in terms of staff time, energy and finances.[36]

Understandably, though, the harassed and overworked curator might well ask, 'Why all this concern – and why put at risk the dignity and detachment of art by attempting to demystify it and its institutions – when visitors in art museums rarely seem to query or object to what is offered at present?' I hope that it is evident that my reasons for concern are as firmly grounded in considerations of academic standards as they are in

political wisdom and social justice. It is not simply that Britain in the 1980s has experienced a government which claims to admire a tendentiously selective revival of 'Victorian values', while also commendably questioning the previously-held-to-be-unquestionable. In pursuit of such 'values' (e.g., the fairground 'pay-for-what-you-use' principle) the present Government, or one of its successors, might one day decide to take the lid off the intimate collaboration of interested groups that allow art museums to determine which constituencies shall benefit most from their services, while affecting to ignore why a significant proportion of the population does not share in what museums themselves claim are among 'the (Western) world's supreme cultural achievements'.

And, lest the reader think that the motivation behind this essay is simply a concern to see (public-sector) art museums mimic the 'independent' museums sector and the leisure industries by charging for, and providing, 'an entertaining experience', let me restate its more serious purpose. For art museums, neither introducing entrance charges nor providing entertainment should be taboos. Indeed, they might contribute to the broader purpose of museums. But, in anticipation of the inevitable moment when the values of the present Government – its *sauve-qui-peut* materialism and carelessness with social, cultural and spiritual values – will be reappraised, it may be wise for art museums to look more closely at the restricted groups who seem to derive most benefit from their collections. With the advent of poorer but wiser and more far-sighted governments, it is possible that cultural programmes may once again be funded with plausible, if not exactly realistic, budgets. Given the exponentially increasing sum of information and knowledge becoming available to their potential visitors in the world outside, art museums should not then be found in that '(Late) Victorian values' posture of pretending that art is purely an aesthetic experience and, by its own nature, essentially self-referential. To negate the multiple social and political contexts within which the creation and the preservation of art take place is not merely to shore it up against interference but, in the long run, to marginalise it as the preserve of those with privileged education and exclusive cultural assets. It may make life simpler for curators, but it insults the vision and the sometimes unconscious 'engagement' of artists as observers of, participants in, and commentators on the world which they inhabit, and it censors the meanings that their work may have for contemporary and subsequent generations.

In the article cited earlier, Wolf drew attention to the former president of the American Psychological Association, Donald Campbell's

. . . notion that a reforming society is one that constantly and creatively experiments with itself to learn from its mistakes and capitalize on its strengths. Within the museum field, one of the ways to experiment is through the application of new evaluation strategies. Evaluation should be used regularly by those institutions that desire to be responsive to the changing demographic and psychographic (attitudes, values, preferences, interests, and beliefs) characteristics of their publics. Some museums do not use evaluation. Others tend to use evaluation at the end of a project, typically to determine a measure of 'success'.

Thus an alert museum would already have been in advance of its public, asking itself questions, aware of the changing habits of visitors in other contexts, and seeking to complement them on its own terms, instead of bewailing change, or pandering in a half-hearted way to populism with hastily cobbled-together gimmicks, as a means to lull visitors into liking what those who work in such institutions hold to be good – that is to say, what those museums already happen to own and wish to study. However, in getting ahead of its public, the museum may be hindered by its structural and bureaucratic problems. Even if the curator recognises that the social and class characteristics, and the expectations, of visitors have changed since he or she trained, that the channels and pace of information supply have multiplied, and that the nature of the knowledge that visitors desire to acquire may have altered, what can she or he do about it?

In his most recent book on museums, Kenneth Hudson defined five global problems which he saw as preoccupying mankind over the next twenty to fifty years (the last two being of particular concern and relevance to museums):

1. the degradation of the environment;
2. the concentration of power in the politico-military machines of the USA and the USSR;
3. the failure of decolonisation;
4. the increasing divide of knowledge between the layman and the specialist, to the exclusion of the former;
5. the self-protection of people of power and influence with generalisations and fobbing-off.[37]

Among the better-endowed art museums (such as the national institutions in Britain) – or those which might band together to share information – which ones are tackling the areas of research into interpretation and success in communication with significant resources? Already the mixed-discipline national institutions, the Victoria and Albert Museum and the British Museum, run departments of 'public services', and the Curators' Building Group of the former has at least issued 'Guidelines

for gallery teams and departments' – as part of a developing corporate strategy – to help brief designers for future gallery developments. Such basic co-ordination of an approach to interpretation appears not yet to have found a focus in the fine-art-only national institutions, so what hope for regional or local museums with fewer staff, lower pay scales, smaller budgets and less rich collections? Ironically, as some observers may attest, on occasion those less well-endowed museums have been the ones to think laterally, to experiment, to innovate and to set an example to their richer peers.[38]

To sum up: in order to improve the quality of visitors' experiences in art museums, there is a need for more serious attention to be given to the following areas:

- a research programme to examine the effectiveness of displays – and ways to improve them, if necessary. In fact, more than enough relevant research – let alone exhortative essays like this one – already exists. What has been lacking is the interest, and then the determination, of those who have the power to implement this research actually to do so. All too often one has heard curators exclaim 'but we know that anyway' or 'we've heard it all before'. This, it seems, excuses them from doing much that is new. Whether this is because it wasn't their idea originally, or perhaps because it will attract the opprobrium of the peer group and its supporters (collector-trustees, artists, art critics, art dealers) who effectively determine what form museum career ladders will take, is unclear.
- a change in museum staffing structures to overcome such inertia or indifference. It may mean the downgrading of the curator/art historian to equal status with the researcher/interpretation specialist, the designer/cognitive psychologist, the educator/communicator and the historian/anthropologist, in the interest of achieving certain declared objectives for success in the museum's programme and activities. It may also mean the retraining, or removal, of certain members of the staff or of the governing body, where the museum's more broadly redefined objectives are seen to require new areas of scholarship and new skills for a public service institution. Given the pace of development and change in the late twentieth century, how appropriate is it that the world-view of a substantial majority of decision-takers should have been formed before the loss of the British Empire?
- The mixing of non-fine-art with fine-art disciplines, in order to keep

abreast with a non-art historian perception of history and culture. It was certainly understandable, and may have been right, that mono-disciplinary institutions were needed in the eighteenth and nineteenth centuries, so as to provide the loci for establishing particular structures or sequences in new (natural-, scientific-, anthropology- or art-centred) histories, where those groups, classes or races who 'owned or acquired, and thus controlled' the source material could choose the constructions that were to be put on it. Already today, and increasingly in the future, as mono-European races catch up with, or overtake, Europeans, these non-disciplinary constructions deserve re-examination. This applies as much to nationalistic notions of 'heritage' (and to Britain's privileged historical and economic opportunity, which enabled it to blow the whistle at the moment when it had amassed an inordinate amount of the world's cultural property, and pretend to outlaw further exchanges and looting) as to the context and interpretation placed on non-European cultures by Europeans. A desire to explain (and exploit) the uses of the late twentieth-century technologies – including replicas – for the benefit of visitors, would signal in part that shift of emphasis in museum circles, which Danielle Rice suggested, from 'owning' to 'interpreting'. The mixing of disciplines – such as social history, economics, or the anthropology of European societies, with art history – would help to narrow the gap between those classes who naturally understood, or who had been initiated into, the mysteries and unspoken whys and wherefores of the history of art and those who are unable to fathom who canonised 'important milestones/masterpieces in art', and why.

- A recognition of differences in class and education would be the key to releasing more, and variously angled, information resources. The present fiction in museums – that every visitor is equally motivated, equipped, and enabled 'to experience art directly' – should be abandoned. It is patronising, humiliating in practice, and inaccurate. In order to encourage the acquisition of knowledge and understanding in museums – especially today, when so many other attractions compete for visitors, and make the effort to measure and match their needs – something more than the traditional curatorial 'hands-off' approach is called for. The search for ways in which to cultivate and then satisfy inquisitiveness could begin, at the most basic level, with curators learning from the warding staff (a museum's single, most significant, wasted asset) about how people react to 'hangs' in galleries, what they appreciate and what they overlook, what they most want to know more about,

and what hiatuses they find puzzling or incomprehensible. Since at present the warding staff, even more than the information desk, are those closest to visitors at the moment when they make contact with works of art, the curator could usefully build on warders' experience, and train them for specific duties of observation and reporting, in order to assist the museum in pursuing some of its declared objectives for success.

- A reorganised or redesigned building for non-art historian visitors, which would be more than an architect-designed warehouse (with little or no seating) or an architectural showpiece – even though both have their merits. The need for such reorganisation would become clearer once an 'orientation area' had begun to function, because addressing the nature and quality of the experience that visitors may expect will call for closer attention to their information needs, and to the differing levels of thinking skills that may reasonably be demanded of them. This in turn will necessitate attention to visiting patterns, comforts and foibles, and to adapting rooms for more closely specified interpretation and communication goals, as well as to their sequential arrangement. The positive identification of sites or sequences which cause misunderstanding, confusion or irritation to visitors will be the first signs of the museum's success in this area of endeavour.

Assuming, as one is entitled to, that curators possess in equal measure intellectual honesty and a dedication to public service, their increasing attention to analysing the museum's shortcomings in visitor services – rather than to the desiderata for their specialism within the collections – could be the first step towards improving the quality of visitors' experiences in art museums.

8

Museum Visiting as
a Cultural Phenomenon

NICK MERRIMAN

A consideration of the recent literature on museums and the 'heritage debate' shows that most analysis has taken the form of critical reviews of the messages inherent in contemporary museum presentations, with little concern being demonstrated for the experience of those who actually visit them. We do not therefore know how people use museums and whether they assimilate the messages, intended or unintended, that museums give out, and consequently museums and exhibitions are rarely planned with a clear understanding of the composition and expectations of their clientele. This has been noted recently by Eilean Hooper-Greenhill[1] who points out the relatively unsophisticated nature of research into museum visiting in Britain, and in particular, the lack of a large-scale survey of the general public and its uses of museums.

In 1985 I attempted to remedy this lack of information by implementing a national survey of attitudes to, and uses of, heritage in Britain.[2] The survey was explicitly designed with the aim of developing a theoretical framework within which to understand the cultural meaning of museum visiting, as it was felt that most earlier museum surveys remained at the descriptive level owing to the absence of such a framework. An interim summary of results and an exposition of the survey design has already appeared elsewhere.[3] Now that the full results of the survey have been written up[4] it is possible to return to the central aspect of the work, the cultural context of museum visiting, and examine it in greater detail. In doing so, some arguments presented in my earlier article are here expanded, and some are revised in the light of more recent developments. It is now clear, for example, that any understanding of museum visiting in our society will not only have to explain why some groups consistently stay away from museums, but also, in the light of the demonstrated boom in heritage presentations,[5] why museums are becoming increasingly popular with a wider range of people than ever before.

Incidence of museum visiting

The survey found the yearly incidence of museum visiting in Britain to be between 40 and 58 per cent, with 47 per cent being a likely actual figure.[6] However, it was noted that definitions of museum visitors on the criterion of visits over a twelve-month period alone could be misleading and that it is important to establish whether 'non-visitors' never visit museums, or whether they simply visit at a frequency of less than once a year. Accordingly, respondents were asked when they had last visited a museum, and it was found that a total of 82 per cent of the population claimed to have visited a museum at some time in their lives (Table 1).

TABLE 1 *When respondents last went to a museum*
'When did you last go [to a museum]?'

FREQUENCIES	(%)
Within the last 4 years	68
5–10 years ago	5
11–20 years ago	4
21+ years ago	4
Never	18
	100% (sample size N=956)

The fact that most individuals who would be classified as non-visitors on the basis of visits in the course of the last year have in fact visited a museum at some time does suggest that museum visiting is indeed a mass activity, as the authors of a Canadian survey have argued.[7] What is less certain, however, is what proportion are still active museum visitors. It was not possible to determine whether those who have not visited a museum for several years are likely to visit again at some stage, or whether they have been deterred by their last experience. Figures for those who are no longer active visitors could range from 32 per cent of the population, if it is hypothesised that those who last visited over five years ago are unlikely to go again, to 18 per cent if it is restricted to just those who have never visited a museum. Nevertheless it is significant that between a third and a fifth of the population can be estimated to be true non-visitors in the sense that they either never have visited a museum, or never will again.

When museum visiting is examined over a greater time-depth, it is

clear that the use of annual visiting incidence as the criterion for distin-
guishing between visitors and non-visitors is inadequate. This may ex-
plain why, in her survey of museum visiting, Marilyn Hood finds that
the characteristics and attitudes of her occasional participants are closer
to those of non-participants than of frequent participants.[8] They may
in fact be the same sort of people distinguished into two groups by the
arbitrary cut-off point of one year. Rather than dividing museum partici-
pants into three groups, it may be more accurate to isolate five: frequent
visitors (visit three or more times per year) who comprise 17 per cent
of the sample, regular visitors (visit once or twice a year) comprising 37
per cent, occasional visitors (last visited between one and four years ago)
comprising 14 per cent, rare visitors (last visited four or more years ago)
also 14 per cent, and finally non-visitors (never visited a museum) who
make up 18 per cent of the sample.

It is important to note, however, that exact figures of national museum
participation are difficult to determine because no general population
surveys previously conducted (including this one) have taken into account
school groups, other visitors under the age of eighteen, and overseas
visitors, because there is no adequate frame such as the electoral registers
from which to sample. Together they comprise a very substantial pro-
portion of the museum-visiting public. For example, the Museums
Database Survey found that children account for a third of visits to local
authority and independent museums and a quarter of visits to national
museums,[9] and in Canada organised school groups account for between
10 and 40 per cent of visits to different museums.[10] In addition, a survey
of visits to tourist attractions in England found that 22 per cent of
visitors to museums and galleries were from overseas.[11] Consequently,
the characteristics and attitudes of perhaps around half of the public
who visit museums are unknown.

As absolute figures of museum visiting are difficult to obtain, the main
aim of the survey was to produce a representative database which would
allow systematic *comparison* of the attributes and attitudes of different
adult participant groups.

Main characteristics of museum visitors

Table 2 presents the demographic characteristics of the five types of
museum visitor. Gender is not statistically significant in distinguishing
between the different types, and is not presented here. The results confirm
on a national scale the findings of smaller surveys concerned with

museum visiting. The most frequent museum visitors tend to be of high status, to have received tertiary education, and to be students or in work, while those who rarely or never visit museums tend to be the elderly, those of low status, to have left school at the earliest opportunity, and to be looking after the home or in retirement. The occasional visitors (those who last visited a museum up to four years ago) are the most homogeneous group, while the regular visitors (those who visit once or twice a year) tend more towards the characteristics of the frequent visitors. Age seems to be the strongest factor in influencing the frequency of museum visiting, with the low-status elderly being the group least likely to visit museums. The characteristics of rare visitors seem to be closely similar to those who have never visited a museum, but it is useful to maintain them as separate groups in order to compare the attitudes of those who have never visited a museum with those who have.

TABLE 2 *Museum visiting by age, status, education and activity status (%)*

| | TYPE OF MUSEUM VISITOR | | | | | | |
AGE (%)	Frequent	Regular	Occasional	Rare	Non-visitor	%	N
‹35	20	39	16	14	11	100	300
35–59	20	42	12	9	16	100	374
›60	10	25	15	21	29	100	271
STATUS (%)							
High	25	41	14	10	9	100	150
Middle	17	40	13	13	17	100	605
Low ‹60	12	25	22	16	25	100	85
Low ›60	8	19	13	23	38	100	92
EDUCATION (%)							
Minimum	13	35	15	16	21	100	651
Stayed on at school	22	40	14	11	13	100	150
Tertiary education	32	41	10	11	6	100	123
ACTIVITY STATUS (%)							
Full-time work	20	42	13	11	14	100	435
Part-time work	18	35	4	3	3	100	88
Housework	11	39	11	18	21	100	117
Student	56	19	13	6	–	100	16
Unemployed	16	35	20	13	14	100	69
Retired	12	25	15	19	28	100	221
ALL (%)	17	37	14	14	18	100	949

Reasons for going to museums

Respondents' unprompted reasons for going to the last museum they visited could be divided into eleven basic categories (Table 3). Although they are not all mutually exclusive, the figures do nevertheless suggest that the largest group of museum visitors visit because of a specific interest in the subject of the museum or in one of the exhibitions in it, or because of a general interest in, for example, museums, history or art. Visiting also has important social aspects, in that 12 per cent went as part of their sightseeing, and 12 per cent went to take others. Casual reasons for visiting the museum (to shelter from the rain, or use the toilets, etc.) only account for a small proportion of visitors' motivations.

Reasons for visiting museums vary significantly with the type of visitors. The keen, frequent visitors were much more likely to have gone on their last museum visit because of a specific interest, while those who just visit once or twice a year were much more likely to have gone as part of their holiday sightseeing. Those who last visited between one and four years ago were more likely to have gone for non-specific reasons such as 'general interest' or because it was nearby. Finally, the rare visitors who last visited five or more years ago were likely to have gone for casual reasons (to pass the time, to shelter from the rain), or for part of a course of work or study. The more frequent the visiting, then, the more specific the reason for the visit, and the less frequent the visiting, the more likely that it was undertaken for casual reasons not related to the museum's aims, or with the school when the visitor had no choice.

TABLE 3 *Reasons for last museum visit, by type of museum visitor*
'Why did you go to that particular place?'

| | TYPE OF VISITOR | | | | |
REASON FOR VISIT	Frequent	Regular	Occasional	Rare	ALL
General interest	13	20	23	14	18
Specific interest	35	22	18	18	23
Sightseeing	8	16	10	7	12
Because it is nearby	10	11	15	9	11
For self-education	2	1	1	3	1
For work-study	6	3	8	22	8
To take others	11	13	13	13	12
A return visit	5	6	–	–	4
To use facilities	–	–	2	–	1
Casual reasons	6	5	7	10	7
It was recommended	4	3	2	3	3
	100%	100%	100%	100%	100%
(SAMPLE SIZE N)	(156)	(341)	(132)	(122)	(762)

Attitudes towards museums

It is only when we move beyond the production of statistics about visitors' characteristics to actually questioning them on their feelings about museums and the experience provided by them that we can start to work towards an understanding of the museum visit as an activity in the context of wider British culture. Accordingly a large part of the survey studied this issue. Questions were divided into two sections: those concerned with attitudes to the museum's displays and other facilities, and those concerned with people's wider image of the museum as an institution.

There are significant differences between different types of visitor in attitudes towards museum displays. For example, while overall, 21 per cent agreed that there are too many words to read in museums, only 8 per cent of frequent visitors agreed, compared with 27 per cent of rare visitors and 40 per cent of people who had never visited a museum (Table 4). The attitude of the latter group is interesting because it must be based on images received from family, peers and the media rather than personal experience, which suggests that a generally diffused negative image does affect museum participation (see also Table 5 below).

A similar effect is seen in attitudes towards museum attendants. Rare visitors (46 per cent) and non-visitors (52 per cent) were significantly more likely than the other groups to agree that museum attendants were like guards.

TABLE 4 *Attitudes to the amount of text in museums,*
by type of visitor (%)

'There are too many words'

TYPE OF VISITOR (%)	Strongly agree	Agree	Neither	Disagree	Strongly disagree	%	N
Frequent	1	7	13	53	26	100	160
Regular	1	16	12	58	12	100	344
Occasional	3	11	19	60	6	100	132
Rare	4	23	16	53	4	100	125
Non-visitor	6	34	23	33	5	100	148
ALL (%)	3	18	16	53	12	100	909

There are some aspects of the presentation inside museums that produced general agreement. For example, a total of 58 per cent of respondents agreed that presentation in museums can be dull, with only 34 per cent

disagreeing. There is no significant variation amongst the various visitor types: the same proportion of frequent visitors agreed as non-visitors. This does suggest that museum visitors, despite being committed to museums, can still be critical of their experience. Later in this essay it is argued that for certain social groups, museum visiting is just one of the leisure activities they are socialised into doing: they may go because it is 'one of the things they do' in spite of sometimes finding the experience dissatisfying.

The museum's image as an institution

In the interim summary of the main results of the survey, it was shown that there were very clear divisions between visitors and non-visitors in the associations of the word 'museum', and in attitudes to the atmosphere and relevance of the museum.[12] Here this can be treated in a little more detail and the attitudes cross-tabulated with the extended typology of visitors.

To gain an impression of people's images of the museum as an institution, respondents were asked to tick which institution a museum reminded them of most from a list built up from earlier informal interviews and a reading of previous surveys. Respondents were split three ways between those associating the museum with a library, those seeing it as most like a monument to the dead, and those seeing it as one of the other choices (Table 5). The more frequently respondents visit museums, the more likely they are to associate it with a library; the less frequently they visit, the more likely they are to associate it with a monument to the dead.

This latter image definitely demonstrates a negative attitude towards museums, and agreement with it indicates the persistence of a popular 'deathly' image of museums which is investigated further below. As the image is so strong amongst people who have never visited a museum, it must be assumed that the attitudes of peers and family are again important influential factors in attitude formation, as well, of course, as the images promoted by the media.

The image of the library may be seen as positive or negative. It does perhaps suggest a place of quiet learning and contemplation, rather than a place of enjoyment and entertainment. The overall image of museums amongst both active visitors and rare or non-visitors is still predominantly one of quietness, studious for the first group and deathly for the second.

TABLE 5 *Image of museums, by type of museum visitors (%)*
'Which of these things do museums remind you of most?'

	TYPE OF VISITOR					
TYPE OF INSTITUTION	Frequent	Regular	Occasional	Rare	Non-visitor	ALL
Monument to the dead	17	28	43	48	47	34
Community centre	6	3	1	2	2	3
Church or temple	10	8	8	13	14	10
School	12	12	10	6	12	11
Library	44	40	32	23	24	35
Department store	4	–	–	1	–	1
Other	9	9	6	6	2	7
	100%	100%	100%	100%	100%	100%
(N)	(158)	(340)	(130)	(127)	(157)	(913)

Answers to a question on the atmosphere of the museum were consistent with the distribution of these positive and negative images. The great majority (78 per cent) of frequent visitors agreed that museums have a pleasant atmosphere and only 7 per cent disagreed, compared with 58 per cent of rare visitors who agreed and 22 per cent who disagreed. Non-visitors were even less likely to agree (39 per cent), and 20 per cent disagreed, with the largest group (41 per cent) neither agreeing nor disagreeing.[13]

Of all the attitudes to museums solicited in the survey, the one producing the most significant variation in answers was that about the relevance of museums to our daily lives. While overall only 25 per cent of respondents felt that museums have nothing to do with our daily lives, 55 per cent of non-visitors and 38 per cent of rare visitors agreed, compared with 11 per cent of frequent visitors and 13 per cent of regular visitors (Table 6). This strongly suggests that one of the more important factors in influencing whether a museum visit is undertaken is the museum's perceived relevance to the individual.

Factors in museum visiting

Having demonstrated a number of differences in attitudes towards museums amongst different types of visitor (and non-visitor) it is important to be able to assess what sort of things attract people to museums more than others, and what sort of things deter some people. In my earlier article it was argued, following David Prince,[14] that structural and

cultural deterrents should be distinguished. The structural factors assessed were respondents' age, and availability of museums and transport, and the cultural factors studied were interest in the past and images of the museum. It was argued that, overall, cultural deterrents were more important than structural ones.[15] With a fuller analysis, it is possible to add statistical weight to this argument by including additional structural and cultural factors such as ability to pay and attitudes to the past and present. Regression analysis showed that structural factors such as access to a vehicle and feelings about paying for admission do not play a primary rôle in determining museum visiting, perhaps because there are sufficient numbers of free museums available locally for most people to visit should they wish. It was not possible to include availability of museums in the analysis, but a separate examination suggested that effects were not consistent and that it was not a crucial factor.[16] Sex also has no significant effect, as has been shown by previous cross-tabulations.

TABLE 6 *Attitudes to the relevance of museums,*
by type of visitor (%)
'Museums have nothing to do with our daily lives'

TYPE OF VISITOR (%)	Strongly agree	Agree	Neither	Disagree	Strongly disagree	%	N
Frequent	1	10	7	61	23	100	160
Regular	2	11	10	67	11	100	344
Occasional	2	27	15	47	9	100	132
Rare	6	32	9	50	3	100	126
Non-visitor	14	41	12	27	6	100	155
ALL	4	21	11	54	11	100	917

Of those variables that do have a significant effect on visiting, analysis shows that the strongest factor in museum visiting is whether an individual feels that the past is worth knowing about. Simple cross-tabulations showed that 91 per cent of respondents felt it definitely or probably worth knowing about the past,[17] but when this is cross-tabulated with types of visitor, it becomes clear that over a quarter of non-visitors are not interested in the past (Table 7), and this may explain their absence from museums. However, around three-quarters of non-visitors, and 83 per cent of rare visitors still declare themselves to be interested in the past, so their absence cannot be explained simply by lack of interest.

Rather, interest in the past is the first condition for museum visiting, such that people who are not interested in the past will tend not to visit museums, but some people who are interested in the past will still be deterred from going.

TABLE 7 *Interest in the past, by type of museum visitor*
'Is it worth knowing about the past?'

TYPE OF VISITOR (%)	Definitely	Probably	Perhaps	No	%	N
Frequent	93	6	1	—	100	158
Regular	88	10	2	1	100	348
Occasional	84	10	4	2	100	133
Rare	68	15	10	8	100	128
Non-visitor	49	24	16	11	100	160

The next most important factor in determining whether museum visiting is undertaken is the individual's attitude to the experience provided by the museum, followed by the image of the museum and the individual's age, which have approximately the same independent effect. As might be expected, the more positive one's attitudes to, and image of, the museum, the more frequently one is likely to visit. Age has a negative effect; in other words, the older one is, the less likely one is to visit. Table 2, however, shows that this effect is mainly concentrated amongst those who are over sixty.

After age, the demographic variable with the most important independent effect is education. As the survey has earlier suggested, the longer the formal education received, the more frequently visiting occurs. The next significant factor affecting museum visiting is the individual's attitude to the present, which is more important than attitudes to the past. Contrary to those who might see museums and visiting heritage as a refuge for those with unfavourable views of present-day society, who are nostalgic for yesteryear,[18] the survey shows that the more positive (i.e., favourable) one's views are of contemporary society, the more one is likely to visit museums. This has important implications for the interpretation of museum visiting put forward below, where it is argued that museum visiting is to a large extent undertaken to demonstrate cultural affiliations in the present, although this does not preclude a genuine interest in the past and in the subjects exhibited in museums. Finally comes housing tenure, with home owners more likely to visit museums than those who rent their accommodation. Although this could

be interpreted as a structural factor, standing as a fairly crude proxy for those who rent their accommodation being less affluent, the fact that respondents' feelings about paying to go into museums is not a significant factor tends to argue against this. Housing tenure is more likely to be an indicator of lifestyle, of the sort of cultural aspirations which render museum visiting a likely probability.

Approaches to the explanation of museum visiting

An attempt must now be made to explain exactly why it is that cultural factors predominate over structural ones in determining the extent to which museum visiting is undertaken. An adequate explanation has to show, for example, the derivation of adverse images of the museum amongst those who tend not to visit them. Two approaches predominate in the literature. One focuses on the leisure choices open to the individual given his/her background and circumstances, and takes its cue from work in cognitive psychology. The other focuses on larger social aggregates and is derived from cultural sociology.

The cognitive psychology approach to museum visiting is exemplified in the USA by the work of Marilyn Hood,[19] recently reviewed by Hooper-Greenhill,[20] and in Britain by the work of David Prince.[21] From this perspective, museum visiting (or non-visiting) is held to be most strongly influenced by the individual's attitudes to the museum. These attitudes are derived from the individual's perceived leisure needs, which in turn result from past experience and general life needs.[22]

Hood terms these individual values, attitudes and perceptions 'psychographic variables' and sees them as far more important than demographic variables in explaining museum visiting. She has isolated six major attributes underlying adult choices of leisure activities, such as meeting people, having new experiences and participating actively, and explored their relationship with museum visiting through a telephone survey of 502 residents of Toledo, Ohio. Her conclusions are that people decide whether or not to participate in museums on the basis of their evaluation of these attributes and on how they were socialised towards certain types of activities.

Hood's work is a useful contribution, but is flawed by her lack of concern with explaining why it is that the patterns she isolates actually occur. She argues that people make active choices in how they will use their leisure-time, but does not acknowledge any of the social constraints on leisure choices, which are apparently made quite freely.

Like Hood, Prince argues that leisure activities are used to satisfy

certain socio-psychological needs,[23] but he is prepared to place a greater emphasis on the social and environmental factors that shape these needs. Cultural, subcultural, family and peer-group influences all play an important rôle in forming leisure needs, and in determining the attitudes of the individual towards different leisure activities. In understanding museum visiting and non-visiting, then, the individual's image of the institution is a vital influence on the choice of whether or not visiting occurs.[24]

In a study of the use of countryside interpretation facilities, Prince suggests that individuals maintain a behavioural consistency in the sort of leisure activities they will undertake: those who use country trails are also likely to visit museums, nature reserves and craft centres. This consistency 'is rooted in leisure needs and nurtured by cultural orientation and subgroup allegiance through socialisation and the maintenance of self'.[25]

Prince's contribution to the study of museum-visiting patterns is important in several respects. His approach is first and foremost explanatory, and he therefore insists on the fundamental need for an explicit interpretative theory which places museum visiting in its social context. He notes the importance of taking structural factors into account in a full explanation of visiting patterns, but shows that it is the public image of museums that is the most important explanatory factor. At first glance it would appear that this approach is vindicated by the survey presented here, because attitudes have the strongest effects, followed by age, and only then do 'status' factors (education and housing tenure) come into consideration. However, in examining the survey results, it is necessary to ask where the attitudes and images of museums and the past come from, why they consistently seem to be associated with certain social groups, and to determine the exact nature of the relationship between images of the past, museum visiting, and ideas about the present. These problems are not fully answered in the cognitive psychology approach. Occasionally Prince attempts to explain the derivation of different attitudes and images of the museum when he relates them to age and social status, but these are left as apparently sufficient explanations; no analysis is made of the deeper social processes that structure age and class in British society and which lie behind the production of these images and attitudes.

This problem can be explained by the fact that the analysis focuses at the level of the individual. Such an approach makes it difficult to deal with larger social aggregates as entities in themselves, and thus the political

and ideological aspects of museum visiting tend to be ignored. The psychological approach is an apolitical one, treating leisure 'needs' as simply different rather than the product of a hierarchical culture. It shows the direction in which explanation of museum visiting should move, but in order to examine the problem more fully, it is necessary to take a wider approach that deals with social aggregates, and, crucially, takes the history of museums and their present cultural context into account. The work of Pierre Bourdieu provides a useful starting-point for such an analysis, as it attempts to understand museum visiting in its broader socio-political role, while at the same time placing great emphasis on the importance of individual socialisation – principally through family and school – as an explanatory factor.

Bourdieu's work over the last twenty years or so has been chiefly concerned with understanding the mechanisms whereby class-based power and privilege are reproduced. In the course of this work he has carried out analyses of students and the academic hierarchy, of school education, of taste and manners, and of museums and art galleries. In each he has developed a series of key terms which have to be understood when reviewing his analysis of the social rôle of museums. A cornerstone of his work is that social life can be analysed in terms of two mutually convertible forms of power, the symbolic and the economic. Economic power can only be mobilised through symbolic power, which is itself derived from the possession and accumulation of 'cultural capital'. The first kind of cultural capital takes the form of the taste, manners and style deriving from prolonged exposure to higher, or bourgeois, culture.[26] Aspects of this, such as connoisseurship and an aesthetic ethos, only come about through a long investment of time by parents and teachers. The second kind of cultural capital is the material manifestation of these cultivated 'dispositions', such as school and university certificates. These can act as an important medium of exchange between cultural and economic capital, because the investment of time and resources in the accumulation of cultural capital has an initial pay-off in the acquisition of educational qualifications, and, through these, an ultimate economic pay-off in the job market.[27] The specific way in which this works is best shown by examining the rôle of the educational system in legitimating the reproduction of hierarchical society, because, according to Bourdieu, it is education which most strongly influences museum visiting.

Bourdieu argues that one effect of schooling is to produce a culture of consensus, by which the maintenance of hierarchical social relations is (mis)recognised as natural and legitimate by all classes. He argues that

schooling imposes an arbitrary set of values (arbitrary in the sense that
they are not fixed or resident in nature) in favour of the dominant class.
Because the school has the illusion of neutrality this arbitrary set of
values is misrecognised as legitimate and natural. Thus the school incul-
cates both a *recognition* of the legitimacy of the dominant culture – and
of the illegitimacy of the culture of the dominated – and a *misrecognition*
that the dominant culture is an arbitrary construction.[28]

At the same time, schooling produces a culture of distinction, and it
is in the operation of this that the social rôle of other cultural activities
such as museum visiting has the closest parallels. A primary 'habitus' is
formed by the family and the social environment of the family from the
child's earliest days. The family habitus is crucial because it is this that
forms the child's language structures, the 'linguistic capital' with which
it enters the school system.[29] The child brought up in a family that talks
to it in a certain way, and in a certain environment which places a high
value on books and learning, will be predisposed to achieve more in
school than the child whose primary habitus is not open to these influ-
ences. This occurs because the former child will feel much more at home
in the culture of the school, being more familiar with it and speaking
the language in which the educational experience is couched. In other
words, the child is more likely to share the habitus of those who construct
the syllabus and comprise the teaching staff.

Many of these ideas are also reflected in Bourdieu's work on museums
and galleries. In a wide-ranging project in the mid-1960s he and various
colleagues conducted surveys first in twenty-one French art museums,
and subsequently in other European museums,[30] aimed at defining the
principal characteristics of museum visiting and the social conditions of
its practice. As with other surveys, they found that museum visiting was
generally restricted to the better educated, and that the groups most
represented in the general population were least represented in the
museum public.[31] In explaining this phenomenon, Bourdieu follows
through the operation of the habitus in the wider society after it has
been transformed by the schooling process and differences in cultural
competence have been amplified.[32]

The works of art in art museums are seen as transmitting specialised
messages, the decoding of which is learned at school, and so rather than
being appreciated for its own sake by the untutored eye, Bourdieu argues
that aesthetic appreciation is socially determined:

the richness of 'reception' . . . depends above all on the competence of the 're-
ceiver', i.e., on the degree to which he masters the code of the 'message'.[33]

Just as with the school, therefore, the museum and the works in it are understood best by those who are predisposed by their habitus to acquire the cultural competence to do so. Those in possession of the competence to render art and the experience of the art gallery meaningful feel at home in the museum and know how to behave there. For those less well-equipped, misunderstanding and confusion are inevitable. A sense of being 'overwhelmed' is experienced and in their 'functional' habitus they seize on the material qualities of the work, such as size, colour, or subject.[34]

From Bourdieu's point of view, then, museums and art galleries are an example of the successful way in which a consensual recognition of dominant culture is produced while at the same time most are excluded from participating fully in it: museums, like art and cultural practices in general, act by affirming 'distinction':

In the slightest details of their morphology and their organisation, museums betray their true function, which is to increase the feeling of belonging for some and of exclusion for others.[35]

However, just as the psychological approach can be criticised for its failure to relate leisure to wider social processes, Bourdieu's work can be criticised for going too far in the other direction and emphasising class distinctions to the exclusion of other explanatory factors. Part of the reason for this lies in his concentration on art galleries, i.e., at the extreme end of the museum spectrum, where visitors are much more sharply differentiated along lines of education and status than they are in other museums[36] and where, consequently, arguments about class determination are easier to invoke. When visiting patterns to other museums are taken together with the results of the survey reported here, it is evident that class alone cannot explain visits to general museums. These are participated in much more widely than Bourdieu's study of art museums suggests, and visiting them is much more strongly influenced by structural factors, position in the life-cycle, and by the accidents of an individual's history and psychology. In addition, Bourdieu's arguments are directed towards the situation as it existed in France in the mid-1960s, arguments which may not be applicable to Britain twenty-five years later, after the 'heritage boom' has occurred. His analysis is purely concerned with the oppressive aspects of museums and their rôle in social reproduction, and is not easily able to explain the current popularity of museums. Finally, his work is also flawed by its concentration on visitors only, with the result that no information is directly available on deterrents amongst non-visitors.

Synthesis: 'leisure opportunity'

An attempt can now be made to construct a theoretical framework from the most useful elements of the above two approaches, taking into account the criticisms advanced of them. Examining the wider socio-politics of leisure as Bourdieu does can help to expand the analysis provided by psychology, which in turn is more rigorous in looking at the effects of a number of factors such as attitudes and demographic variables and in not ascribing all cultural differences to class alone.

A concept that might provide a bridge between the two approaches is that of 'leisure opportunity' used by Kelly,[37] whose arguments are very similar to those advanced in the psychological approach, but where the individual is firmly conceived of as being part of a wider society.

In a review of the leisure field Kelly argues that social factors influence leisure not as direct determinants but through the 'opportunities' that they provide. The sort of nominally independent variables used in surveys, such as income, occupation, education level, age, sex and race, and the indices of social status he suggests, are best understood as 'indicators of socialisation probabilities'. For example, rather than being a direct determinant of leisure, status is an indication of the kind of interests and opportunities likely to be a part of a person's experience.[38]

The two main components of leisure socialisation are the family (and other childhood influences), and the subsequent 'life career model',[39] consisting notably of schooling and the influences of peers. The basic similarity with Bourdieu's theory becomes apparent here. Just as the primary habitus developed in the family will structure the reception of the school experience, so too will initial family socialisation set the scene for the subsequent perception of leisure opportunities. An individual socialised into certain activities will develop a disposition which internalises cultural (and material) constraints as actual choices.[40] Thus, leisure can be seen to operate in the same way in which Bourdieu notes that education works: to promote the self-exclusion of those least equipped to participate in it, misrecognised as a *choice* not to participate. This choice is both created by the adverse image of museums passed down through family and peer group, and also justifies the choice not to participate. For certain groups, museums are 'not for us'.

The divisiveness of museums

According to the survey, after the precondition of interest in the past, the most important factors affecting museum visiting are people's

attitudes to the experience provided by the museum, followed by its general image and the individual's age. More detailed cross-tabulations showed that the less people visited, the more they were likely, for example, to think there were too many words in museums and that the attendants were intimidating. They were also far more likely to see museums as irrelevant to their daily lives and to look on them as monuments to the dead.

A review of the historical development of museums will clearly show why many people might have found them intimidating. From their beginnings they tended either to be associated with large aristocratic homes where the collections were a testimony to the power of the owner, or with early polymaths whose cabinets were encyclopaedic in range and had little supporting explanation. For those unfamiliar with either environment, visiting such a collection would have been confusing and even intimidating. When more purpose-built museums were created in the Victorian period, the aristocratic connotations were continued: layouts were poor, leading to the musty and dead image popularised by Victorian cartoonists, collections were often of objects unfamiliar to ordinary people, and the buildings tended to be large 'temples of culture' designed as much to overawe as to instruct.[41] Indeed, it is possible at this period to find museums being founded for explicit social reasons, for example, to foster a reverence for the Almighty,[42] or 'to make men cautious how they listen to scatter-brained revolutionaries'.[43] Victorian philanthropy was thus a double-edged sword, whereby genuine schemes of improvement could be harnessed to the inculcation of values in the interest of dominant social groups.

From its earliest development, then, the museum was part of high culture, and followed aristocratic models both in buildings, contents, and methods of display. Little or no concessions were made to other visitors, and where they were, it was frequently in the interests of ideological indoctrination. The intimidating or irrelevant image of the museum seems thus to date from at least the last century. The theory developed above can help to explain the processes whereby these images have been transmitted and remained meaningful over such a long period.

Historically, therefore, the museum has acted, intentionally or not, to inculcate dominant values or a recognition of the legitimacy of dominant culture amongst the populace. For those not schooled in the code of the museum, it would have been an alien and intimidating place, while for the cultivated it could be a refuge of peace and learning. The former would have tended to exclude themselves from participation, justifying

this as a deliberate choice ('the choice of the necessary'), and therefore not perceiving museum visiting as a viable or worthwhile activity. The commonest way in which the justification of this 'choice' would have been manifested would have been in negative images of museums amongst non-visitors. Once such a system is set in motion it becomes self-fulfilling and can be difficult to break out of. However, it is not merely a matter of a freak survival of old-fashioned images: the fact that these historically derived images still exist suggests that they express something that people feel about museums today. Much of this must be explained by the persistence of their association with high culture. The regular surveys done by the Henley Centre for Forecasting, together with this survey and others, clearly show that museum visiting is still one of a package of high-culture leisure activities, along with going to the theatre and classical concerts, participated in by well-educated, relatively affluent young- to middle-aged 'culture vultures', who have been socialised into perceiving these activities as a legitimate and worthwhile use of their time. Visiting museums and historic buildings is still associated with being cultured and has, historically, aristocratic connotations which are enjoyed and emulated by some, and rejected by others. The latter, who tend to be those of low status, have a habitus whose initial (family-based) effects are so strong that schooling does little to alter it and they therefore exclude themselves at the earliest available opportunity both from school and museums and justify this by seeing them in an unfavourable light, as not being worthwhile.

So far the argument has examined the derivation and operation of adverse attitudes and images of museums, largely from a class basis. However, the next most important independent factor in the regression analysis was age, and it is here that the wider scope of the psychological approach helps to provide a fuller explanation. Briefly, the individual's age, regardless of their social status, has a 'double effect' in either encouraging or discouraging museum visiting, and serves both to demonstrate the narrowness of an entirely class-based explanation and to introduce a dynamic element to the explanation.

As Table 2 has shown, the main effect of age on museum visiting is seen amongst the over-sixties, 50 per cent of whom have either never visited a museum or last visited one more than five years ago. The first reduction in opportunity is a 'period effect', i.e., the effect of the conditions of the period in which those who are now over sixty were initially brought up. Anyone over sixty at the time of the survey was born before 1925 and consequently grew up in a time when there were only a third

of the museums that are available today,[44] and when people were not only more likely to have left school at the minimum age but also more likely to have received a shorter education while they were there. A number of factors would therefore have dictated that they were less exposed to museum visiting in their early years, and would have received less socialisation into the museum code while at school. This lack of exposure would have been accompanied, for those from a working-class background, by a habitus that was not immediately disposed to making the most of museums, so that many might never have visited a museum during their childhood and would be unlikely ever to visit one now, having learned from an early age to exclude themselves for lack of 'competence' in reading the museum code.

In addition to the 'period effect' making for a low incidence of museum visiting among the over-sixties, there is also a 'biological age' effect associated with being old, already noted in Prince's work on museum visiting.[45] When considering the relative lack of participation by the elderly in museum visiting, it is necessary to look at the ways in which old age is socially constructed as well as its biological effects. For example, although many elderly people are constrained in their leisure activities by deteriorating health, and by lack of income and transport (the latter two, in fact, being social factors produced by the marginal position of the elderly in our society), there is considerable evidence that interest in out-of-home leisure activities actually subsides at this time.

This has most concisely been expressed in the concept of 'disengagement', whereby in old age a person may withdraw or 'disengage' from interaction with others in society, and be treated as disengaged by others.[46] Subsequent research has both confirmed and denied the theory, but the general consensus seems to be that it is a more accurate explanation of the leisure pattern of the elderly than the converse theory of re-engagement.[47]

Thus, those who are now of retirement age, especially those who are of low status, are doubly discouraged from museum visiting. In the first place, many would not have been socialised into seeing museum visiting as worthwhile and may have received a negative image of museums from early experiences of alienating local museums. These images are mutually self-reinforcing, both through the influence of the media and through their subsequent inability to decode the museum. In the second place, even those who did visit museums are less likely to do so now because of the structural and psychological factors associated with old age and especially with retirement, which tend to be accompanied by withdrawal.

The above arguments have demonstrated that, at root, the action of museums in contemporary culture is to divide society into those who have

the 'competence' to perceive museum visiting as a worthwhile leisure opportunity, and those who do not. Those who do not go justify their exclusion by the sorts of unfavourable images examined in the survey. This seems to be essentially the argument put forward by Bourdieu in claiming that such activities as museum visiting are productive of 'distinction' between social classes:

Art and cultural consumption are predisposed, consciously and deliberately or not, to fulfil a social function of legitimating social differences.[48]

However, although social status or class is of importance in an explanation, it by no means determines reactions to museums. Other factors such as age and education also have an important structuring rôle, and individual attitudes and images are no doubt formed by a process too complex to be isolated by the relative crudity of such a large-scale survey as this.

The popularity of museums

Although it is suggested that the basic rôle of museum visiting is to distinguish a 'cultured' group from other groups, this model lacks the dynamism to allow for the incorporation of the heritage boom that has occurred since Bourdieu's analyses were carried out. The current popularity of museums and heritage attractions can be explained by the specific conjunction of numerous historical factors. In the first instance, long-term studies have noticed a steady increase of leisure-time available to people and a generally steady increase in disposable income.[49] This has been accompanied by a general increase in many kinds of leisure outlets, from restaurants to holidays, and some of the expansion of the heritage market must be accounted for by the tourism boom predicated on this expansion of available leisure-time and money. However, there do seem to be particular reasons why the past and heritage are so popular. It has been suggested that much of the past-orientation of contemporary society is a product of the changes consequent upon industrialisation and post-war social and economic changes, and also of the uncertainty about the future which has accompanied Britain's decline as a world power and the advent of nuclear weapons.[50] The 'turn to the past' seems a genuine phenomenon, and individuals' intrinsic interest in actually knowing more about the past should not be underplayed. Much of the specific popularity of museums and historic buildings must lie in a genuine wish to come to terms with the past. Indeed, the survey shows that the overwhelming majority of people are interested in the past, and that most visitors express a specific interest in the subject of the museums they visit, or in history in general (Table 3).

Expansion of secondary education, an increase in numbers of museums, and an improvement in museum presentations have all accompanied the increase in leisure-time and disposable income outlined above, so that more people than ever before have the structural and intellectual opportunity to take advantage of heritage presentations.[51] Robert Hewison[52] argues that the expansion of heritage presentations is an index of Britain's decline, and in the senses outlined above, a desire for the past may seem to be so. However, visiting these presentations can conversely be seen as an index of affluence. This is because it tends not to be those who have experienced decline (the unemployed, for example) who visit museums and heritage presentations, but those who are relatively affluent. As education and the amount of disposable income has increased for all socio-economic groups, it is arguable that the traditional working-class ethos has been gradually eroded by more middle-class values. It is possible that more and more people are taking up museum visiting as part of a lifestyle that is appropriate to their changed status.

This is known as 'the embourgeoisement thesis', and received much attention in the sixties and seventies.[53] The original thesis, that the achievement of high salaries and living standards amongst manual workers would lead to their assimilation to the middle-class, was shown to be too simplistic: distinctively middle-class attitudes and patterns of behaviour with regard to political and industrial advancement were not strongly found amongst affluent workers. An increasingly individualistic and family-focused social outlook *was* found, however – with collective action being the best means of achieving these ends.

The largest investigation of 'embourgeoisement' found that a concern to advance their living standards was a major motivation in the lives of manual workers.[54] Material advancement might indeed be thought by these groups to be best achieved by collective action. However, their leisure was not studied; it is possible that leisure-time can be used by some groups for individual *social* advancement. It has been suggested in the discussion of cultural and economic capital above that affluence needs to be legitimised and operationalised by the assumption of an appropriate lifestyle. In their leisure, then, it is to be expected that groups experiencing relative affluence would use something like museum visiting, with its higher cultural associations, to acquire a certain amount of cultural capital, or, for those denied advancement in the labour process, it may actually be the main means of advancement. This may well explain why it is that active museum visitors are more likely to have positive attitudes to the present than those who tend not to visit museums, and

why attitudes to the present are a more important predictor of visiting than attitudes to the past: people who are better off in the present unsurprisingly have favourable attitudes to it, and are visiting museums because of their cultured connotations, as a way of legitimating their higher status with an appropriate leisure activity. They also tend to have fairly negative views of the past, seeing it as something we have progressed from, as a way of legitimating their present status.

Museum visiting is particularly well-placed for this, because 'opportunities' to visit are now relatively high due to the raising of the school-leaving age and the expansion in numbers of museums. In addition, museums are relatively 'open' institutions, most of them being free (or cheap) to enter, and people can come and go as they please. As well as being divisive, therefore, museums, by their openness, can be used as a means of social climbing for those who have come to realise the 'opportunity' to visit them. Museums are associated with 'being cultured' and for various reasons (increased education, increased affluence, desire for improvement of self and children), increasing numbers of people are wishing to participate in such a cultured lifestyle in order to achieve or demonstrate upward social mobility.

Conclusions

In summary then, museum visiting can be conceived of as a two-tier process: first the 'opportunity' to visit museums has to be available, and then, if it is, the opportunity has to be actually realised. For most of the people who are not active museum visitors, museum visiting has not been available as a leisure opportunity because of period, age and status effects. Their behaviour, especially if they are over sixty, is unlikely to be changed. In addition, there is still a substantial proportion of the population (estimated at between a third and a fifth) for whom the museum is not a recognised leisure activity because of its image and high culture associations. The first action of the museum is therefore divisive; that is, people are divided into those who possess, or wish to acquire, the habitus to make sense of a visit, and those who do not. However, the second action of the museum is incorporative. This is because greater numbers of school visits, improvements in museum display and the general lengthening of education have socialised more people to be competent in 'reading' museums. In addition, higher standards of living have brought with them a desire to emulate the lifestyle associated with the more privileged. More people than ever before therefore probably have the opportunity to visit museums but not all take advantage of this by

actually visiting. The determination of participation at this level will no doubt be related to factors beyond the scope of this survey, such as individual tastes and interests, the competing attraction of other activities, and structural factors such as health, mobility, time and other commitments. The greatest hurdle to get over in museum visiting is the initial 'opportunity'.

Once the 'period' effects amongst those currently over sixty are removed, the prospect would seem to be quite optimistic for the widening of museum audiences. The current expansion in the museum public is a product of wider education and of improvements in museum design and practice, which have met halfway to make more people familiar with their code and thus make them less intimidating. However, the disengagement effects of ageing will always be present, as will the still substantial proportion of the population who are denied the opportunity of museum participation by social factors. These could only be removed by change in the wider society. Failing this, there will doubtless always be a significant group who will never visit museums. If the current cutbacks in educational provision continue, it is likely that this group will again increase.

9

Museums and Cultural Property

NORMAN PALMER

At no other time in our history has there existed so intense an interest in the preservation of our cultural patrimony. In England, new museums are appearing at a rate of one a fortnight;[1] the demand for further institutions (such as a National Medical Museum, or a National Museum of Sport) suggests that the pace is unlikely to slacken. The public appetite for historical detail concerning our national treasures is reflected in the copious press reports about paintings of dubious provenance, or the achievements of marine and terrestrial archaeology; while the recent debate about the possible disposal of objects from our national museums and galleries (NMGs) has been exceptionally vigorous.

Inevitably, such activity often manifests itself in legal responses: in an increasing complexity of controls upon the market in cultural property, or in the demand for some other species of legal reform. Already, controversies of legal significance occupy a substantial proportion of our national press. At a time when the museum profession is being required to draw increasingly upon a variety of disciplines in order to adapt and survive, legal proficiency can surely occupy no lower a priority than the more general skills of economic literacy, resource management and commercial enterprise which have become so substantial a part of contemporary museum and gallery administration. In such circumstances, no modern curator or administrator can discharge his or her responsibilities confidently without some appreciation of the jurisprudential environment. It is the object of this short account to supply a compass to that landscape.

Cultural life cannot subsist in a legal vacuum. Every human transaction or pursuit is subject to law, whether statutory or judge-made. In the following pages, I shall examine some of the cardinal legal principles which affect the administration of galleries and museums. I shall consider especially those legal constraints which apply to the acquisition, custody and disposal of cultural artefacts. There is, perhaps, no more interesting

area of English law, nor one within which the elements of public and of private law, of municipal and international law, and of civil and criminal law, more vividly coalesce.

Several preliminary points should be made. First, not every source of discipline is strictly legal in character: there exist a series of voluntary codes which depend for their effect upon consensual acceptance rather than upon legal authority. The Museums Association, for example, has promulgated both a Code of Practice for Museum Authorities (1977) and a Code of Conduct for Museum Curators (1983). Although many institutions subscribe to these guidelines, one cannot readily envisage their being legally enforced. The likeliest means of enforcement would probably be the precarious mechanism of an implied contract among members of the Association, and this seems so remote a prospect as to be virtually inconsiderable. A similarly voluntary atmosphere pervades the Code of Professional Ethics adopted by the 15th General Assembly of the International Council of Museums at Buenos Aires in 1986.

Another example of extra-legal influence is the principal international convention within the field of cultural property, the UNESCO Convention of 1970. This Convention, which addresses the problems of controlling the illicit import, export and transfer of cultural property, has not been acceded to by the United Kingdom and therefore has no formal legal effect. But museums in England have already shown a significant willingness to adhere to the spirit of the Convention. Article 4.4 of the International Council of Museums' Code requires member institutions to take reasonable steps to co-operate in the return to its country of origin of any object which has been transferred in violation of the Convention, provided that the country of origin has both sought the return of the artefact and has demonstrated that it is part of that country's cultural heritage, and provided that the institution itself is 'legally free to do so'. The provision is unlikely to have much impact upon the national museums and galleries of the United Kingdom, whose current powers of disposal are closely circumscribed and certainly do not extend to the surrender of artefacts on the ground of their initial illegal exportation; but Article 4.4 might well become persuasive in the case of a private museum, whose governing instrument did not expressly prohibit the sort of voluntary restitution which the Article contemplates. Elsewhere, Article 4.4 enjoins museums to respect the Hague Convention for the Protection of Cultural Property in the Event of Armed Conflict (1954) and, in particular, ' . . . to abstain from purchasing or otherwise appropriating or acquiring cultural objects from any occupied country,

as these will in most cases have been illegally exported or illicitly re-moved'.

There appear, therefore, to exist a number of non-mandatory precepts which exert a significant moral force among museum administrators. Whether these professional codes are adequate for their task is, of course, debatable; recent press reports concerning the trade in illegally acquired cultural property are discouraging on this point.[2] But in so far as the codes have influenced professional standards, they clearly cannot be left wholly out of account.

Even within the realm of formal law, English law contains relatively few provisions which are peculiar to cultural property alone. Unlike many other nations, we have no specific code dictating the ownership, conservation and alienation of national treasures.[3] There are, admittedly, several modern statutes which deal directly with specific aspects of our cultural patrimony: for example, the Ancient Monuments and Ar-chaeological Areas Act 1979, the Protection of Wrecks Act 1973 and the National Heritage Act 1983. There also exist certain independent statutes governing our national museums and galleries (for example, the British Museum Act 1963), and certain specific provisions relating to cultural property within wider legislation (for example, the control upon the export of artistic works contained in the Export and Customs Powers (Defence) Act 1939 and the Export of Goods (Control) Order 1978, as amended). Beyond these provisions, the modern English law must be gleaned from a corpus of general laws which make no individual reference to cultural property at all.

An example is the common law doctrine of treasure trove. This doctrine remains the principal device by which archaeological finds are compul-sorily acquired by the nation. It did not, of course, start life as an instrument for the protection of cultural heritage, but as a dimension of the Royal Prerogative aimed at providing an owner for property whose original proprietor had disappeared. Even today, the doctrine seems capable in principle of applying to articles with no antiquarian value.

Similar observations apply to discovered archaeological objects which do not qualify as treasure trove (and which do not, therefore, belong by Prerogative to the Crown). Title to such objects will normally be deter-mined according to the civil law of finders: a complex body of law which applies equally to the discovery of such modern articles as a gold identity bracelet, found on the floor of the VIP lounge at Heathrow Airport,[4] and to the finding of a pump upon land adjoining the highway.[5] The civil law of finders was, incidentally, described as requiring reform by

the Law Reform Committee in 1971.[6]

The same general character affects our laws governing title to artefacts acquired abroad. The legal principles which determine (for example) the ultimate ownership of cultural property stolen from a private collector in England and sold to another private collector in Italy[7] are the same as those which determine the ownership of a cargo of timber originally purchased in Russia, then wrecked off the coast of Norway and sold there without the original purchaser's consent.[8] Likewise, the doctrines by which we identify the validity of a compulsory acquisition of privately owned art treasures by a foreign sovereign[9] are essentially the same as those by which we recognise a foreign nationalisation of ships, or shares, or oil.

In controversies between private parties, such generalisation may be quite acceptable. It is when questions of national ownership are raised that the inadequacy of our general law as an instrument of cultural protection stands revealed. Compared to that of many Continental and Commonwealth countries, English law seems remarkably haphazard and piecemeal. There is much to be said for a modern statute which expands and revises the current protection of our cultural patrimony, and consolidates it within a single source.

The third point is that, in any discussion of the legal response to questions of heritage, one must maintain a perspective. It is easy to overstate the rôle of the law in the field: to assume that every problem results from a deficiency in the law, or is capable of being cured by legal means. In many respects, considerations other than the narrowly juridical have proved more influential upon the condition of our cultural patrimony; political, diplomatic and economic facts in particular. Nor can one doubt that these competing considerations will continue to be paramount in some cases. For example, no one would seriously contend that the controversy over the Elgin Marbles can be resolved by litigation designed to establish the contractual or constitutional legitimacy of their original removal. If a resolution is to be found, it will be diplomatic rather than forensic in nature.

The general administration of our national museums and galleries must also be viewed against this wider perspective. Important changes are occurring within this sphere, as within every other sphere of public institutional life. Some of the developments are chronicled by the Office of Arts and Libraries in its Consultative Paper on Powers of Disposal from Museum and Gallery Collections:[10] they include the transfer of responsibility for the maintenance and control of buildings to Trustees

from the Property Services Agency, and the switch from direct-vote funding to funding by three-year grant-in-aid. Other, more parochial signals are more immediately disquieting. The National Audit Office, for example, has recently expressed concern about the number of cultural objects which are being kept in inadequate storage conditions in NMGs,[11] while the Museums and Galleries Commission (in its first general report upon the national collections since 1929) has identified other severe difficulties faced by the national institutions;[12] the fact, for example, that the National Gallery's current purchase grant has a purchasing power of little more than half the corresponding grant a decade ago; the increasing preoccupation of directors and curators with managerial and commercial functions, to the detriment of scholarship, and the widening gap between running-cost funding and civil service pay awards. Perhaps most significantly, the Government has recently instituted a review of the circumstances in which NMGs might acceptably be given more extensive powers to dispose of articles from their collections.[13]

Such developments do not result from economic considerations alone. Some are inspired by the serious political conviction that public institutions should maximise the support which they receive from private funding, and should become independently responsible for their financial management.[14] It is, perhaps, significant that the Consultative Paper of the Office of Arts and Libraries provides the following definition of the Government's task in relation to the NMGs:

... to provide the political and conceptual framework within which the NMGs can flourish; to ensure that public funds are spent properly and effectively; and to ensure that the Trustees and Directors are equipped with the appropriate statutory powers to do their jobs effectively.[15]

At no point does this document seek to include among the responsibilities of the Government the provision of adequate public funds to enable the functions of the NMGs to be discharged. On the other hand, it is stated to be government policy to confer upon these institutions a '... greater responsibility for their actions and for the use of the resources made available to them'.[16] Reviewing recent legislation in this field, the Museums and Galleries Commission (MGC) has reached the clear conclusion that '... the Government can now claim to have discretion as to how much to contribute to a national museum's approved expenditure'. The position is contrasted with that prevailing ten years ago, when '... no one doubted that the Government accepted the full financial responsibility for the national museums, whether they were run by an Education Department or by the Trustees'.[17]

In such circumstances, a picture derived exclusively from formal laws would be imperfect. All obligations which are imposed by law upon public institutions are ultimately dependent upon the economic capability of those institutions to satisfy them. A duty such as that imposed upon the Victoria and Albert Museum by s.2(1)(b) of the National Heritage Act 1983 (that is, to secure so far as is reasonably practicable that the objects in the collection are exhibited to the public) loses much of its meaning when a shortage of resources for the cataloguing of accessions, or for the construction of new buildings, necessitates the long-term storage of objects in crates in the basement. In short, modern museum administration cannot be divorced from its political and economic context. Its fundamental statutory precepts are subordinate to policies and budgets.

ACQUISITION

When a museum acquires an object for exhibition or research, it is naturally concerned about whether the acquisition falls within its budgetary and constitutional powers. Its principal concern, however, is likely to be whether the transaction by which it acquires the object is capable in law of transmitting a good title. Allied to this may be the question whether the article has been illegally obtained in, or illegally exported from, some foreign jurisdiction. Such a history may not only cast a shadow upon the vendor's or donor's title, but may also render the acquisition contrary to the Code of the Museums Association or of the International Council of Museums.

It is a fundamental principle of English law that no one can transmit a title which he himself does not enjoy: *nemo dat quod non habet*.[18] The principle holds good whatever the legal vehicle by which the object purports to be conveyed. In general, no institution which takes a chattel by gift, bequest, sale or exchange will acquire property in that chattel unless the person from whom the chattel was obtained was himself the owner. It is immaterial whether the acquiring institution was unaware of the supplier's defect in title and acquired the object in good faith, genuinely believing him to be the owner.

The principle is crucial to the protection of ownership under English law, but the consequences for an innocent purchaser can be severe. Suppose, for example, that a museum purports to acquire by purchase or exchange an article which does not in fact belong to the supplier: he may have stolen it from another museum, or may have bought it in all

honesty from someone who himself lacked title. In acquiring the article, however innocently, the museum commits the tort of conversion against the real owner. The real owner can therefore sue the museum for the return of the article, or for damages calculated according to its value, together with any additional damages representing the real owner's consequential losses.[19] The museum is strictly liable in such proceedings: not only is it incapable of pleading its own innocence as a defence,[20] but it is also unable to obtain a reduction in its liability on the ground that the conversion which it committed was induced, in part, by the true owner's contributory negligence.[21] Moreover, the insecurity of its tenure of the object renders any attempted disposal of it to another institution equally perilous. If a purported sale or exchange of the article fails to produce a good title in the acquirer, the disposing museum will be guilty of a breach of contract and is liable to have the transaction rescinded, or to be sued for damages.[22]

Even where the vendor of the object does enjoy property in it, the sale may fail for other reasons to confer a good title upon the purchaser. For example, a sale by churchwardens of church property without the prior grant of a faculty authorising the disposal will prevent the purchaser from acquiring property. In the recent case of Re St Mary's Barton-on-Humber [1987] 2 A11 ER 861, the Chancellor issued a stern warning to antique dealers of the perils of buying church artefacts without checking whether the necessary faculty had been obtained. A similar warning should be heeded by museums and other cultural institutions; otherwise, such property is liable to be retrieved by the church, leaving the acquirer substantially out of pocket.[23]

Transactions which take the form of a purported sale or exchange are, in the main, covered by s.12 of the Sale of Goods Act (SGA) and s.2 of the Supply of Goods and Services Act (SGSA), both of which imply a condition that the supplier has the right to supply the goods. This means that, if the seller or exchanger is not in fact the owner of the goods which he is purporting to supply, and if the transaction does not generate an independent title in the acquirer by virtue of one of the statutory exceptions to the principle *nemo dat*, the acquirer can set aside the contract and reclaim either his price or the goods which he gave in exchange. In commercial sales, the principal advantage of this power of rescission is that the buyer can avoid having to bear the cost of the depreciation of the goods: he is entitled to claim the return of his original price, regardless of the amount by which the goods have fallen in value since the purchase, and regardless of the value of any use which he has

had of them between the date of purchase and that of rescission.[24] This affords the purchaser at least some consolation for having bought goods which were not the seller's to sell. In the case of those cultural artefacts which normally appreciate with time, however, the buyer's ability to reclaim the original price may seem less attractive than an action for damages based upon the expected value of the chattel which he would have owned, had the seller's obligations been performed, and which he must now attempt to replace. Of course, a buyer is perfectly entitled to elect to sue for damages under s.12 SGA or, if he prefers, s.2 SGSA (although it is not certain that he would necessarily recover the full value of the expected appreciation of the goods). An action for damages might also be brought under the two warranties implied by these provisions; indeed, a warranty – unlike a condition – can generate only a right to monetary compensation, and not a right to rescind.[25]

Perhaps the principal drawback of ss.12 and 2 is that the supplier who has broken his obligations as to title may well have disappeared (or have become insolvent) by the time his default is actually discovered. In this event, the acquirer's remedy will be worthless. Clearly, it is preferable for an acquiring museum to assure itself as to the validity of its supplier's title in the first place than to rely upon the prospect of recovering its loss when the title proves defective. The provenance of the object must therefore be carefully examined, and all available sources of information relating to contemporary illegal movements of cultural property should be consulted.

Unfortunately, the proprietary history of such objects will often be vague or ambiguous. The problems are especially acute in relation to imported articles, the title to which may depend upon inaccessible foreign laws and their applicability in England. But even objects which have never left this country can generate intricate proprietary puzzles. In part, these can result from the sheer informality or legal ambiguity of some earlier transaction concerning the object: a familiar example is the question whether a painting has been donated outright to a church by an ancestor of the claimant, or merely lent. On other occasions, it will be the sheer difficulty of applying English law (and in particular, of answering the almost impossible factual questions which it raises) which will constitute the source of uncertainty. I shall look briefly at two such areas, both of which are relevant to the ownership of discovered antiquities.

DISCOVERED ANTIQUITIES

The question here is deceptively simple: to whom do archaeological or

'The Great War': German postcard depicting the sinking of *The Lusitania*, 1915.
BBC Hulton Picture Library.

antiquarian objects discovered upon English soil belong? I propose to
leave aside the case of marine archaeology and to consider only terrestrial
finds.

Of course, if the original owner or his successors can be traced the
property will belong to them. Occasionally, it is true, the owner may
have made some later disposition of the property in favour of another
party. An example can be glimpsed in the recent case of *The Lusitania*
[1986] 2WRL 501. There, Mr Justice Sheen took the view that passengers
on the liner who had originally owned objects which had gone down
with the vessel itself, and who were later paid out by their insurance
companies, had relinquished their ownership in favour of their insurers
(who could, in turn, be regarded as having abandoned their ownership).
Generally, however, the original owners or their descendants continue
to hold the property, regardless of the period which has elapsed since
the object was mislaid.

Such, at least, is the theory. Realistically, the question of original
ownership is almost invariably immaterial. So far as concerns most ar-
chaeological finds, it is hard enough to identify the original proprietor,
let alone his current successor in title. The law is faced with a proprietary
vacuum and must find somebody to fill it.

The first question is whether the article qualifies as treasure trove. If

it does not, its entitlement will normally be allocated according to the civil law of finders. Both systems of law are deficient, both in their opacity and in their inefficiency as a medium of cultural conservation.

(i) Treasure Trove[26]

Property which is treasure trove belongs to the Crown: the Crown is entitled to it and can in theory dispose of it at will. This entitlement is one aspect of the Royal Prerogative, and its proceeds were one of the traditional revenues of the Crown. The Crown's title prevails, not because the goods were originally Crown property, but because the original owner can no longer be found. The Crown's title is superior to the finder's and to that of the owner of the land where the goods were found.

Nowadays, the Crown's rights are exercised through the British Museum. Most finds which are declared to be treasure trove pass into the custody of the museum. The museum advises the Treasure Trove Reviewing Committee, which will normally award the finder a reward calculated according to the value of the find. In exceptional cases, the museum may return the finds as of insufficient interest, or keep the finds but recommend that no reward (or a reduced reward) be paid. The latter course is generally reserved for cases where finders have dishonestly concealed their finds.[27]

When are goods treasure trove?

Three main rules have been established by legal writers and by judicial decisions. A typical and authoritative statement of these rules is to be found in Chitty's *Prerogatives of the Crown* (1802).

Treasure trove, is where any gold or silver in coin or plate or bullion is found concealed in a house, or in the earth, or other private place, the owner thereof being unknown, in which case the treasure belongs to the King or his grantee, having the franchise of treasure trove.

First, then, the goods must be of gold or silver. Other metals cannot constitute treasure trove and do not belong as of right to the Crown. This rule is inconvenient because many artefacts made from baser metal such as bronze will be of equal historical value. But the limitation to gold and silver articles has recently been confirmed by a decision of the Court of Appeal. In *Attorney General of the Duchy of Lancaster* v *G E Overton (Farms) Ltd* [1982] 1 A11 ER 524, a treasure hunter armed with a metal detector found 7,811 Roman coins of the third century AD on land which was owned and occupied by the defendant company. The

land lay within the liberties of the Duchy of Lancaster. The coins had been issued within a period of great debasement of the currency and were made of alloys of silver and base metal. The silver content was low, varying from less than 1 per cent to a maximum of *c.*20 per cent according to sample tests. The Attorney General for the Duchy of Lancaster claimed them on behalf of the Crown, and a coroner's inquest decided that they were treasure trove. In proceedings before the Chancery Division (and subsequently in the Court of Appeal) the Attorney General based his argument for their classification as treasure trove on two alternative propositions: either, that treasure trove was not confined to gold and silver but applied to coins comprised of other metals; or, that if treasure trove were thus confined, these coins were silver. In formulating the first of these contentions, he relied upon certain textbook writers. One of these, Blackstone, had defined treasure trove as 'any money or coin'. However, both Mr Justice Dillon and the Court of Appeal decided against the Attorney General on both points. Their Lordships held that no object (coinage or otherwise) could be treasure trove if it were not substantially gold or silver, and that these coins ('antoniniani') could not, on any realistic analysis, be described as silver. The Crown's claim therefore failed and the coins were declared to be the property of the company which owned the land.

Secondly, the goods must have been concealed in some private place. Treasure trove is confined to property which was buried or otherwise secreted by someone who intended to return to retrieve it later. Things which were merely lost cannot be treasure trove, nor can goods which were deliberately secreted, but with the intention of abandoning them. Of course, it may be impossible many centuries after the event to decide whether the goods were lost, abandoned or temporarily hidden. In order to assist the decision, it seems that the law will presume that goods concealed in an inaccessible place were intended to be retrieved unless the contrary is proved: *Attorney General* v *Trustees of the British Museum* [1903] 2 Ch 598. This presumption clearly aids the Crown's assertion that the goods are treasure trove.

The evidence adduced in such cases is often very flimsy. In the Overton case, for example, Mr Justice Dillon observed that had he been wrong on the question of the metallic constituency of treasure trove, he would have held that these coins (and the earthenware urn containing them) were concealed and not lost. Practically the only evidence supporting this view was the existence of the urn and the rural locality – 'it is difficult to suppose that anyone would have placed such a large number

of coins in an urn in what seems to have been a rural locality rather than a town if he were not hiding them'. Further, they were buried in the earth below the level that would be disturbed by an ordinary ploughshare. Mr Justice Dillon conceded that the evidence was slight and unsatisfactory, 'as always in these cases'. Such conclusions are hardly flattering to the principle of law that demands them.

Thirdly, as we have seen, the ownership of the goods must be unknown. If a successor to the original owner can still be located, and the goods would pass normally to him under our law of wills or intestacies, the Crown does not get property and the successor is entitled to the goods.

The doctrine of treasure trove is not confined to coinage or currency but extends to other artefacts. Chitty, for example, refers to 'coin or plate or bullion';[28] so do Blackstone[29] and Coke.[30] It seems correct to regard the doctrine as applicable to all artefacts of the required metallic constituency and not to limit it to coin, plate or bullion. This view appears to have been tacitly accepted in recent inquests, where (for example) gold buckles and silver brooches have been declared treasure trove.

Defects of the law of treasure trove[31]

These are substantial. The limitation to gold and silver articles excludes a vast spectrum of antiquities from Crown acquisition: copper coinage, bronze weaponry, stone and earthenware artefacts, documents, glassware and human remains, to name but a few. The rule that the object should not have been abandoned removes from the realm of treasure trove burial offerings (such as the Sutton Hoo treasure) and articles which were merely lost, rather than deposited with the intention of retrieving them later. An example of the latter is the Middleham Pendant, an exquisite jewel found at Middleham in Lincolnshire in 1986, and later sold for over £2 million. It is a remarkable law which allocates title to such an article according to the presumed intention of an original owner who died many centuries ago.

The system of rewards has also attracted criticism. The practice of the Treasure Trove Reviewing Committee is to recommend that a reward will be paid only to the finder (or his estate). This may be thought inequitable to landowners, upon whose land the finder may have been trespassing at the time of the discovery. A non-treasure trove object, discovered in such circumstances, would belong to the landowner rather than to the finder: why should their fortunes be reversed when the goods are declared treasure trove?

'The Middleham Pendant'

Much more could be said to demonstrate the inadequacies of the doctrine of treasure trove as a means of safeguarding our cultural heritage. The doctrine was not designed for that purpose and has become increasingly ill-equipped to cope with the demands of modern amateur and commercial archaeology. It is gratifying to see that a recent paper from the Law Commission proposes a thorough investigation of the general subject of the preservation of cultural artefacts;[32] but it remains unlikely that we shall see concrete statutory reforms until well into the last decade of the present century.

(ii) *The civil law of finders*

If a discovered antiquity does not qualify as treasure trove, entitlement to it will normally depend upon the general law of finders. Occasionally, it is true, the unauthorised removal of such an object will attract criminal penalties: see, for example, s.1(3) of the Protection of Wrecks Act 1973 (which makes it an offence to interfere with a marine wreck lying within an area designated as restricted by the Secretary of State) and s.42 of the Ancient Monuments and Archaeological Areas Act 1979 (which imposes restrictions upon the use of metal detectors in areas designated as protected places, and renders it an offence to remove without authority articles of archaeological or historical interest from such a site). But such legislation has no immediate impact upon the actual question of title. For that, we must turn again to the common law.

An owner of goods who loses them remains, of course, their owner and can always (subject to the Limitation Act) recover them from a finder or an occupier on whose land the goods were lost: *Moffatt* v *Kazana* [1969] 2 WLR 71. In cases where the true owner does not reappear to claim his property, however, the normal principle is that a finder who has reduced the goods into his possession has a right to them against the whole world except the real owner. Thus in *Armory* v *Delamirie* (1721) 1 Stra 505 a chimneysweep's boy who had found a jewel was held entitled to recover it (or damages for its value) from a jeweller to whom he had handed it for valuation, and who had refused to return it to him.

This principle is, however, based upon the assumption that the finder has been the first person to reduce the object into his possession. If that is so, the old rule enunciated in The Winkfield [1902] P 42 – that possession counts as title – operates in his favour, allowing him to defend his possession against any third-party interloper. In certain cases, however, someone other than the finder will already have obtained an earlier or

'supervening' possession of the object when the finder assumes control of it. In such a case, it is that other party, and not the finder, who has the right to retain the object against everyone but the true owners.

ASSURING ITSELF AS TO TITLE

The importance of these principles to an acquiring museum cannot be overstated. Unless the museum is certain that the party purporting to supply the object has a good title (or is acting on the true title-holder's behalf) the museum is liable to be deprived of the property or rendered liable in damages for its conversion. It is therefore all the more regrettable that the identification of title to discovered antiquities should depend upon so archaic and ambivalent a body of principle. To expect an acquiring institution to conduct the sort of legal and factual investigation necessitated by the doctrines of treasure trove and possessory title (doctrines which have engaged judges for many centuries) is absurd. No decision illustrates more vividly the convoluted and elusive principles upon which such disputes are resolved than the notorious Derrynaflan[33] case, where litigation as far as the Irish Court of Appeal was needed in order to clarify the validity of the State's title as against that of the two finders.

THE DERRYNAFLAN CASE

The issues were complicated and only the briefest analysis can be given here. In February 1980 a father and son named Webb found a beautiful collection of ecclesiastical treasures on land near Derrynaflan Church in County Tipperary. The Webbs had been using a metal detector at the time, and it seems clear that their digging up of the treasure (as opposed to their original entry on to the land) violated any implied permission on the part of the landowners. These owners were two farmers called O'Leary and O'Brien; needless to say, they had been wholly unaware of the presence of the hoard.

The treasures consisted of a silver chalice, silver paten, paten-stand and a decorated bronze strainer-ladle. They were subsequently dated to around the ninth century AD. The Webbs took the hoard to the National Museum of Ireland and an understanding was reached that the museum would retain possession of it pending determination of its true ownership.

While still in possession of the articles, the museum approached the landowners and agreed to acquire, for the sum of £25,000 apiece, the

The Derrynaflan Chalice. National Museum of Ireland, Dublin.

entirety of their interest in the hoard. This enabled the State to add a second defence to the argument of treasure trove which they raised when the Webbs, tiring of the delay, eventually sued for the return of the hoard. In response to the claim, the State contended first that, since the objects were treasure trove, title to them vested in the State as it would have vested in the Crown prior to independence; and secondly, that the landowners' title was superior to that of the finders and had subsequently been conveyed to the State, whose interest was therefore now paramount irrespective of the character of the hoard as treasure trove.

Both arguments were rejected by Mr Justice Blayney at first instance. He held that, since the doctrine of treasure trove was an aspect of the Royal Prerogative which had not been specifically preserved and conferred upon the new State under its Constitution, that doctrine was of no effect in Ireland and could not be used as an instrument of state acquisition. Further, Mr Justice Blayney held that the terms of the letter which the museum wrote to the Webbs shortly after their delivery of the hoard to the museum amounted to an acknowledgement that the museum was to hold the hoard as the Webbs' bailee. A bailee is estopped at common law from denying his bailor's title; in other words, he cannot resist a claim for the return of the goods to his bailor by asserting that property rests with someone other than the bailor himself.[34] By writing the letter, the museum therefore undertook to treat the Webbs as the true owners irrespective of the real location of title in the hoard, and disabled itself from relying upon any later alleged acquisition of title on its own part.

The State appealed successfully to the Court of Appeal. Delivering judgement for the majority of the Court, the Chief Justice agreed that the authentic prerogative of treasure trove had not survived the transition to the Irish Free State. But a right equivalent to that of treasure trove nevertheless existed by virtue of the character of Ireland as an independent, sovereign state. Relying particularly upon Article 10, the Chief Justice held that the ownership of so great a national asset as the Derrynaflan Hoard represented a necessary implication, for the common good, to be derived from the Constitution at large: an inherent attribute of the sovereignty of the State. Further, one of the incidents of this inherent power was the ability of the State to reward finders as an act of grace. Here, the Webbs had acted honestly in bringing the hoard to the museum and had conducted their dealing upon an 'underlying assumption' that they would be 'treated honourably'. These circumstances justified the grant of a joint reward of £50,000, divided equally between them.

The Chief Justice also held that the terms upon which the museum had accepted delivery of the hoard did not, in law, preclude it from later asserting a superior title in itself by virtue of the conveyance from O'Leary and O'Brien. Three strands of reasoning can be drawn from this aspect of his decision. First, the literal terms upon which the Webbs' delivery of custody was made – 'pending determination of legal ownership' – were not such as to amount to an undertaking by the museum to acknowledge title exclusively in the Webbs; rather, the question of ownership was left open, with the result that the normal implied term as to the bailor's exclusive and unquestionable title was displaced by the particular circumstances. Secondly, the bailee's conventional estoppel does not apply in any event to a case where the bailee defends the bailor's action on the ground that title now vests in the bailee himself (as opposed to vesting in some third party): when a bailee gets title in himself the bailment ends and with it terminates the estoppel. Thirdly, the landowners' title was indeed superior to that of the finders here, with the result that the conveyance to the museum endowed it with an equally superior title. The fact that the goods were buried in the ground conferred a prior possessory right upon the landowners, which was violated when the Webbs removed the hoard; and the fact that the Webbs were trespassers meant that, independently of the issue of prior possession, they were disentitled from acquiring any rights superior to those against whom their trespass was committed.

Somewhat different views were expressed upon some of these issues by Mr Justice Walsh and Mr Justice McCarthy; but, in the event, the Court was unanimous that the hoard should be awarded to the State.

Unanimity, however, is one thing; legal clarity is quite another. It seems extraordinary that a nation's entitlement to its cultural patrimony should depend upon the sort of recondite and complicated questions that were examined in this case. The judgement of the Chief Justice concludes with a significant suggestion that the Irish version of the doctrine of treasure trove should be clarified by legislation in the near future.

TRANSACTIONS OCCURRING ABROAD

So far, we have assumed that every material event in the proprietary life of a cultural object has taken place in England, and therefore that the question of title to the object is governed solely by English law. Frequently, however, matters of foreign law may be involved. For example, a painting

may be stolen from a gallery in England and exported to Italy, where the law affecting title to stolen goods favours the innocent purchaser more than in England. The painting may be bought in Italy by a bona fide purchaser, in circumstances which would give him an impeccable title under Italian law but would not displace the title of the original owner under English law. Later, the purchaser may bring the painting to England and the original owner, hearing of its presence within the jurisdiction, may issue a writ seeking its return. Who has the better title; and which system of law, English or Italian, should be applied by the English court?

The position concerning such matters is straightforward. The validity of a disposition of personal property is governed by the law of the country in which the chattel was situated when the disposition took place. If, therefore, the purchaser in our example is regarded as having acquired a good title to the painting by Italian law (the law of the country in which the painting was situated when the sale to him occurred) that title will be recognised and enforced by an English court as well. This is known as the *lex situs* rule.

The rule is well illustrated by the decision of Mr Justice Slade in *Winkworth v Christie Manson & Woods Ltd* [1980] 1 A11 ER 1121. There, William Wilberforce Winkworth owned a quantity of Japanese works of art, which he kept at his home in Oxfordshire. They were stolen from his house and resold abroad. Certain of the objects were purchased in Italy by the Marchese Paolo da Pozzo, who sent them in due course for sale at Christie's. Winkworth sued both Christie's and the Marchese for the return of the artefacts, and was met by the defence that under Italian law the Marchese, being a bona fide purchaser, gained a good title overriding that of the original owner. Mr Justice Slade agreed that Italian was the applicable law and dismissed Winkworth's claim. However valid Winkworth's original title, it could not survive a later disposition which was capable by the law of the country where the goods were then situated of transmitting a better title to the buyer:

The proprietary effect of a particular assignment of movables is governed exclusively by the law of the country where they are situated at the time of the assignment. An owner will be divested of his title to movables if they are taken to a foreign country and there assigned in circumstances sufficient to the local law to pass a valid title to the assignee. The title recognised by the foreign *lex situs* overrides earlier and inconsistent titles no matter by what law they may have been created.[35]

Mr Justice Slade was willing to recognise five exceptions to this

principle. The law of the situs of the chattel would be inapplicable if the party acquiring the chattel had not acted in good faith; or if the foreign law were so objectionable as to render its enforcement contrary to English public policy; or if the goods had been in transit (or their situs were casual or unknown) at the time of the disputed disposition; or if some extra-territorial statute required that the issue be governed by English law in any event; or perhaps if the case involved some general assignment of chattels (such as occurs upon an intestacy or bankruptcy) rather than a particular assignment such as a sale.

Notwithstanding these exceptions, it is clear that the *lex situs* rule carries substantial risks for all owners of cultural property. Their title may be lost by an initial theft of the article from their country of domicile, followed by a sale to an innocent purchaser abroad. The volume of thefts from museums, churches and private homes has intensified in recent years, and there have been several occasions when an original proprietor has been deprived of his ownership through a sale in some overseas jurisdiction, whose laws are more clement than our own towards bona fide purchasers. Perhaps the most distressing of these episodes involved the theft of a series of carved wooden panels, dating from around 1500, from the parish church at Stowlangtoft in Suffolk.[36] The panels depicted Christ's Passion and the Harrowing of Hell and were carved in Flanders; they had been given to the church by a local family during the nineteenth century. They were taken by the thieves to Holland and sold eventually to a Dutch television producer. The Rector of Stowlangtoft then instituted proceedings in the Dutch court, but his action failed. The Dutch purchaser, having evidently acted in good faith, had satisfied the requirements of Dutch law as to the acquisition of title, and since Holland was the place in which the carvings were situated at the time of the sale, Dutch was apparently the applicable law. It follows that, even if the carvings were in due course to be brought back to England, an English court would be unable to order their restoration to the Church. The sole remaining prospect of their return to Suffolk appears to lie in a negotiated repurchase from the current holder, with all the attendant expense.

Such incidents are not peculiar to English owners of cultural property; a loss of title can equally occur when such property is illegally exported from a foreign country. If a sculpture is stolen from a museum in Israel and sold to a bona fide purchaser in England, in circumstances which would create a valid new title in the purchaser under English law but not under Israeli law, the English court will recognise the change in ownership.

Foreign state ownership raises somewhat different problems. If a foreign sovereign State legislates to nationalise (for example) all archaeological finds which are situated within its territory, an English court is likely to implement the decree and to recognise that any former owner has been effectively deprived of his property: see *Princess Paley Olga* v *Weisz* [1929] 1 KB 718. The problem arises when the legislation seeks to affect property outside the foreign jurisdiction; here, the acquisition is likely to be disregarded as constituting an ineffective attempt at extra-territorial legislation: see *King of Italy* v *Marquis Cosimo Tornaquinci* (1918) 34 TLR 623. The distinction arose sharply in a recent case involving the illicit exportation of a Maori carving. The object under dispute in *Attorney General of New Zealand* v *Ortiz* [1984] AC 41 was a carved door, made of totara wood, which formerly stood at the entrance to the treasure house of a Maori chief. It measured four feet by five feet and consisted of five finely-carved panels. Having been lost for a long period in a swamp at Waitara on the North Island, it was rediscovered in 1972. It was illegally exported from New Zealand and eventually despatched for sale to Sotheby's in London. The New Zealand Government issued proceedings for its recovery, relying on the Historic Articles Act 1962. Stated broadly, this New Zealand statute declared that historic articles exported from New Zealand without the proper authority were to be forfeited to the Crown. However, the House of Lords held that the relevant legislation did not purport to vest the ownership of such articles automatically in the Crown, but merely to render them Crown property when they had been seized after illegal exportation. Until such seizure there would be no forfeiture in the sense in which the word was employed in the legislation; and since no seizure had here taken place, the Crown had no property or right to possession sufficient to sustain its claim. No English court would, in any event, recognise or enforce an attempt by a foreign State to acquire property in objects which were outside its territory at the critical time.

The result, of course, was that the New Zealand nation failed to regain a substantial part of its heritage. The decision is a sobering one, because the New Zealand statutes were couched in similar terms to our own legislation governing the export of works of art and kindred objects. It seems that, however effective this legislation may be in other ways, it cannot be invoked as a means of asserting immediate national ownership once the illegal exportation has occurred.

However, a more recent decision presents a slightly more promising picture. In *Kingdom of Spain* v *Christie Manson & Woods Ltd* [1986]

3 AII ER 28, the Goya painting *La Marquesa de Santa Cruz* was removed from Spain by means of forged export documents. The Spanish Kingdom sought a declaration from the English Court of Chancery that the exportation had been illegal. Its avowed purpose in so petitioning was not to assert any independent resultant ownership in the picture, but to avoid the continued use of forged documents. The Court held that the Kingdom enjoyed a sufficient interest in the proper observance of its export procedures to justify the award of the remedy sought. Of course, the resultant declaration would almost certainly depress the price of the picture and thus assist the Kingdom in any competitive purchase (although the judge was careful to remark that he did not consider this result to have been the main objective of the proceedings). The sort of strategy followed by the Spanish Kingdom in the case of illegal exportation is clearly more likely to lead to the eventual return of the disputed object to its parent nation than that adopted by the Government of New Zealand in Ortiz.

CUSTODY, CONSERVATION AND DISPLAY

A museum's obligation of safekeeping with regard to objects in its custody can exist in one of two main forms. First, all museums owe a duty to take care of articles loaned to them for exhibition or for other scholarly purposes. Secondly, a national museum or gallery may owe a positive duty to safeguard and exhibit its own objects.

The first duty is by far the most important; it applies to a much broader range of institutions, and it is much more easily enforced. Even here, however, the normal civil law responsibilities of the borrower museum may be less significant than in the case of other types of borrower. The reason is to be found in the Government Indemnity Scheme.[37] The purpose of this scheme is to facilitate museum and gallery loans by providing a publicly funded indemnity to the owner or lender of a cultural object in the event of damage, destruction or loss. The existence of this indemnity should, in appropriate cases, relieve the borrower of the need to take out commercial insurance, although it is to be noted that the terms of the indemnity do not affect any right of the owner to claim compensation from the borrower if the borrower has deviated from any of the special conditions imposed by the owner when making the loan. Moreover, the borrower remains answerable for the first £100 in relation to objects valued up to £4,000, and for the first £100 plus 1 per cent of the total value in relation to objects valued over £4,000. Further

conditions upon the operation of the indemnity include the adoption by the borrower of special security measures stipulated by the Minister for the Arts on the advice of the National Security Adviser and the display of the relevant objects only in places which have been given security clearance. The indemnity does not cover deterioration which is occasioned by inadequate physical or environmental conditions on the borrower's premises during the period of the loan, or injuries to the relevant objects caused by the deliberate act of the owner or lender or his employees. In cases where the borrower has contravened any of the specified conditions of storage or transportation, the Minister is stated to be entitled to pursue a claim or settlement against the borrower in the name of the owner, who must give all such information and assistance as the Minister shall require. Consistently with this, the Minister expressly reserves the right to recover the amount of any indemnity which he has paid from a borrower who has failed to observe the stipulated security conditions.

It follows that there will be many situations in which the indemnity scheme does not apply, or in which the borrowing institution's responsibility for misadventures occurring to borrowed artefacts must continue to be determined according to the terms of the transaction and upon the basic common law.

THE BORROWER AS BAILEE[38]

In pure legal terms, a borrower of a chattel is described as a bailee: that is, as someone to whom possession of the article has been delivered for a limited period or purpose while ownership continues to reside in someone else (the bailor). In cases where the lender can be said to derive no benefit whatever from the delivery, the bailment transaction is said to be a gratuitous one by way of *commodatum*. If, however, the lender derives some reciprocal benefit, however slight, the bailment is characterised as a bailment for reward, probably by way of *locatio conductio rei*.

In principle, it is unlikely that the precise characterisation of the bailment will affect the borrower's obligations towards the article. Most modern authorities concur in requiring all bailees, gratuitous or rewarded, to take such care of the bailed property as a reasonable man in their position would take in all the circumstances. Occasionally, judges have expressed this obligation in terms of the care and skill which a reasonable man would exercise towards his own goods; but it seems clear that the standard is to be set by the activities of the normal, prudent museum-keeper in the same professional circumstances as the particular

bailee, rather than according to the standards of the private householder.

The operation of this duty of care is accompanied by an unusual burden of proof. Once it is demonstrated that the article has been lost, damaged or destroyed while in the borrower's possession, the lender need adduce no further evidence in order to succeed in his claim. Upon proof of these facts, the burden then shifts to the borrower to establish one of two things: either, that he did in fact exert the appropriate degree of safekeeping towards the object in question, or that any failure on his part to exert that necessary degree of care did not contribute causally to the loss or injury which actually occurred. If the borrower cannot convince the court affirmatively of either of these facts, he will be liable to the lender. It is not necessary for the lender to produce positive proof of the borrower's lack of reasonable care.

In both respects, the bailee's burden is an onerous one. The obligation of safekeeping requires him to take account of the value, vulnerability and disposability of the goods, the special problems of the vicinity in which they are stored or exhibited and the peculiar skills of professional thieves who specalise in that class of article. The borrower must take reasonable precautions to render the premises secure against fire, flooding and climatic changes as well as against vandalism and theft, and must exercise care in the employment and supervision of staff. He must ensure that his employees remain vigilant against untoward events, and that a proper system of checking exists in order to detect such events as soon as reasonably possible after their occurrence. His duty also extends to the taking of reasonable measures to counteract any adverse occurrence which did not necessarily arise through his original fault: for example, by notifying the police or the lender as soon as possible after a theft, or by activating protective measures after a fire or explosion. He must also notify the owner promptly in the event of a third-party claim to the chattel.

The courts have taken an equally inclement attitude towards the second aspect of the bailee's burden of the proof. It is not sufficient, under this 'non-causative' defence, for the borrower merely to show that the adverse circumstance would have occurred in any event. He must positively demonstrate that the particular negligent omission of which he was guilty did not, in any way, facilitate the misadventure itself. Thus, a borrower who failed to activate overnight security procedures, with the result that a loaned painting was stolen, could not escape responsibility merely by showing that the thieves were sufficiently skilful or desperate to have penetrated the building, and perpetrated the theft, irrespective of this loophole.

Two further aspects of the borrower's obligations merit special attention, because each of them suggests a liability more exacting than that of ordinary negligence in particular circumstances. The first concerns possible 'in-house' thefts. In any situation where the bailed article is stolen, the bailee must show not only that reasonable precautions were taken by him personally but that the disappearance was not caused by the theft, or complicity in the theft, of any member of his staff to whom he had entrusted part of his obligation of safekeeping.[39] This liability exists quite independently of any liability which the museum-proprietor may or may not owe by virtue of his negligent employment of staff. Thus if a painting is stolen, and the borrowing institution cannot prove that it was not stolen by a security guard or curator in the relevant department (that is, by an employee charged with the custody of the particular object) the borrower must answer for the loss.

Secondly, the bailee must comply strictly with any express limitation upon his possession which the lender has imposed. The contravention of any fundamental restriction upon his lawful possession will render the borrower strictly liable as an insurer for any ensuing damage or loss, irrespective of whether this ensuing misfortune results from his personal negligence or not.[40] By 'deviating' from the terms of the loan, the borrower forfeits his status as a bailee and thus his right to be exonerated upon proof of reasonable care.

The commonest form of deviation is probably the unauthorised sub-lending of the article to another institution, or its exhibition or storage in a place other than that agreed. Another form of deviation is the unauthorised retention of the article by the borrower beyond the period originally permitted.

Although modern authority is not decisive on this question, it appears that the borrower's conventional duty of care does not extend to requiring him to insure the bailed article against events which arise independently of his fault.[41] An obligation to insure seems to arise only by express undertaking on the borrower's part, and not as an implied term of the bailment relation. But clauses requiring insurance are common in cases of loans which are not covered by the Government Indemnity Scheme, and there would ordinarily seem to be little difficulty in their contractual enforcement. The borrower enjoys, by virtue of his possession, the necessary insurable interest in the goods.

Having regard to the substantial number of thefts which are reported from museums and art galleries, it is surprising that so few decided authorities exist upon the practical implications of the borrowing institution's duty of

care. The author has traced only one recent Commonwealth authority upon the obligations of an art gallery towards borrowed exhibits, and this was somewhat less than typical because the gallery formed part of a private residence.

In *Bell* v *Tinmouth* (1987) 39 DLR (4th) 595, Mr Justice Paris of the Supreme Court of British Columbia held that the proprietors of the gallery were liable to the lenders of works of art which had been stolen from the gallery over a weekend. The gallery-owners had been negligent in leaving the gallery unattended, and with insecure window-fastenings, over that period. The judge's finding of negligence was fortified, in his opinion, by the fact that the proprietors had sent out over a hundred invitations to potential clients, thereby publicising the presence of the works in the gallery. This decision may be contrasted with that of the English Court of Appeal in *Spriggs* v *Sotheby Parke Bernet* (1986) 278 EG 969, where the momentary lack of vigilance on the part of an attendant at a Sotheby's preview of precious stones (as a result of which the plaintiff's diamond was stolen) was held to constitute a breach of the defendants' duty of care as bailees; although, in the event, the defendants were held to be protected from liability by an exclusion clause in their contract.

Such principles are clearly significant in the light of recent misadventures affecting cultural property. Three instances will be given, involving simple loss, theft and deliberate damage respectively. In October 1987, the *Sunday Times* reported the loss by the British Council of the written score of Sir William Walton's *Belshazzar's Feast*; in theory, the possessors should be answerable for the loss unless they can invoke the limitation period or can demonstrate that the loss occurred independently of their fault. In June 1988, the magazine *Private Eye* reported the theft of Lucien Freud's painting of Francis Bacon from an exhibition organised by the British Council in West Berlin. The painting was, apparently, valued at £75,000 and was covered by the Government Indemnity Scheme, but the Treasury is reported to be considering compensatory action against the National Gallery in Berlin. In July 1977, as the Museums and Galleries Commission Report recounts,[42] the shotgun attack upon the Leonardo cartoon at the National Gallery provoked questions on the part of the media as to the efficacy of security arrangements in NMGs; an issue which could become even more delicate if the damage by vandalism related to an article on loan. It is worth, in this context, drawing attention to the functions of the National Museums Security Adviser, an appointment which has existed since 1981 and which has proved, in the opinion

of the MGC, '. . . of considerable value and importance to museums'. His responsibilities are described in the MGC Report of 1988 as follows:

The Security Adviser advises on all aspects of security: he visits by invitation to discuss security systems for new, refurbished and existing buildings, takes part in reviews of the number and deployment of warding staff, and follows up any thefts; oversees the running of training courses for warding staff, gives lectures, and meets security officers quarterly; inspects the receiving museum's premises when items are to be lent from a national collection, or when items are accepted in lieu of tax; maintains records of the security arrangements at foreign institutions to which items are lent, and visits the locations of major touring exhibitions. He also gives ad hoc advice to non-national museums on security matters, and maintains contact with police forces at home and abroad.[43]

POSITIVE CONSERVATION

The borrower's duty of care clearly requires him to refrain from actively exposing the object to adverse environmental conditions. An obvious illustration can be drawn from the old case of *Mytton* v *Cock* (1739) 2 Stra 1099, where the private bailee of a painting was held liable in damages for keeping it in a damp cellar, with the result that the painting peeled. More difficult questions can arise when the impending deterioration of the object calls for positive, immediate acts of preservation on the borrower's part. For example, a mummified object may suddenly show signs of decay, or a manuscript may start to fade. In such a case, the more important question for the borrower may be whether he is entitled to reimbursement for any urgent restorative treatment which he performs (or engages in) in relation to the object.

The legal solution to this question represents something of a conundrum. In cases, at least, where the lender cannot be contacted in advance, the borrower will evidently be entitled to be indemnified for the costs of preserving the object from environmental hazards, provided that the acts of preservation were necessary as part of the borrower's normal duty of care: The Winson [1982] AC 939. The difficulty is that virtually no authority exists as to when a bailee is obliged to carry out restorative work as an incident of his duty of care and when, on the other hand, the necessary acts of restoration fall beyond the demands of that duty. The position is additionally complicated by the fact that many lenders of cultural property would object most strongly to unauthorised acts of restoration by borrower institutions, however altruistically intended. The borrower's right to an indemnity is clearly displaced when he knows that the lender forbids the work in question;[44] but in what circumstances

should such a prohibition be inferred?

A starting-point may be the well-established principle that the conventional bailee is not answerable for deterioration caused to the bailed object by ordinary wear and tear. Applying this rule, the borrower of an item of cultural property may resist liability on the ground that its physical impairment represented no more than the natural erosion of time. But such an argument will carry little weight if the form of impairment is one which, by his very acceptance of the article, the borrower has tacitly undertaken to guard against, and one which the lender himself has (by virtue of proper curatorial techniques) successfully avoided throughout his ownership. In other words, the 'wear and tear' defence can apply only when the wear and tear in question does not result from the borrower's failure to take reasonable care to keep the property in suitable atmospheric and environmental conditions.

Certainly, the borrower will be answerable for positive conduct which increases the danger to the object from environmental hazards; he may also be liable for failing to take reasonable steps to combat a sudden environmental risk which arose independently of any initial fault on his part, or for such omissions as the failure to maintain temperature or humidity levels, when maintenance was reasonably practicable. But the position is less certain when the deterioration stems from a sudden, independent change in the intrinsic condition of the cultural object itself. Here, the relevant criteria would appear to be: (i) what undertakings did the lender reasonably understand the borrower to have made in accepting delivery? and (ii) what would a reasonably competent and prudent custodian of the object do in equivalent circumstances?

Placed in such a dilemma, the borrower may well decide that it is more prudent for him to avoid remedial work completely. If he performs such work when his duty of care did not demand it, the borrower forfeits his right of indemnity and could even render himself liable for an act of wrongful interference with the article. He will, moreover, be accountable for any personal negligence in relation to the work of preservation, and may also be answerable for the negligent acts of any independent contractor to whom he delegates the work. But if, on the other hand, the borrower omits to carry out such restorative work when his duty of care does demand it, he will be liable for the resultant deterioration. The borrower's position is therefore an unenviable one, which reflects no great credit on the law. Only two things can be said with relative confidence: first, that the borrower must, if at all practicable, obtain the lender's authority before commencing any restorative treatment, and

secondly that such matters should preferably be settled in advance of the delivery by the terms of the loan transaction.

NATIONAL MUSEUMS AND GALLERIES

Hitherto, we have considered mainly the duties of private institutions with a distinct legal personality. Somewhat different considerations apply, however, to the national museums and galleries of the United Kingdom. Several of these institutions owe a specific legal obligation to exhibit their artefacts,[45] whereas in other cases the Museums and Galleries Commission believes that such a duty would be implied; indeed, in the Commission's opinion, it should represent one of the distinctive features of every NMG that it should 'exhibit its collections so as to provide the widest public benefit'.[46]

There are two respects in which such obligations differ from the position of exhibits in private museums or galleries. The first, of course, is that a private institution will conventionally owe no duty in relation to cultural property belonging to it. Such an institution cannot be compelled to exhibit the property if it does not choose to, and cannot be made liable for any act of carelessness injuring the property (indeed, as a matter of general law there would seem to exist no constraint upon deliberate destruction). Occasionally, it is true, an object may be bequeathed to a private institution on trust, or may be donated upon specific terms regulating its exhibition and retention. In general, however, the duty of caring for and exhibiting their own property is peculiar to national museums and galleries.

The second point concerns the enforcement of the obligation. Ownership of the collections in the NMGs is vested in the Trustees of each institution. It is therefore upon the Trustees that the obligations of safeguarding and maintaining the collections, and of permitting public access to them, are imposed. It is probably unrealistic to contemplate an action for damages against Trustees whose gross neglect of a collection (for example) leads to substantial theft or decay, although in theory such recourse may be permissible. It should also be borne in mind that the weight of these statutory obligations depends in part upon the economic resources which the Trustees receive in order to discharge them. Nevertheless, the MGC has recently emphasised that Trustees are ultimately accountable to the Courts, and its Report of 1988 instances the Attorney General's successful application to the High Court in 1987 for the removal and replacement of the Trustees of the Henry Reitlinger Bequest (who own a private museum in Maidenhead).[47] Action by the Charity

Commissioners represents another possibility in extreme cases.

Failing any purely legal redress, the ultimate official sanction against defaulting Trustees would probably be the withholding of the institution's grant-in-aid. As the MGC Report observes, however, such a response would be largely self-defeating.[48] The recent propensity towards private funding might also, eventually, diminish the effectiveness of such sanctions.

It is worth noting, however, that other temporal sanctions can and do attend the failure of a national museum or gallery to exhibit its property to public satisfaction. In May 1988, *The Times* reported that Mr Rodney Brangwyn, the great-nephew of Sir Frank Brangwyn, had been provoked by the failure of museums to exhibit paintings already donated from his uncle's collection into reversing his former decision to donate a further series of pictures. Mr Brangwyn pointed out that fewer than 10 per cent of the paintings given away by Sir Frank during the last twenty years of his life were currently on display, and that a picture entitled *The Poulterer's Shop*, which the Tate acquired in 1916, had not been exhibited since 1939. The position of Mr Brangwyn may be compared to that of Sir Denis Mahon, who was reported by *The Times* on another occasion[49] as thinking of rescinding a proposed bequest because of the possibility of new powers of disposal; Mr Brangwyn appears, if anything, to regard the selling of donated property as preferable to its indefinite interment in cellars.

DISPOSAL

Legal questions concerning the disposal of cultural property are mercifully less common than questions relating to acquisition. In terms of private law, the position of a museum seeking to dispose of a cultural object is broadly the converse of its position when acquiring one. The museum must take scrupulous care to alienate only those items of property which it owns, or which it is otherwise authorised to convey. The sale of an article which belongs to a lender, for example, can render the museum liable in two directions: to the lender himself, for the tort of conversion of his property, and to the purchaser for breach of the condition implied by s.12 of the Sale of Goods Act 1979, that the seller has the right to sell the article. Only on very rare occasions will the museum be entitled to claim that it was capable of conferring a good title upon the purchaser even though it had no such title itself, by virtue of the statutory exceptions to the rule *nemo dat quod non habet*. Even in such

a case, the museum will only (at most) be protected from an action on the part of the purchaser; it remains liable to the original lender whose property it has converted.

Even when a museum enjoys full ownership of the alienated chattel, it may nevertheless commit a breach of its obligations to the purchaser if the disposal was beyond the power conferred on the museum by its governing instrument or constitution. A purchaser who fails to receive property because the sale is in excess of the museum's powers is just as entitled to rescind the transaction under s.12 of the Sale of Goods Act as a purchaser from a museum which never had property in the first place. The disposing institution must therefore examine carefully its powers of disposal as well as its root of title to the chattel.

I shall examine the issue of powers of disposal only in the context of the national museums and galleries. The reasons are two-fold: it is in relation to some of the NMGs, at least, that one finds the clearest statutory definition of a museum's disposal powers; and the subject has provoked a lively recent public debate.

Under the National Heritage Act 1983,[50] the Trustee Boards of three of the NMGs are empowered to dispose of any of the objects in their collections if one of four criteria is satisfied. The NMGs in question are the Victoria and Albert Museum, the Science Museum and the Royal Armouries. Money raised by such disposal can be applied only towards the acquisition of further items for the relevant collection; it cannot be used to defray building costs or general running expenses. Where authorised, a disposal can be by way of sale, exchange or gift. The four criteria are as follows:

(a) The item in question is a duplicate.
(b) The item is, in the Trustee Board's opinion, '. . . unsuitable for retention in (its) collection and can be disposed of without detriment to the interests of students or other members of the public'.
(c) The item is being transferred to another of the NMGs which are listed from time to time in Schedule I to the National Gallery and Tate Gallery Act 1954.
(d) The Trustee Board is satisfied that the item has become '. . . useless for the purposes of (its) collections by reason of damage, physical deterioration, or infestation by destructive organisms'.

Comparable (but not identical) powers of disposal are enjoyed by the British Museum by virtue of subsections 5(1) and (2) of the British Museum Act 1963.

The Office of Arts and Libraries, in its Consultative Paper published in August 1988,[51] has drawn attention to certain characteristics of these disposal powers: they are discretionary rather than mandatory, they are very narrowly drafted, and they are not directed principally (if at all) towards the raising of money. Disposals might well carry resource implications, for example by releasing storage space or reducing other custodial expenses, but it seems clear that the essential judgements under criterion (b), for example, are intended to be aesthetic or scholarly rather than managerial or commercial.

The powers of alienation enjoyed by other national museums and galleries appear altogether less extensive. Neither the Wallace Collection nor (it seems) the collection of the National Portrait Gallery is capable of being depleted in this manner. The National Gallery and the Tate Gallery are empowered only to transfer items from their collections to each other, or to other NMGs.

Towards the end of 1987, the Minister for the Arts announced his intention of introducing a Museums and Galleries Miscellaneous Provisions Bill which would, among other things, confer upon the National Gallery, the National Portrait Gallery and the Tate Gallery a power to dispose of unwanted items. The announcement produced a sharp reaction. The Chairman of the Trustees of the National Gallery wrote formally to *The Times*,[52] declaring that the current Trustees had no intention of invoking the proposed power or of selling any picture from the collection. Sir Denis Mahon was reported as having hinted that he would rescind a proposed bequest of fifteen works to the National Gallery if the Bill became law.[53]

An article in *The Times* by Alison Beckett and John Davison[54] observed that a previous attempt to give the National Gallery similar powers was quashed after eighteen months' controversy in 1954 (when the Gallery's parent statute was enacted); in their contention, experts were continuing to regard the proposal both as a threat to prospective bequests, and as a device enabling future administrations to reduce purchase grants to take account of saleable items. Finally, in an article in *The Times* entitled 'Art Outbid by Avarice',[55] Brian Sewell saw the Bill as representing a 'time bomb waiting for less scrupulous trustees to activate'. In his submission,

Trustees . . . more often than not have neither the scholarship nor the experience to manage a museum. Their ignorance may not matter if they see themselves as a drag anchor to maintain the status quo, but if they see themselves instead as business managers putting into effect the policies of a Government of any

shade, they may ride rough-shod over aesthetic and intellectual considerations and do irreparable damage to the nation's heritage.

The debate has now reached the stage of a Consultative Paper, published by the Office of Arts and Libraries in August 1988.[56] This Paper invites consideration of a series of possible changes to the present restrictions affecting NMGs: for example, the extension of the word 'duplicate' as employed in criterion (a) of the V & A's powers to include 'similar' or 'equivalent' objects as suitable candidates for disposal; or the extension of the phrase 'unsuitable for retention in the collection' in criterion (b) of the V & A's powers to include items which are merely 'not essential to the collection', or 'not required' for it. The document suggests that institutions might acceptably be given a power to dispose of minor items in order to 'trade up' to more significant items, and might be empowered to employ the proceeds of disposal for purposes other than those of acquisition in the strict sense: for example, for cataloguing or conservation, or for certain wider objectives with ministerial consent. There is also a suggestion that galleries of modern or contemporary art might enjoy the right to dispose of works after a stated period in order to keep their collections 'turning over'.

The consultative document is couched in diffident and open terms. It emphasises the continued integrity of donations by way of trust or upon condition, and remarks that the Government entertains no particular view as to the desirable level of disposal in any given case. Moreover, there is a renewed endorsement of the principle that loans from national museums and galleries should continue as vigorously as possible, and a set of proposals as to how the current V & A model of disposals might be narrowed rather than augmented: for example, by requiring prior notification of an intention to dispose in order to permit representations to be made by the public, or by limiting disposals to those which command unanimous or substantial majority support from Trustees and Directors, or by imposing a duty upon the disposing institution to offer the article first to another NMG (or at least to other museums and galleries generally). To some, however, the appearance of these remarks in a Paper which studiously refrains from declaring any governmental commitment to sufficient public funding for NMGs, and which links the discussion to the impending conferment of a new corporate status upon the three aforementioned galleries, may be less than reassuring.

References

Introduction

1 See Edward P. Alexander, *Museums in Motion* (Nashville, Tenn.: American Association for State and Local History, 1979), pp. 6–7.

2 A recent special report of the Museums and Galleries Commission, the first since 1929 to undertake a review of Britain's national museums, makes vivid the crisis facing many of our most important national institutions, and points specifically to the way in which more intellectual pursuits such as scholarship and research, traditionally seen as an essential part of the museum curator's job, are increasingly perceived as being under threat. See *The National Museums and Galleries of the United Kingdom* (London: HMSO, 1988), especially pp. 5–6. Numerous other reports and articles, including the Rayner Report, have pointed to the lack of any clear policy, the lack of agreed aims or ideals, which appears endemic in our national museums; Rayner was especially critical of the Victoria and Albert Museum and the Science Museum in this respect. On the discussion which the report provoked, see Gordon Burrett, 'After Rayner', in Neil Cossons, ed., *The Management of Change in Museums* (London: National Maritime Museum, 1985), pp. 5–8.

3 On the discovery of the modern coelacanth, see the book by J. L. B. Smith, *Old Fourlegs. The Story of the Coelacanth* (London: Longmans, Green, 1956); on its anatomy, see Quentin Bone and Norman B. Marshall, *The Biology of Fishes* (Glasgow: Blackie, 1982) especially p. 218 and fig. 10.7.

4 Robert Lumley, ed., *The Museum Time Machine: Putting Cultures on Display* (London: Routledge/Comedia, 1988).

5 Brian Durrans, ed., *Making Exhibitions of Ourselves* (London: Scolar Press, forthcoming).

1 *Charles Saumarez Smith: Museums, Artefacts, and Meanings*

The origins of this essay lie in two seminar papers. The first was entitled 'The Object as Evidence in Historical Reconstruction' and was delivered in the 'Uses of the Past' seminar in the Department of Geography, University of London, organised by Professor David Lowenthal and Peter Burke. The second paper was given first to the postgraduate students in Gallery Studies in the Department of Art History and Theory, University of Essex, and subsequently to the museum training programme of the V & A. My ideas on the nature and meaning of artefacts in contemporary discourse have been principally influenced by George Kubler, *The Shape of Time: Remarks on the History of Things* (New Haven, Conn.: Yale Univ. Press, 1962); I. Kopytoff, 'The cultural biography of things: commoditization as process' in *The Social Life of Things: Commodities in Cultural Perspective*, Arjun Appadurai, ed. (Cambridge Univ. Press, 1986), pp. 64–90; and Daniel Miller, *Material Culture and Mass Consumption* (Oxford: Blackwell, 1987).

1 For Tradescant's collection, see Arthur MacGregor, *Tradescant's Rarities: Essays on*

the Foundation of the Ashmolean Museum 1683 with a Catalogue of the Surviving Early Collections (Oxford Univ. Press, 1983), and 'The Cabinet of Curiosities in Seventeenth-Century Britain' in Oliver Impey and Arthur MacGregor, eds., *The Origins of Museums: The Cabinet of Curiosities in Sixteenth and Seventeenth Century Europe* (Oxford Univ. Press, 1985), pp. 147–58.

2 MS Rawl. D. 864, Bodleian Library, Oxford, cit. C. H. Josten, *Elias Ashmole, 1617–92*, 4 (Oxford Univ. Press, 1967), pp. 1821–2.

3 For a recent study of the etymology of the word, see Michael Hunter, 'A Note on Early English Usage of the Word "Museum"', in Impey and MacGregor, eds., *The Origins of Museums, p.* 168.

4 W. S. Lewis, Warren Hunting Smith, and George L. Lam, eds., *Horace Walpole's Correspondence with Sir Horace Mann*, vol. XX (New Haven, Conn.: Yale Univ. Press, 1960), pp. 358–9. The history of the foundation of the British Museum has been described in many accounts. See, in particular, E. St. John Brooks, *Sir Hans Sloane: The Great Collector and His Circle* (London: Batchworth Press, 1954); J. Mordaunt Crook, *The British Museum* (London: Allen Lane, 1972); Edward Miller, *That Noble Cabinet* (London: André Deutsch, 1973); and Richard D. Altick, *The Shows of London* (Cambridge, Mass., and London: Harvard Univ. Press, 1978), pp. 15–17, 25–6.

5 For the early history of the South Kensington Museum, see Trenchard Cox, 'History of the Victoria and Albert Museum and the Development of its Collections', *Proceedings of the Royal Institution*, 37:167 (London, 1959), pp. 276–304; John Physick, *The Victoria and Albert Museum: The History of its Building* (London: Phaidon Christie's, 1982); and Charles Saumarez Smith, 'The Philosophy of Museum Display – The Continuing Debate', *The V & A Album*, 5 (London, 1986), pp. 30–38. I have been assisted in my understanding of the early history of the South Kensington Museum by discussions with Anthony Burton.

6 Henry Cole and Lyon Playfair, *First Report of the Department of Science and Art, January 1, 1854* in *Cole Miscellanies*, 9, National Art Library, Victoria and Albert Museum, pp. 187–8, cit. Edward P. Alexander, *Museum Masters: Their Museums and Their Influence* (Nashville, Tenn.: American Association for State and Local History, 1983), p. 159.

7 Moncure Conway, *Travels in South Kensington with notes on decorative art and architecture in England* (New York: Trübner & Co, 1882), p. 56. I am indebted to Professor Henry Glassie of the University of Indiana for recommending that I should study the ideas of Conway.

8 *Ibid.,* p. 33.

9 V & A A.10–1985. Information about the statue is contained in George Clarke, 'Grecian Taste and Gothic Virtue: Lord Cobham's gardening programme and its iconography', *Apollo*, XCVII (June 1973), pp. 566–71; S. Moore, 'Hail! Gods of our Forefathers', *Country Life*, 31 January 1985, pp. 250–51; John Kenworthy-Browne, 'Rysbrack's Saxon Deities', *Apollo*, CXXII (Sept. 1985), pp. 220–27.

10 Michael Thompson, *Rubbish Theory: The Creation and Destruction of Value* (Oxford Univ. Press, 1979); Kopytoff, *The Social Life of Things*, pp. 64–90.

11 I am greatly indebted to the essay by Kate Woodhead, 'An archway from 33, Mark Lane', V & A/RCA MA Course, 1987, unpublished, and for many discussions with her about it.

12 For the life of Pollen, see A. Pollen, *John Hungerford Pollen 1820–1902* (London: John Murray, 1912).

13 Michael Darby kindly informed me about its original position.

14 *The Panelled Rooms II. The Clifford's Inn Room*, Victoria and Albert Museum,

Department of Woodwork (London, 1914), pp. 13–14.

15 The origin for the vogue was apparently the Germanisches Museum at Nuremberg. See Edward P. Alexander, 'Artistic and Historical Period Rooms', *Curator*, VII:4 (1964), pp. 263–81; E. McClung Fleming, 'The Period Room as a Curatorial Publication', *Museum News*, June 1972, pp. 39–43; Dianne H. Pilgrim, 'Inherited from the Past: The American Period Room', *American Art Journal*, 10:3 (May 1978), pp. 4–23; Edward P. Alexander, *Museums in Motion: An Introduction to the History and Functions of Museums* (Nashville, Tenn.: American Association for State and Local History, 1979), p. 86; W. Seale, *Recreating the Historic House Interior* (Nashville, Tenn.: American Association for State and Local History, 1979); M. L. Dakin, 'Throwing out the period room', *History News*, 42:5 (Sept./Oct. 1987), pp. 13–17.

16 These arguments have been reconstructed from oral testimony and from the experience of sitting on many committees on the subject. I am particularly grateful to Dr Clive Wainwright for his help in explaining the institutional background.

17 For current ideas on methods of display, particularly in history museums, see W. Leon, 'A Broader Vision: exhibits that change the way visitors look at the past' in J. Blatti, ed., *Past Meets Present: Essays about Historical Interpretation and Public Audiences* (Washington, DC: Smithsonian, 1987), pp. 133–52.

18 There are convenient summaries and guides to this tendency in scholarship in Thomas J. Schlereth, ed., *Material Culture Studies in America* (Nashville, Tenn.: American Association for State and Local History, 1982); Daniel Miller, ed., 'Things ain't what they used to be', RAIN (Royal Anthropological Institute News), 59 (December 1983); G. W. Stocking, ed., *Objects and Others: Essays on Museums and Material Culture* (Madison, Wis.: Univ. Wisconsin Press, 1985); Thomas J. Schlereth, ed., *Material Culture: A Research Guide* (Univ. Press Kansas, 1985); and Robert Blair St George, *Material Life in America 1600–1860* (Boston: Northeastern Univ. Press, 1988).

19 Claude Lévi-Strauss, 'The Place of Anthropology in the Social Sciences and the Problems Raised in Teaching It' in *Structural Anthropology*, trans. Claire Jacobson and Brooke Grundfest Schoepf (New York: Basic Books, 1963), p. 375.

2 Ludmilla Jordanova: Objects of Knowledge: A Historical Perspective on Museums

1 Robert Louis Stevenson, 'Happy Thought', *A Child's Garden of Verses* (Harmondsworth: Penguin, 1952), p. 42.

2 Sheila Alcock, ed., *Museums and Galleries in Great Britain and Ireland* (East Grinstead: British Leisure Publications, 1988).

3 In addition to works cited later in the essay, I have found the following useful in thinking about museums: Philip Fisher, 'The Future's Past', *New Literary History*, 6 (1975), pp. 587–606; Susan Stewart, *On Longing: Narratives of the Miniature, the Gigantic, the Souvenir, the Collection* (Baltimore: Johns Hopkins Univ. Press, 1984); George W. Stocking, ed., *Objects and Others: Essays on Museums and Material Culture* (Madison, Wis.: Univ. Wisconsin Press, 1985); Robert Harbison, *Eccentric Spaces* (London: André Deutsch, 1977), ch. 8.

4 The analogy with oral history is striking in this connection. There the historian cannot take what she or he is told at face value because memory is never unmediated. It is not a matter of truth or falsity, because things remembered, even if they can be shown not to be strictly accurate, have their own value, and can lead to useful insights. A standard work on oral history is Paul Thompson, *The Voice of the Past. Oral History* (Oxford Univ. Press, 1978); for a recent exploration of the psychological complexity of these issues, see Karl Figlio, 'Oral History and the Unconscious', *History Workshop Journal*, 26 (1988), pp. 120–32.

5 Shelly Errington, 'Artefacts into Art' in Michael Lacey and Sally Kohlstedt, eds., *Collections and Culture: Museums and the Development of American Life and Thought* (forthcoming).

6 On the ideological function of the museum as a means of 'impress[ing] upon those who use or pass through it society's most revered beliefs and values', see Carol Duncan and Alan Wallach, 'The Universal Survey Museum', *Art History*, 3 (1980), pp. 448–69. However, they deal only with fine-art museums that have close relations with the State. The literature on scientific and medical museums is surprisingly sparse; relevant items include: Silvio Bedini, 'The Evolution of Science Museums', *Technology and Culture*, 6 (1965), pp. 1–29, and Susan Sheets-Pyenson, 'Cathedrals of Science: The Development of Colonial Natural History Museums during the Late Nineteenth Century', *History of Science*, 25 (1987), pp. 279–300.

7 Alcock, ed., *Museums and Galleries*, p. 113.

8 Anthony Burton, *Bethnal Green Museum of Childhood* (London: 1986), pp. 5, 36.

9 *Ibid.*, p. 9.

10 *Ibid.*, p. 7.

11 On the history of childhood see, for example, L. Pollock, *Forgotten Children: Parent-Child Relations from 1500–1900* (Cambridge Univ. Press, 1983); P. Ariès, *Centuries of Childhood* (Harmondsworth: Penguin, 1973) and L. de Mause, ed., *The History of Childhood* (London: Souvenir Press, 1976). It should be pointed out that these works have provoked considerable controversy and that there is no consensus on how the history of childhood should be approached.

12 Leonore Davidoff and Catherine Hall, *Family Fortunes. Men and Women of the English Middle Class, 1780–1850* (London: Hutchinson, 1987) analyses the historical context within which I believe such games need to be placed.

13 Marina Warner, *Monuments and Maidens. The Allegory of the Female Form* (London: Weidenfeld & Nicolson, 1985).

14 Child labour is a difficult topic because it has provoked such emotive responses; for sharply contrasting views see, for example, R. M. Hartwell, 'Children as Slaves' in his *The Industrial Revolution and Economic Growth* (London: Methuen & Co, 1971), pp. 390–408, and E. P. Thompson, *The Making of the English Working Class* (Harmondsworth: Penguin, 1968), ch. 10, pt. 4. The silence on class is best exemplified by the displays of children's dress at Bethnal Green. Social differences in clothing are not mentioned, nor are prices given. In fact, a number of the cases clearly contain expensive, handmade or exclusive clothes. To imply that all children at a given time – the cases are arranged by period – wore the same clothes is to deny the realities of a society structured around class, and fosters a rose-tinted view of childhood as a general state of innocence and playfulness.

15 Feminist scholars have been particularly attentive to science as a means of gaining mastery over nature: C. Merchant, *The Death of Nature. Women, Ecology and the Scientific Revolution* (London: Wildwood House, 1982); Evelyn Fox Keller, *Reflections on Gender and Science* (New Haven, Conn.: Yale Univ. Press, 1985).

16 I am thinking here of the 'Hottentot Venus' in the Musée de l'Homme in Paris.

17 Duncan and Wallach, 'The Universal Survey Museum' and Donna Haraway, 'Teddy Bear Patriarchy: Taxidermy in the Garden of Eden, New York City, 1908–1936', *Social Text*, 11 (1984–5), pp. 19–64.

18 For example, the advertisement for The Exploratory Hands-on Science Centre, Bristol, in Alcock, ed., *Museums and Galleries*, pp. 3–4.

19 Althea, *Visiting a Museum* (Cambridge: Dinosaur, n.d.), p. 24.

20 Haraway, 'Teddy Bear Patriarchy'; the phrase 'technologies of enforced meaning' is used on p. 30; 'realism' is also discussed on pp. 34, 37, 42.

21 Dorinda Outram, *Georges Cuvier. Vocation, Science and Authority in Post-Revolutionary France* (Manchester Univ. Press, 1984), pp. 176–7; Richard D. Altick, *The Shows of London* (Cambridge, Mass, and London: Harvard Univ. Press, 1978).

22 No general overview of the history of wax-modelling exists, but E. J. Pyke, *A Biographical Dictionary of Wax Modellers* (Oxford: Oxford Univ. Press, 1973) and supplement (London: Oxford Univ. Press, 1981) is an extremely useful starting-point.

23 Cole has emphasised the important rôle that the cost of alcohol played in the history of anatomical museums, not least in encouraging people to look for 'dry' alternatives, many of which employed wax in one form or another: F. J. Cole, *A History of Comparative Anatomy* (London: Macmillan & Co, 1949), ch. 8 and *ibid*, 'History of Anatomical Museums' in *A Miscellany Presented to J. M. Mackay* (Liverpool: Constable & Co, and London Univ. Press, 1914), pp. 302–17.

24 B. Lanza *et al.*, *Le Cere Anatomiche della Specola* (Florence: Arnaud, 1979).

25 Lawrence Stone, *The Family, Sex and Marriage in England, 1500–1800* (London, 1977), pl. 36.

26 A. Leslie and P. Chapman, *Madame Tussaud. Waxworker Extraordinary* (London: Hutchinson, 1978). The life- and death-masks made by phrenologists also conveyed positive and negative moral lessons and embodied the powerful urge for exactitude; see the catalogue for an exhibition drawn from the collection in the University of Edinburgh's Department of Anatomy, *Death Masks and Life Masks of the Famous and Infamous* (Edinburgh: Scotland's Cultural Heritage, Univ. Edinburgh Press, 1988).

27 *Oxford Illustrated Dictionary* (Oxford Univ. Press, 1975), p. 306. Additional definitions may be found in André Lalande, *Vocabulaire Technique et Critique de la Philosophie*, I (Paris: Félix Alcan, 1928), p. 250, and Emile Littré, *Dictionnaire de la Langue Française*, II (Paris: Hachette, 1878), p. 1653.

28 James Clifford, 'On Ethnographic Surrealism', *Comparative Studies in Society and History*, 23 (1981), pp. 539–64, quotation from p. 555; see also Errington, 'Artefacts into Art'.

29 Clifford, 'On Ethnographic Surrealism', Yve-Alain Bois, 'Kahnweiler's Lesson', *Representations*, 18 (1987), pp. 33–68.

30 Karl Marx, *Capital. A Critical Analysis of Capitalist Production*, vol. I (London: Lawrence & Wishart, 1974), p. 77.

31 Charles Rycroft, *A Critical Dictionary of Psychoanalysis* (Harmondsworth: Penguin, 1972), p. 51; Sigmund Freud, 'Fetishism' in *On Sexuality*, first published 1927 (Harmondsworth: Penguin, 1977), pp. 351–7.

32 Haraway, 'Teddy Bear Patriarchy', and Clifford, 'On Ethnographic Surrealism'.

33 This core epistemology is sensationalism, which accorded the senses unprecedented importance in the processes of learning and discovery. The link between sensationalist philosophy and natural knowledge is well known, and is epitomised by the close links between Locke and Newton. For an unusual slant on these issues which draws out their significance for the visual arts, see Michael Baxandall, *Patterns of Intention. On the Historical Explanation of Pictures* (New Haven, Conn., and London: Yale Univ. Press, 1985), ch. 3.

34 V. Ebin and D. A. Swallow, *'The Proper Study of Mankind . . .'– Great Anthropological Collections in Cambridge* (Cambridge University Museum of Archaeology and Anthropology, 1984), p. 2.

3 *Peter Vergo: The Reticent Object*

1 This essay is in part a revised and expanded version of a paper given at the one-day conference 'Why Exhibitions?', held at theVictoria and Albert Museum, London, on

21 November 1987 under the auspices of the Museums and Galleries Sub-Committee of the Association of Art Historians. I am grateful to Philip Wright, with whom I discussed the content of that original paper, and who was kind enough to read and comment on the present essay.

2 'Still too many Exhibitions', *Burlington Magazine*, CXXX:1018 (January 1988), p. 3.

3 Kenneth Hudson, *A Social History of Museums* (London: Macmillan, 1975), pp. 8–9.

4 G. Brown Goode, 'The Museums of the Future', *Annual Report to the Board of Regents of the Smithsonian Institution* . . . (1891); quoted after R. S. Miles *et. al*, *The Design of Educational Exhibits*, 2nd ed. (London: Unwin Hyman, 1988), p. 3. The distinction between the two opposing standpoints described here is also made with admirable precision by Colin Sorensen in his essay in the present volume, 'Theme Parks and Time Machines', in which he refers to 'the tangible thing and the supportive word, or alternatively, the primary word and the illustrative thing'.

5 Eric Newton, *The Meaning of Beauty* (Harmondsworth: Penguin, 1962), p. 64.

6 See, for example, the results of the survey published in Sweden by Arnell, Hammer and Nylöf: *Going to Exhibitions*, 2nd ed. (Stockholm: Riksutställningar, 1980).

7 Now in the collection of the Library of the Oesterreichisches Museum für Angewandte Kunst, Vienna.

8 *Das Zeitalter Kaiser Franz Josephs, 1. Teil: Von der Revolution zur Gründerzeit*, Bd. 2 (Katalog des Niederoesterreichischen Landesmuseums, Neue Folge Nr. 147, Vienna, 1984), p. 331 (cat. no. 17.1).

9 In preparing the exhibition 'Crossroads Vienna', held at the South Bank Centre, London, November–December 1988, my own thoughts about the rôle of the exhibition designer benefited greatly from numerous discussions with Barry Mazur, FCSD, who was responsible for the design of the show, who accompanied me to Vienna in order to inspect much of the material to be exhibited, and whose observations and suggestions contributed immeasurably, not just to the exhibition itself, but to the present essay.

10 For an account of the 'Degenerate Art' exhibition I have drawn largely on the relevant chapter of Ian Dunlop's *The Shock of the New: Seven Historic Exhibitions of Modern Art* (London: Weidenfeld & Nicolson, 1972), pp. 224–59.

11 The poster in question, by 'Hermann', was done for the Hamburg showing of the exhibition; see Frieder Mellinghof, *Kunst-Ereignisse. Plakate zu Kunst-Ausstellungen* (Dortmund, 1978), Abb. 59.

12 Dunlop, *op. cit.*, p. 252.

13 Cyril Connolly, 'Shivering the Timbers', *Sunday Times*, 4 April 1971; Dunlop, *The Shock of the New*, p. 255.

14 Quoted after Paul Greenhalgh, *Ephemeral Vistas. The Expositions Universelles, Great Exhibitions and World's Fairs, 1851–1939* (Manchester Univ. Press, 1988), p. 19.

15 *Ibid.*, especially ch. 1, pp. 3–26.

4 *Colin Sorensen: Theme Parks and Time Machines*

1 Richard D. Altick, *The Shows of London* (Cambridge, Mass, and London: Harvard Univ. Press, 1978).

2 Colin Amery and Dan Cruikshank, *The Rape of Britain* (London: Paul Elek, 1975).

5 *Paul Greenhalgh: Education, Entertainment and Politics: Lessons from the Great International Exhibitions*

1 Henry Mayhew, 'The Shilling People', quoted from Humphrey Jennings, ed., 'Pandemonium' (London: André Deutsch, 1985).

2 *Ibid.*

3 Anon., 'The International Exhibition of 1861' (London: Journal for the Encourage-
 ment of Arts, Manufactures and Commerce, 1861). The pamphlet was published
 with the incorrect date of the exhibition.
4 Anon., 'Educational Advantages of the International Exhibition' (London: Sixpenny
 Magazine, 1862).
5 Before 1914 there was no code which provided a definition or guideline as to what
 constituted an international exhibition. This came only after the Paris Convention of
 1928. The events cited here were chosen because of their scale, their international
 dimension and their temporariness in terms of facilities.
6 Glasgow constitutes a separate history to the one being examined here. There is now
 a good secondary source available on the Glasgow exhibitions: J. Kinchin and P.
 Kinchin, 'Glasgow's Great Exhibitions' (Oxford: White Cockade Press, 1988).
7 The Great Exhibition Commission owned the expanse of land which is now covered
 by the Victoria and Albert Museum, the Science Museum, the Natural History
 Museum and adjacent parts of the University of London, up as far as the Albert
 Memorial.
8 Charles Lowe, 'Four National Exhibitions in London' (London, 1892).
9 Official Guide, International Exhibition, South Kensington, 1874.
10 *Daily Mail*, 15 May 1909.
11 *The Times,* 21 May 1909.
12 See, for example, 'Utilitarianism' (London, 1861; reprint Open University Press,
 1979).
13 Official Illustrated Catalogue of the Industrial Department, International Exhibition,
 2 vols (London, 1862).
14 Quoted from Richard Mandel, 'Paris 1900: The Great World's Fair' (Univ. Toronto
 Press, 1967).
15 Anon., 'Paris and its Exhibition', *Pall Mall Gazette Extra*, 26 July 1889.
16 G. A. Sala, 'Notes and Sketches on the Paris Exhibition' (London, 1868).
17 Alex Thompson, from 'Dangle's Guide to Paris and its Exhibition' (London, 1900).
18 See Patricia Mainardi, 'Post-modern History at the Musée Gare d'Orsay', *October*
 41, Summer 1987.
19 'Salvador Dali Retrospective', Centre Georges Pompidou, Paris, 1979.

6 *Stephen Bann: On Living in a New Country*

This essay is dedicated to Bill Allen and Patrick Wright, both of whom helped to determine
its form in their different ways.

1 See Stephen Bann, *The Clothing of Clio: A Study of the Representation of History
 in Nineteenth-Century Britain and France* (Cambridge Univ. Press, 1984), pp. 77–92.
2 See Kenneth Hudson, *Museums of Influence* (Cambridge Univ. Press, 1987), pp. 21–2.
 The catalogue of Bargrave's Cabinet of Curiosities, or Museum, is published in John
 Bargrave, *Pope Alexander the Seventh* (London: Camden Society, 1867), pp. 114–40.
3 See Stephen Bann, 'Victor Hugo's Inkblots: Indeterminacy and Identification in the
 Representation of the Past', *Stanford French Review*, 13:1.
4 See Patrick Wright, *On Living in an Old Country: The National Past in Contemporary
 Britain* (London: Verso, 1985): an honorary adjunct to these essays is 'Rodinsky's
 Place', *London Review of Books*, 9:19, pp. 3–5.
5 Donald Horne, *The Lucky Country: Australia in the Sixties* (Harmondsworth: Pen-
 guin, 1964), p. 217.
6 Donald Horne, *The Great Museum: The Re-presentation of History* (London: Pluto
 Press, 1984), p. 1.

7 David Lowenthal, review of Wright, *On Living in an Old Country, Journal of Historical Geography*, 13:4, p. 440. Lowenthal has composed his own fascinating repertoire of contemporary attitudes to the past in *The Past is a Foreign Country* (Cambridge Univ. Press, 1985). For Riegl's concept of 'age-value', see Alois Riegl, 'The Modern Cult of Monuments: Its Character and Origin', trans. K. W. Forster and D. Ghirardo, in *Oppositions*, 25 (New York: Rizzoli).

8 Quoted in Wright, *On Living in an Old Country*, p. 251.

9 These streets vie together for the accolade of the most historic street in Australia, and Macquarie Street, in particular, has several fine refurbished buildings from the early colonial period. It is, of course, relevant that these early buildings are inseparably connected with the convict settlement of New South Wales, whilst Adelaide was established at a later date by free settlers.

10 It was an appropriate location for the opening of the Centre for British Studies of the University of South Australia. I should here record my debt to the Director, Dr Robert Dare, whose invitation to me to lecture on this occasion provided the stimulus for the theme of this essay.

11 See Roland Barthes, 'Rhétorique de l'Image', *L'Obvie et l'Obtus* (Paris: le Seuil, 1982), trans. Stephen Heath, in *Image-Music-Text*, new ed. (London: Fontana, 1987). For consideration of the diorama as a precursory form of photographic realism, see Bann, *The Clothing of Clio*, p. 26ff. It is worth noting the preservation in some Australian museums of dioramas of high quality. In the Australian War Museum at Canberra, however, the outstandingly fine dioramas have been insensitively interspersed with photographic panels which seem to suggest an embarrassment at the diorama's typically scenographic effect.

12 In addition to the article by Barthes cited above, it is worth considering the wider uses of the code of 'Italianicity' in 'Dirty Gondola: The image of Italy in American advertisements', *Word & Image*, 1:4, pp. 330–50.

13 It is obviously the case that such a message is specially aimed at young people, and hardly at all at the foreign traveller in South Australia. The fact that the museums of the History Trust of South Australia are specifically addressed to a local population is not the least interesting thing about them.

14 T. B. Macaulay, *History of England from the Accession of James the Second*, illus. and ed. C. H. Firth (London: Macmillan, 1914), vol. III, p. 1187.

15 The legend of Littlecote is featured in a ballad which forms episode XXVII in Canto V of *Rokeby*. Scott's voluminous note, which begins with a description of the hall 'supplied by a friend', goes on to tell the story of a hideous case of infanticide by the owner of Littlecote, one Darrell. 'By corrupting his judge, he escaped the sentence of law.' The corruption involved making the estate over to Judge Popham. See Walter Scott, *Rokeby: A Poem in Six Cantos*, 4th ed. (Edinburgh: Ballantyne, 1814), pp. 225–6 and 400–404. It is reported by Scott that visitors are still shown a piece of the bed-curtain, cut out and then sewn back again, which helped to detect the criminal in the first place. This detail, however, no longer forms part of the tour of Littlecote.

16 Macaulay, *op. cit.*, p. 1191.

17 See Herbert Butterfield, *The Whig Interpretation of History* (London: Bell, 1968) for the fallacy that 'Clio herself is on the side of the Whigs', p. 8.

18 See Roland Barthes, 'The reality effect', trans. R. Carter, in Tzvetan Todorov, ed., *French Literary Theory Today* (Cambridge Univ. Press, 1982).

19 See J. M. Cameron who, in an investigation of the relationship of British novelists to the Catholic European tradition, describes as 'intellectually debilitating' the Whig interpretation that 'sees glory in the proceedings of 1688' and reduces the conflicts of the Civil War to a quarrel of sects, *20th Century Studies*, 1 (March 1969), p. 87.

20 For a summary of the successive positions in Civil War and eighteenth-century British

historiography, see J. C. D. Clark, *Revolution and Rebellion: State and Society in England in the Seventeenth and Eighteenth Centuries* (Cambridge Univ. Press, 1986), pp. 1–5.

21 This stirring address took place in a fine assembly hall which was vividly reminiscent of the English university (and collegiate) tradition. On the general issue of how far the debate about the Civil War, and other central issues in British historiography, can inform the Australian sense of history – on more than an academic level – it is interesting to note the views of Donald Horne. In distinguishing between the two 'strands' of intellectual activity represented by Sydney and Melbourne in the early post-war period, he suggests that for the latter 'the Putney debates are required reading', for the former 'Plato's account of the trial of Socrates'. At Melbourne University, he detects 'a feeling that the English Puritan Revolution is still being fought (if in social terms) . . . ' (*The Lucky Country*, p. 208).

22 For an acute analysis of Disneyland, see Louis Marin, 'Disneyland: A Degenerate Utopia', in *Glyph*, 1 (Baltimore: Johns Hopkins Univ. Press, 1977), pp. 50–66. Marin has interesting things to say about the use of the family as a historical theme in this context: 'Here, the visitor becomes a spectator . . . seated in front of a circular and moving stage which shows him successive scenes taken from family life in the nineteenth century, the beginning of the twentieth century, today, and tomorrow. It is the *same* family that is presented in these different historical periods; the story of this "permanent" family is told to visitors who no longer narrate their own story. History is neutralised; the scenes only change in relation to the increasing quantity of electric implements, the increasing sophistication of the utensil-dominated human environment' (p. 63). It will be evident that 'The Land of Littlecote', despite the superimposed spectacular features, purveys history rather differently.

23 *Historic Houses, Castles and Gardens Open to the Public*, 1988 ed., p. 38: entry on Littlecote.

24 For a discussion of William Frederick Yeames's famous picture of the Cavalier boy being interrogated by Puritans, see Roy Strong, *And when did you last see your father? – The Victorian Painter and British History* (London: Thames & Hudson, 1978), pp. 136–7. The treatment of the Civil War period as family drama has, of course, subsequently commended itself to a number of historical novelists and television producers.

7 Philip Wright: The Quality of Visitors' Experiences in Art Museums

1 Dr Pieter Pott, Director of the Leiden Museum of Ethnology, Holland, distinguished three basic motives for visiting: *aesthetic* – the wish to experience beauty; *romantic* or *escapist* – the urge to leave the everyday world for a short time; *intellectual* – the wish to satisfy a certain thirst for knowledge (quoted by Kenneth Hudson, *A Social History of Museums: What the Visitors Thought* (London: Macmillan, 1975), p. 74.

2 I am not convinced by the commotion over introducing entrance charges for publicly funded museums in Britain. It is of course desirable that access to museums be free, just as it might be that admission to plays or concerts be likewise gratis. But anyone who has travelled widely in Western Europe or in the USA, where charging for entrance to museums is the norm, would be hard put to prove that these countries are any more visually illiterate or insensitive than we are. The 'tradition' of free entry is no more than a habitual practice, inherited from the wills of possibly guiltily rich private collectors or from socially manipulative town and city corporations in the nineteenth century, where the dividing line between selfless charity and proselytisation for the culture of controlling groups in society would be difficult to pinpoint. As numerous recent studies have also shown, by far the most significant and effective barriers to entry to museums are those of class and culture, and not that of the purse.

3 See, for example, Appendix A in Hudson, *A Social History of Museums*.

4 For example, Hudson, *A Social History of Museums*; Edward P. Alexander, *Museums in Motion: An Introduction to the History and Functions of Museums* (Nashville, Tenn.: American Association for State and Local History, 1979); Oliver Impey and Arthur MacGregor, eds., *The Origins of Museums: The Cabinet of Curiosities in Sixteenth and Seventeenth Century Europe* (Oxford Univ. Press, 1985); Kenneth Hudson, *Museums of Influence* (Cambridge Univ. Press, 1987); and not forgetting Geoffrey Lewis's contributions in the Museums Association's *Manual of Curatorship* (London: Butterworth/MA, 1984).

5 The proximity of the art-dealing world to museums was once again alluded to, recently, and predictably aroused a measure of hostile comments from both sides, in articles by Kenneth Hudson, *Museum News* (Jan. 1988) and Dr Celina Fox, *The Spectator*, 4 June 1988.

6 The specific detail of this famous relationship between an authenticating art historian-expert and the world's leading salesman of 'masterpieces' is set out in Colin Simpson's *The Partnership* (London: Routledge, 1987).

7 An amusing and somewhat tongue-in-cheek account of curatorial indulgence, which is by no means unknown today, may be glimpsed in ch. VI of the first volume of Kenneth Clark's autobiography, *Another Part of the Wood* (London: John Murray, 1974).

8 There is a double irony in that Timothy Clifford's controversial but remarkable redecoration and rehanging of Manchester City Art Gallery – where he was director from 1978–84 – recreating the original style of the Victorian art gallery (with rich blue, red or green walls to set off the paintings, and reintroducing decorative arts, and plants, into the rooms), resulted in a fifties, complete, white-walled suppression of the original nineteenth-century decoration, for which all paintings had been hung in a single row at median eye-level. Clifford's new work at the National Gallery in Edinburgh underlines, however, the antiquarian leanings which appear to have motivated these restorations. Though clearly visually striking, unorthodox for today, and historically stimulating, they no more illuminate the meanings of the works for late twentieth-century visitors than the white-walled fifties hang and, in some cases, in the interest of antiquarian authenticity (smaller) paintings have been literally 'obscured' from visitors by being stacked high up on the wall!

9 As the Museums' Group of the Association of Art Historians' day conference 'Why Exhibitions?' revealed in April 1988, differences of opinion between art historians and curators have begun to emerge more clearly over who controls the brief for exhibitions and, indeed, over who decides who makes which exhibitions. The differences arise particularly where 'progressive' curators engage 'traditional' art historians, or vice versa, or more sharply perhaps where a curator fails to engage the expert (art historian) in a particular field, but organises the exhibition in-house: both art historians and curators regard exhibitions as important opportunities in personal career terms.

10 Hudson, *A Social History of Museums*, p. 6.

11 See n. 1, above.

12 Danielle Rice, 'On the ethics of museum education', *Museum News*, June 1987, pp. 13–19.

13 In 'From the Parthenon', an essay co-published with the magazine *Art Monthly* in *Broadcast television and the arts* (Television/South West Arts, 1984), pp. 27–8, John Wyver wrote of Kenneth Clark's television series, *Civilisation*: 'To a considerable degree *Civilisation* . . . shares the critical approaches of the film profile: a focus on individuals, a stress on feeling . . . and a narrative account . . . But it also depends on a fourth crucial element: a positivist concept of knowledge.

'For Clark and (most of) his followers, the acquisition of knowledge is dependent

on direct *experience* of a place or a canvas or a fresco. Hence the familiar filmic device of showing the narrator in the Pazzi Chapel, or the Louvre, or Chartres. Such involvement, it is implied, gives him and by extension you the viewer, direct access to a "truth" about the Renaissance . . .

'Such a style has numerous antecedents, but clearly draws on early 19th century notions of enlightenment through undertaking the Grand Tour and, later, on the Victorian middle-class version of travel in both organised tourism and "magic lantern" slide shows.

'. . . Further, knowledge for Kenneth Clark is not only dependent on experience, but is "natural", a matter of simply visiting enough places. If you too had gone to such places . . . then you too would have come to precisely the same conclusions as Lord Clark.

'Knowledge in this system, then, is not problematic. There is little room for complexity and contradiction, and knowledge is certainly not seen as a *construction*, produced within and according to the tenets of particular political or social or ideological frameworks.'

14 In the British Collection at the Tate Gallery (the national collection of historical British art) there is no visible or written reference to the fact that the National Gallery and National Portrait Gallery in London, and the Scottish National Portrait Gallery in Edinburgh, own earlier British works, or why so few have survived both sixteenth- and seventeenth-century waves of iconoclasm.

15 Bob Tyrrell, 'The leisure paradox', *Museums Journal*, 87:4 (1987), p. 207.

16 For example, Judith Huggins Balfe in 'Bring on the baby boomers: a new look at adult learning in museums', *The Journal of Museum Education*, 22 (Fall 1987), about the Museum of Modern Art and the American Museum of Natural History in New York: ' . . . the median family income was $50,000, 70% of the adults had graduated from college, and 40% had studied in graduate school. At MOMA, fully 70% had taken art history at some time in college.' Or Nathalie Heinich, 'The Pompidou Centre and its public: the limits of a utopian site', *The Museum Time Machine: Putting Cultures on Display*, ed. Robert Lumley (London: Routledge/Comedia, 1988), pp. 202–3: 'As regards social origins, we are generally dealing with a highly educated public. More than half of Beaubourg's visitors have spent at least three years in higher education. Almost a third have passed their baccalaureate [at least 3 A-Levels equivalent] and/or have two years of advanced general or technical education. Only 15% do not have their baccalaureate . . . only 3% are manual workers (who formed 18% of the adult French population in 1982) . . . By contrast, almost 30% are executives and professionals (4.4% of the population) . . .'

See also the BBC Survey on the public for the visual arts (carried out in February–March 1979), published in 1980.

17 Dr Lee Draper, 'Partners in learning', *Western Museums Conference Newsletter*, 2 (1987), excerpted from the doctoral thesis 'Friendship and the Museum Experience' and available from University Microfilms International, Ann Arbor, MI.

18 Huggins Balfe, *op. cit.*, n. 16.

19 A useful indication of the range of surveys, and their general conclusions, can be found in Eilean Hooper-Greenhill, 'Counting visitors or visitors who count?' in R. Lumley, ed., *The Museum Time Machine*.

20 Margaret Hood, 'Staying away – why people choose not to visit museums', *Museum News*, 61:4 (1983), quoted by Lee Draper and Eilean Hooper-Greenhill.

21 Draper, *op. cit.*, n. 17.

22 Hudson, *Museums of Influence*, p. 179.

23 Summarised from Victor Middleton's paper 'Visitor expectations of museums', given at the Scottish Museums Council's 1984 annual conference, 'Museums are for people'

(London: HMSO, 1985), pp. 17–25, in which he enumerated ten expectations which every museum might find worth looking into.

24 Robert L. Wolf, 'Museums in their blackberry winter', *Museum Studies Journal,* 17 (Fall 1987); this is echoed by Dr George MacDonald (in 'The future of museums in the Global Village', *Museum,* 55, 1987, p. 214): 'According to Dr Robert Kelly of the University of British Columbia, people in the information society draw their status from the experiences they have and the information they control, rather than the wealth objects they possess. Museum visitors responded in kind and attended quality shows for their information, and blockbusters for the experience (shared with others) which they provided. Where layers of glass signalled the monetary value of museum treasures of the past, the new visitor wanted more "experiential" exhibits where the object was not so separated from the viewer. Specialised museums proliferated which allowed demonstrations or even direct contact with the objects, as in children's museums and open-air museums.'

25 Rice, *op. cit.,* n. 12.

26 For example, Beaubourg has estimated that a recent annual total of 7.3 million visits to the Center signified around 800,000 individual visitors; i.e., a ratio of roughly one visitor to nine visits (although the basis for calculating this ratio was not given): quoted by Heinich, in R. Lumley, ed., *The Museum Time Machine,* p. 211.

27 For example, two very competent examples are to be found, once again, in American museums – leaders in their respective fields: at the Heard Museum of Anthropology and Primitive Art in Phoenix, Arizona, and at the Corning Glass Center in Corning, NY. The first passes all its visitors through, but does not compel them to view a short audiovisual programme which sets the elegiac tone for the history of the (south-west) Native American, whose material culture is portrayed in the museum. The second issues, and personally explains, a leaflet to each visitor or group of visitors, which sets out the time needed for visiting the three principal components of the Center – viewing Corning's collection of world glass, observing the Steuben Glass Factory at work, and the hands-on experiences in the Hall of Science and Industry – and provides a clear map of the purpose-built Center (and of other attractions for visitors in the town).

28 See Franz Schouten, 'Psychology and exhibit design: a note', *The International Journal of Museum Management and Curatorship,* 6 (September 1987), pp. 259–62.

29 Quoted by Christopher Zeuner in his review of the AIM Workshop, 'The American way with visitors', *AIM Bulletin,* 11:2 (April 1988), p. 3.

30 Marie Hewitt, 'Developing strong evaluation efforts', *The Journal of Museum Education: Roundtable Reports,* 12:1, pp. 18–20.

31 Harvey Green, Vice President for Interpretation at the Strong Museum, in a letter to this writer in January 1988.

32 See Section III: Visitor Services, especially chs. 44–8 (incl.). See also R. S. Miles *et al., The Design of Educational Exhibits* (London: Unwin Hyman, rev. p/b ed., 1988).

33 Sherman Lee, *The Bulletin of the Cleveland Museum of Art,* LVII:6 (June 1970), p. 164 (kindly supplied by William Talbot, Assistant Director for Administration at the Cleveland Museum).

34 For example, Bloomsbury painting could be set 'in its own context' (the decorative arts of the Omega Workshops, Bloomsbury homes and patrons, etc.): as 'avant-garde' in contrast to the Art Pompier of High Edwardian Taste at the apogee of our Empire; as rather 'timid and eclectic' in contrast to contemporary avant-garde work from Europe (Fauves, Expressionists, Cubists); as 'traditionally studio-based' in contrast to contemporary political and social issues raised in Britain at the time, and in contrast to the impact of Futurism in many other European countries before World War I. Or,

file 11

art of an identified historical period – such as the early seventeenth century in Holland – could be set in the context of its worth to its original commissioner or purchaser as a reflection of his or her taste, social standing and wealth; in the context of the then current taste for the antique or for the interest in, and study of, the natural history, customs and trade with the New World and the Orient; or in the context of the state of theology, morals, secular values and religious beliefs during the concurrent, devastating Thirty Years War, and so on.

35 Gayle Kavanagh, 'Ah, yes, but . . . a few thoughts on the objects vs. people debate', *Social History Curator Group News*, 16 (1987), p. 7.

36 Hewitt, *op. cit.,* p. 30.

37 Hudson, *Museums of Influence*, p. 173.

38 It is not fair to single out some innovative museums in such a brief note and, by omission, unjustly slight others who might be equally as deserving of recognition, but in the last ten years or so the exhibition and activities programme of the Aberdeen Art Gallery, the education and collection practices of the Southampton Art Gallery, the permanent collection display at the Sainsbury Centre in Norwich (and, in striking contrast, that of Manchester City Art Gallery mentioned in n. 8, above), and the multiracial programme of Cartwright Hall Art Gallery in Bradford, have all ventured beyond the current orthodoxies in art gallery and museum practices.

8 Nick Merriman: Museum Visiting as a Cultural Phenomenon

The research presented in this paper forms part of a Ph.D. thesis submitted to the University of Cambridge in 1988. I am grateful to the British Academy, St John's College, HBMC and the Cole Trust for providing funding. In addition I am very grateful to my supervisors, Cathie Marsh and, later, Kate Pretty for all their advice and encouragement. The Museum of London kindly allowed me a sabbatical to finish the thesis. Thanks are also due in particular to Ian Hodder and Colin Renfrew, and to Cathie Marsh, Eilean Hooper-Greenhill and Fred Baker for commenting on a first draft of this paper.

1 Eilean Hooper-Greenhill, 'Counting visitors, or visitors who count?', in Robert Lumley, ed., *The Museum Time Machine* (London: Routledge/Comedia, 1988), pp. 213–32.

2 The survey used an American postal survey technique known as 'The Total Design Method', which relies on personalisation and follow-ups to elicit maximum response. The questionnaire was built up from initial unstructured interviews, tested by a pilot survey, and then sent out to a random sample of 1500 adults selected from the electoral registers of Great Britain. A 66 per cent response rate was achieved, and, when the characteristics of non-respondents were determined, the results were weighted to emulate a sample representative of the total population. Analyses were made using the SPSS-X data analysis package. Standard explanatory variables such as age and educational background are used. 'Status' is a composite variable based on answers to questions on housing tenure, car ownership and education. Owing to an interaction of age and status amongst the low-status elderly, low-status respondents under sixty have been distinguished from low-status respondents over sixty. All results presented here are statistically significant at the level $p = .05$; 'N' is the size of sample; and all figures have been rounded to the nearest one per cent.

3 Nick Merriman, 'The social rôle of museum and heritage visiting', in S. Pearce, ed., *Museum Studies in Material Culture* (Leicester Univ. Press, 1989), pp. 153–71.

4 Nick Merriman, 'The role of the past in contemporary society, with special reference to archaeology and museums', unpublished Ph.D. thesis, University of Cambridge, 1988.

5 For example, Robert Hewison, *The Heritage Industry* (London: Methuen, 1987).

6 Merriman, *op. cit.*, n. 3, p. 155.

7 Brian Dixon, Alice E. Courtney and Robert H. Bailey, *The Museum and the Canadian Public* (Toronto: Culturcan Publications, 1974).

8 Marilyn G. Hood, 'Staying away – why people choose not to visit museums', *Museum News*, 61:4 (1983), pp. 50–57.

9 David Prince and Bernadette Higgins-McLoughlin, *Museums UK: The Findings of the Museums Data Base Project* (London: Museums Association, 1987).

10 Henry Sears, 'Visitor characteristics and behaviour', in B. Lord and G. Lord., eds, *Planning Our Museums* (Ottawa: National Museums of Canada, 1983), pp. 33–44.

11 English Tourist Board, *Survey of Visits to Tourist Attractions* (London: ETB, 1983).

12 Merriman, *op. cit.*, n. 3, pp. 160–61.

13 Merriman, *op. cit.*, n. 4, Table A11.

14 David Prince, 'Behavioural consistency and visitor attraction', *International Journal of Museum Management and Curatorship*, 2 (1983), pp. 235–47.

15 Merriman, *op. cit.*, n. 3, pp. 157–61.

16 Merriman, *op. cit.*, n. 3, pp. 157–61.

17 Merriman, *op. cit.*, n. 4, pp. 173–4.

18 For example, see Robert Hewison, *The Heritage Industry* (London: Methuen, 1987) and Patrick Wright, *On Living in an Old Country* (London: Verso, 1985).

19 Marilyn Hood, 'Adult Attitudes Towards Leisure Choices in Relation to Museum Participation', unpublished Ph.D. dissertation, Ohio State University, 1981; *op. cit.*, n. 8, pp. 50–57.

20 Hooper-Greenhill, *op. cit.*, n. 1.

21 David Prince, 'Countryside interpretation: a cognitive evaluation', *Museums Journal*, 82 (1982), pp. 165–70; 'Behavioural consistency and visitor attraction', *International Journal of Museum Management and Curatorship*, 2 (1983), pp. 235–47; 'The museum as dreamland', *International Journal of Museum Management and Curatorship*, 4 (1985), pp. 243–50.

22 Prince, 1983, *op. cit.*, n. 21, p. 242.

23 David Prince, 'Museum visiting and unemployment', *Museums Journal*, 85 (1985), p. 86.

24 David Prince and Tim Schadla-Hall, 'The image of the museum: a case-study of Kingston-upon-Hull', *Museums Journal*, 85 (1985), p. 40.

25 Prince, 1983, *op. cit.*, n. 21, p. 242.

26 Pierre Bourdieu, *Distinction* (London: Routledge, 1984).

27 Pierre Bourdieu, *Outline of a Theory of Practice* (Cambridge Univ. Press, 1977).

28 Pierre Bourdieu and J.-C. Passeron, *Reproduction in Education, Society and Culture* (London: Sage, 1977), pp. 35–41.

29 Bourdieu and Passeron, *op. cit.*, n. 28, p. 73.

30 Pierre Bourdieu and Alain Darbel, *L'amour de l'art: les musées et leur public* (Paris: Editions de Minuit, 1966); *L'amour de l'art: les musées européens et leur public*, deuxième edition revue et augmentée (Paris: Editions de Minuit, 1969).

31 Bourdieu and Darbel, 1969, *op. cit.*, n. 30, p. 35.

32 Bourdieu and Passeron, *op. cit.*, n. 28, p. 43.

33 Bourdieu and Darbel, 1969, *op. cit.*, n. 30, p. 71. My translation.

34 Bourdieu and Darbel, 1966, *op. cit.*, n. 30, p. 62–6.

35 Bourdieu and Darbel, 1969, *op. cit.*, n. 30, p. 165. My translation.

36 Patrick Heady, *Visiting Museums. A report of a survey of visitors to the Victoria and Albert, Science and National Railway Museums for the Office of Arts and Libraries* (London: Office of Population and Census Surveys, 1984); Rudolf Klein, 'Who goes to museums?', *Illustrated London News*, April 1974, pp. 27–9.

37 Robert Kelly, *Leisure* (London: Prentice-Hall, 1982); *Leisure Identities and Interactions* (London: Allen & Unwin, 1983).

38 Kelly, 1983, *op. cit.*, n. 37, p. 35.

39 Kelly, 1982, *op. cit.*, n. 37, p. 172.

40 Kelly, 1983, *op. cit.*, n. 37, p. 46.

41 See Kenneth Hudson, *A Social History of Museums* (London: Macmillan, 1975) for examples of the reactions of visitors to early museums.

42 T. Greenwood, *Museums and Art Galleries* (London: Simpkin Marshall, 1888).

43 Augustus H. L. F. Pitt Rivers, 'Typological museums, as exemplified by the Pitt Rivers Museum at Oxford, and his provincial museum at Farnham, Dorset', *Journal of the Royal Society of Arts*, 40 (1891), pp. 115–22.

44 Calculations based on Figure 2.3 in David Prince and Bernadette Higgins-McLoughlin, *Museums U.K.: The Findings of the Museums Data Base Project* (London: Museums Association, 1987).

45 David Prince, 1983, *op. cit.*, n. 21.

46 E. Cumming and W. Henry, *Growing Old* (New York: Basic Books, 1961).

47 Kenneth Roberts, *Leisure*, 2nd ed. (Harlow: Longman, 1981), p. 79. It may be, however, that the growing trend towards early retirement may bring about a wider phenomenon of 're-engagement'. Increasing numbers of retired people in their fifties or early sixties may use their retirement to re-engage in such activities as museum visiting.

48 Bourdieu, *op. cit.*, n. 26, p. 27.

49 This is shown by a scrutiny of the summaries in *Social Trends* (London: Central Statistical Office) for the last 10–15 years.

50 See, for example, Dean MacCannell, *The Tourist: A New Theory of the Leisure Class* (New York: Schocken Books, 1976) or Michael Bommes and Patrick Wright, '"Charms of residence": the public and the past', in Centre for Contemporary Cultural Studies, ed., *Making Histories: Studies in History-Writing and Politics* (London: Hutchinson, 1982), pp. 253–301.

51 The expansion of museum education services in the 1960s as a result of the Rosse Report may also have played an important rôle in making museums more accessible to a wider range of people (E. Hooper-Greenhill, *pers. comm.*).

52 Hewison, *op. cit.*, n. 18.

53 See, for example, J. Goldthorpe, D. Lockwood, F. Bechhofer and J. Platt, *The Affluent Worker in the Class Structure* (Cambridge Univ. Press, 1969), or F. Hirsch, *The Social Limits to Growth* (London: Routledge, 1977).

54 Goldthorpe *et al.*, *op. cit.*, n. 53, p. 121.

9 *Norman Palmer: Museums and Cultural Property*

1 See the report in *The Times*, 20 August 1988. The figure was produced by the Museums Association which, in January 1989, launched 'Museums Year'.

2 See, for example, the article entitled 'Call to halt trade in stolen treasure' in *Sunday Times*, 28 August 1988.

3 Contrast, for example, the Norwegian Cultural Heritage Act (no. 50) of 1978, or the Australian Protection of Movable Cultural Heritage Act (no. 11) of 1986. The latter is described in its preamble as an Act designed not only to protect Australia's own heritage of movable cultural objects but 'to support the protection by foreign countries of their heritage of movable cultural objects . . .'

4 *Parker* v *British Airways Board* [1982] QB 444.

5 *Kowal* v *Ellis* (1977) 76 DLR (3d) 546.

6 Cmnd. 4774 (1971).
7 *Winkworth* v *Christie Manson & Woods Ltd* [1980] 1 A11 ER 1121.
8 *Cammell* v *Sewell* (1860) 5 H & N 728.
9 *Princess Paley Olga* v *Weisz* [1929] 1 KB 718.
10 August 1988.
11 *Management of the Collections of the English National Museums and Galleries*, 23 March 1988, paras. 4.1–4.11.
12 *The National Museums*, 6 April 1988, passim.
13 See *Powers of Disposal from Museum and Gallery Collections*, the Consultative Paper issued by the Office of Arts and Libraries.
14 See further on this question the proposals advanced by Sir Philip Goodhart MP in the Bow Group Research paper no. 7 (1988), *The Nation's Treasures*, where it is proposed (inter alia) that the 1964 agreement whereby museum staff are treated as civil servants should be abandoned, and that 'Acquisition policy should become the sole financial responsibility of the trustees of the national collection', *ibid*. For an account of the pressures currently facing local museums, see the Museums Association's paper *Answering the Challenge* (1988), reported in *The Times*, 14 September 1988.
15 *Op. cit.*, n. 10, at para. 11.
16 *Op. cit.*, n. 10, at para. 10.
17 *Op. cit.*, n. 10, at para. 10.
18 Sale of Goods Act 1979, s.21(1).
19 See generally Torts (Interference with Goods) Act 1977, s.3.
20 *Moorgate Mercantile Co. Ltd* v *Twitchings* [1977] AC 890.
21 Torts (Interference with Goods) Act 1977, s.11(3).
22 See further n. 23 below.
23 There are, however, two mitigating factors to the *nemo dat* rule. The first is that it is subject to a number of statutory exceptions: situations where a purchaser of chattels may become their lawful owner even though no such ownership resided in the person who purported to sell them to him. These exceptions are mainly contained in ss.21–5 of the Sale of Goods Act 1979 and s.2 of the Factors Act 1889. The second mitigating factor is that an acquirer who fails to obtain the promised title to the goods has a right of redress against the supplier. Such, at least, is the position where the disposition to him takes the form of a purported sale or exchange: see, in particular, s.12 of the Sale of Goods Act 1979 (in the case of a contract of sale) and s.2 of the Supply of Goods and Services Act 1982 (in the case of a contract of exchange).
24 *Rowland* v *Divall* [1923] 2 KB 500.
25 SGA 1979, s.53(1).
26 Palmer (1981) 44 MLR 178.
27 As in the case of the Thetford hoard.
28 *Prerogatives of the Crown*, p. 152.
29 1 BL Com (14th ed.) 295.
30 3 Co Inst 132.
31 Palmer (1981) 44 MLR 178.
32 *Treasure Trove* in Law Reform Issues (September 1987), paras. 12, 13.
33 *Webb* v *Ireland* (1987) Unrep., 16 December.
34 Palmer, *Bailment* (Law Book Co. of Australasia, 1979), ch. 3.
35 [1980] 1 A11 ER 1121, at p. 1135.
36 See, generally, *The Times*, 20 January 1987; 2 August 1988.
37 Promulgated pursuant to the National Heritage Act 1980, s.4(1). See especially the *Standard Conditions*, published by the Museums and Galleries Commission.

38 Palmer, *op. cit.*, n. 34, chs. 9, 13, 19.
39 *Morris* v *C. W. Martin & Sons Ltd* (1966) 1 QB 716.
40 *Shaw & Co.* v *Symmonds & Sons* [1917] 1 KB 799; *Mitchell* v *Ealing LBC* [1978] 2 WLR 99.
41 *Mason* v *Morrow's Moving & Storage Ltd* [1978] 4 WWR 5 34.
42 *Op. cit.*, n. 12, pp. 33–4.
43 *Ibid.*
44 It should be noted that it is now common practice for loan agreements specifically to prohibit the borrower from undertaking even the most urgent tasks of restoration or repair of the borrowed object without the prior consent of the owner.
45 For example, under the British Museum Act 1963, ss.3(1), 3(3).
46 *Op. cit.*, n. 12, at p. 5: and see at pp. 7–9.
47 *Op. cit.*, n. 12, at p. 17.
48 *Op. cit.*, n. 12, at p. 19.
49 See n. 52 below.
50 Ss.6 (V & A), 14 (Science Museum), 20 (Royal Armouries).
51 At paras. 20–22.
52 *The Times* 16 October 1987.
53 *The Times*, 13 May and 10 August 1988.
54 *The Times*, 8 September 1988.
55 *The Times*, 21 November 1987.
56 *Powers of Disposal from Museum and Gallery Collections* (1988); and see further Bow Group Research Paper no. 5 (1988), *The Nation's Treasures* by Sir Philip Goodhart MP.

Select Bibliography

The bibliography which follows offers only a selection from the growing literature on museology generally. It comprises, for the most part, books and anthologies which relate specifically to the field of enquiry covered by the present volume. Many of the books listed contain their own extensive bibliographies which should be consulted for further reading; more detailed references, especially to periodical literature and to articles in newspapers, professional journals and the like will also be found in the notes relating to the individual essays in this anthology.

Alcock, Sheila, ed., *Museums and Galleries in Great Britain and Ireland*, East Grinstead: British Leisure Publications, 1988.

Alexander, Edward P., *Museums in Motion: An Introduction to the History and Functions of Museums*, Nashville, Tenn.: American Association for State and Local History, 1979.

——*Museum Masters. Their Museums and their Influence*, Nashville, Tenn.: American Association for State and Local History, 1983.

Altick, Richard D., *The Shows of London*, Cambridge, Mass., and London: Harvard Univ. Press, 1978.

The American Museum Experience: In Search of Excellence, Edinburgh: Scottish Museums Council, 1986.

Bann, Stephen, *The Clothing of Clio: A Study of the Representation of History in Nineteenth-Century Britain and France*, Cambridge Univ. Press, 1984.

Bellow, Corinne, ed., *Public View. The ICOM Handbook of Museum Public Relations*, Paris: ICOM, 1986.

Bourdieu, Pierre, 'The Aristocracy of Culture', *Media, Culture and Society*, 2, 1985.

Chamberlin, Russell, *Loot. The Heritage of Plunder*, London: Thames & Hudson, 1983.

Communicating with the Museum Visitor. Guidelines for Planning, Toronto: Royal Ontario Museum, 1976.

Cossons, Neil, ed., *The Management of Change in Museums*, London: National Maritime Museum, 1985.

Duncan, Carol, and Wallach, Alan, 'The Universal Survey Museum', *Art History*, 3:4, December 1980.

Dunlop, Ian, *The Shock of the New: Seven Historic Exhibitions of Modern Art*, London: Weidenfeld & Nicolson, 1972.

Durrans, Brian, ed., *Making Exhibitions of Ourselves*, London: Scolar Press, forthcoming.

Greenhalgh, Paul, *Ephemeral Vistas: The Expositions Universelles, Great Exhibitions and World's Fairs*, 1851–1939, Manchester Univ. Press, 1988.

Hall, Margaret, *On Display. A Design Grammar for Museum Exhibitions*, London: Lund Humphries, 1987.

Harris, John S., *Government Patronage of the Arts in Great Britain*, Chicago/London: Univ. Chicago Press, 1970.

Hewison, Robert, *The Heritage Industry*, London: Methuen, 1987.

Hudson, Kenneth, *A Social History of Museums*, London: Macmillan, 1975.

——*Museums of Influence*, Cambridge Univ. Press, 1987.

Horne, Donald, *The Great Museum*, London: Pluto Press, 1984.

Impey, Oliver, and MacGregor, Arthur, *The Origins of Museums: The Cabinet of Curiosities in Sixteenth and Seventeenth Century Europe*, Oxford Univ. Press, 1985.

Lowenthal, David, *The Past is a Foreign Country*, Cambridge Univ. Press, 1985.

Lumley, Robert, ed., *The Museum Time Machine: Putting Cultures on Display*, London: Routledge/Comedia, 1988.

Miles, R. S. *et al.*, *The Design of Educational Exhibits*, London: Unwin Hyman, rev. p/b ed., 1988.

Miller, Daniel, *Material Culture and Mass Consumption*, Oxford Univ. Press, 1987.

Miller, Edward, *That Noble Cabinet. A History of the British Museum*: André Deutsch, London 1973.

Museums are for People, Edinburgh: Scottish Museums Council, 1985.

Myerscough, John, *Facts about the Arts, 2*, London: Policy Studies Institute, 1986.

The National Museums and Galleries of the United Kingdom, London: HMSO, 1988.

Pick, John, *Managing the Arts? The British Experience*, London: Rhinegold Press, 1987.

Physick, John, *The Victoria and Albert Museum*, Oxford: Phaidon Press, 1982.

Schlereth, Thomas J., ed., *Material Culture Studies in America*, Nashville, Tenn.: American Association for State and Local History, 1982.

Stocking, George W., ed., *Objects and Others: Essays on Museums and Material Culture*, Madison, Wis.: Univ. Wisconsin Press, 1985.

Weil, Stephen E., *Beauty and the Beasts. On Museums, Art, the Law and the Market*, Washington, DC: Smithsonian, 1983.

Witteborg, Lothar P., *Good Show! A Practical Guide for Temporary Exhibitions*, Washington, DC: Smithsonian, 1981.

Wright, Patrick, *On Living in an Old Country: The National Past in Contemporary Britain*, London: Verso, 1985.

Index